T0161436

The Orange Balloon Dog

THE ORANGE BALLOON DOG

Bubbles, Turmoil and Avarice in the
Contemporary Art Market

Don Thompson

 Douglas & McIntyre

Copyright © 2017 Don Thompson

2 3 4 5 — 21 20 19 18

All rights reserved. No part of this publication may be reproduced, stored in a retrieval system or transmitted, in any form or by any means, without prior permission of the publisher or, in the case of photocopying or other reprographic copying, a licence from Access Copyright, www.accesscopyright.ca, 1-800-893-5777, info@accesscopyright.ca.

Douglas and McIntyre (2013) Ltd.
P.O. Box 219, Madeira Park, BC, V0N 2H0
www.douglas-mcintyre.com

Cover design by Anna Comfort O'Keeffe
Text design by Shed Simas / Onça Design
Indexed by Kyla Shauer
Printed in Canada

Douglas and McIntyre (2013) Ltd. acknowledges the support of the Canada Council for the Arts, which last year invested $153 million to bring the arts to Canadians throughout the country. We also gratefully acknowledge financial support from the Government of Canada through the Canada Book Fund and from the Province of British Columbia through the BC Arts Council and the Book Publishing Tax Credit.

Cataloguing data available from Library and Archives Canada
ISBN 978-1-77162-152-6 (paper)
ISBN 978-1-77162-153-3 (ebook)

CONTENTS

THE ART OF MORE

TEARS IN THE MARKET FABRIC

AN UBER FUTURE

THE NEW WORLD OF MUSEUMS

THE BUBBLE

ART, PAY, LOVE

"The art world used to be a community, but now it's an industry."

—Jeffrey Deitch, art dealer[1]

"To admire art is human. To acquire it is divine."

—Christie's full-page advertisement in the Styles section of the Sunday *New York Times* and the Art section of the *Financial Times* of London on May 24, 2015

HIGH SCHOOL WITH MONEY

DEMAND AND PRICES AT THE HIGH END OF TODAY'S CONTEMPORARY ART market are driven by the ultra-rich, national wealth funds, agents and untaxed transactions. The idea that the most newsworthy aspect of contemporary art is the price paid for it is now widely accepted.

My two previous books on the contemporary art market, *The $12 Million Stuffed Shark* (2009) and *The Supermodel and the Brillo Box* (2014), were written on the premise that the market for contemporary art involved informed buyers and sellers who interacted to determine a rational price for a work of art. In the early stages of writing this book, that premise was shaken.

One challenge came in November 2014, at the evening and day sale art auctions at Christie's, Sotheby's and Phillips in New York which generated $1.66 billion in four days. Christie's alone registered a record-breaking $853 million. The combined total represented $6 million in

sales each auction minute. Following that auction cycle, specialists said they were confident the next year or two would produce a billion-dollar auction evening.

Two Andy Warhol silkscreens with ink, *Triple Elvis [Ferus Type]* (1963) and *Four Marlons* (1966), sold at Christie's as lots 9 and 10. Each carried a pre-auction estimate of $60 million. *Elvis* shows singer Elvis Presley as a gun-toting cowboy in a publicity still for the 20th Century Fox movie *Flaming Star*. It had three bidders and brought $81.9 million. *Marlons* is a silkscreen reproducing a still from the Columbia Pictures movie *The Wild One*. It portrays actor Marlon Brando wearing a leather jacket and cap. It brought $69.6 million. Both were consigned by the German state-owned casino WestSpiel, where they had hung for years in a members' lounge, uncommented on. They were sold to provide equity funding against which the Westphalian state would provide financing for a new casino in Cologne.

It is never clear whether audience applause following a record auction lot sale acknowledges the auctioneer's efforts or the bidder's determination, or represents appreciation for being witness to a record being set. The *Elvis* sale brought sustained applause. *Marlons* brought none, perhaps because it was the second offered and did not equal the hammer price for *Elvis*.

Another challenge to my premise of market rationality came two weeks later while I was browsing at a booth at Art Basel Miami. I had a ten-minute discussion with a New York couple on the merits of a small Warhol portrait on exhibit, offered at $17.5 million. On the spur of the moment they decided to acquire. "It has great colours," the woman gushed, "and it is Christmas. Let's buy it."

At the time there were crises outside the art world. One was the West African Ebola epidemic. I couldn't help thinking, as the couple went to negotiate their Warhol purchase-because-they-could, of the dent they could make in the epidemic with a $17.5-million donation for medical technicians and supplies. Or of how much larger a dent WestSpiel could create with its $151.5 million from the two Warhol silkscreens.

The reality, as I hope emerges from the examples that follow, is that prices for high-end contemporary art bear little plausible relationship to any concept of present or future value. Some sellers get to preen, some buyers get to display their new toys and play a grown-up version of "Mine is much bigger than yours." Others get to store their art in foreign

duty-free warehouses in the hope of future price appreciation. The *New York Times* gets to publish half-page stories that treat contemporary art sale prices the way the newspaper might report an initial public offering for a new photo-sharing app.

Buyers, mostly male and mostly from the financial world, become case studies for the income inequality discussed in Thomas Piketty's 2014 book *Capital in the Twenty-First Century*, which was first published in French in 2013. Piketty argues that the rich—notably the world's 2,200 billionaires—will continue to get richer as a result of free-market capitalism. The reason, he says, is that returns on invested capital are greater than growth in incomes or rates of economic growth. There is another reason, which Piketty doesn't mention. Digital technology businesses tend to have "winner-take-almost-all" dynamics that produce a huge gap between the successful and the almost successful. Think of Facebook or Uber. The digital age produces greater wealth inequality.

There are certainly more wealthy individuals prepared to make bids of $100 million and up at auctions. Piketty calculates that by 2045, the richest one-tenth of 1 percent of the population will own half the planet's wealth. They may also own the same percentage of the great art left in private hands. In the interim much of that great art appears at top art fairs, where VIPs who can afford the art get free admission. Those who can't afford the art pay high ticket prices.

In November 2014, hedge fund operator Steven Cohen was the only bidder at Sotheby's New York—at $101 million—for Alberto Giacometti's sculpture *Chariot* (1950). This is a 4¾-foot-tall (1.45-metre) bronze stick-thin figure of a goddess atop a chariot with large wheels (see photo insert after page 96). Sotheby's had estimated *Chariot* as high as $115 million. It was the second most expensive sculpture ever sold at auction, but the press reported the price as a failure for the auction house rather than as a miscalculation in the estimate.

In November 2015, Shanghai resident Liu Yiqian spent $170 million at Christie's New York for *Nu couché* (1917–18), a striking red Modigliani painting of a reclining nude model (see photo insert after page 96). In February 2016, Chicago hedge fund operator Ken Griffin paid the David Geffen Foundation $500 million for two Abstract Impressionist paintings, Willem de Kooning's *Interchange* (1955) and Jackson Pollock's *Number 17A* (1948).

11

Have you heard of Adrian Ghenie? He is a promising Romanian artist, still under forty when his 2008 painting *Nickelodeon* (see photo insert after page 96) was offered at Christie's London in October 2016, with an estimate of £1 million to £1.5 million ($1.2 million to $1.9 million). The name apparently refers to a small movie theatre. *Nickelodeon* is large, 7¾ × 13½ feet (2.36 × 4.14 metres). It sold for £7.2 million ($9 million), more than four times its high estimate. Los Angeles dealer Stefan Simchowitz described Ghenie extravagantly, as "positioned as the next [Francis] Bacon."[2] There were seven bidders for *Nickelodeon*; the final two were each wealthy, each unwilling to back down from a challenge. The successful bidder was a European collector bidding on the phone.

The 1-percenters who spend fortunes on the works of artists such as Giacometti and Warhol are not the problem, at least not to the long-term health of the art market. A more serious problem is the prices being paid for mid-level artists. Of even greater concern are prices paid for emerging artists. What can you say about several million-dollar sales, in a single fall 2014 auction, for work by artists who had never had solo shows with a mainstream dealer? It has become ever more difficult for artists to receive recognition unless their work is expensive. This is the art of more.

Some newly branded artists are rewarded like football stars. Consider Oscar Murillo, a young, lesser-known artist said to sometimes paint with a broomstick. One of his works, *Untitled (Drawings off the wall)* (2011) was purchased the year of its creation for $7,000. It resold at Phillips New York in 2014 for $401,000. The profit represented a return of about 5,600 percent.

One collector on the waiting list for a Murillo painting was given a delivery date for a sight-unseen work, agreed to the price and immediately resold the right to the painting for a reported 75-percent profit—the sale agreement listing only the artist, the medium, size and approximate delivery date. One version of the story has the second purchaser immediately reselling for a similar profit.

In 2016 the high end of the dealer segment was expanding. Larry Gagosian had fourteen gallery spaces in eight countries. David Zwirner, Pace and Marian Goodman had opened spaces in London. London gallery Lisson opened in New York. Each occupied some of the most expensive real estate on earth. The sales totals required to break even in these locations were described as improbable. The percentage of retail

space devoted to art galleries in the city centres of New York, London and Paris was the highest in history.

Being a high-end dealer, or an artist represented by one, is perceived as entree to a life of privilege. Über dealers travel on private jets and vacation on yachts. Major art auctions and art fairs get business-section coverage in the *New York Times*. One characteristic of the contemporary art market since the financial crash of 2008 is the pursuit of iconic artwork, trophy hunting at the highest level. Each successive auction season and major art fair sees a widening of the price chasm between trophy works and the rest. The use of the term *iconic* in discussing contemporary art is itself interesting. The word originally referred to religious artifacts. It is now commonly applied to Warhol silkscreens, Jean-Michel Basquiat graffiti paintings and Christopher Wool word paintings.

There are not that many truly iconic works. Other art becomes what the auction specialist or the dealer or art adviser says it is. One market research firm, ArtTactic, sells access to a "top twenty" list of artists, with the listing based not on a measure of quality but rather on an analysis of market price momentum. Another firm, ArtRank, uses an algorithm to categorize emerging artists: "Buy now," "Sell now" and "Liquidate" (unload at any price). Its premium service is limited to ten clients, each of whom pays $3,500 a quarter. In 2014, Los Angeles artist Parker Ito saw a painting in his 2012 *Wet Paint* series reselling for £56,000 ($67,000). It had initially sold at $1,800. ArtRank then listed Ito as "Liquidate." His prices immediately dropped. Three months later, ArtRank reclassified him as "Buy." As in any market, the price volatility attracts even more speculators.

ArtRank has its dedicated followers. Los Angeles collector Rolando Jimenez called it "an essential tool if you want to evaluate your emerging art-collecting ventures as a serious investment."[3] New York art critic Jerry Saltz refers to some of the painters included in its listings as producing work for collectors who want expensive visual comfort food.

Price bubbles occur when prices of securities or other assets rise faster than inflation or incomes and exceed the valuation justified by so-called fundamentals. The meaning of *fundamental* is more straightforward for financial assets than in the art market. Is the reputation of the artist a fundamental? Is an edition of a sculpture limited to five a fundamental? What additional value accrues to a work if it is promoted as enabling

13

the new owner to join an elite set of collectors? Is reasonable value just whatever a bidder is prepared to offer?

The high-end contemporary art world—dealers, agents and auction houses—is far more complex and sophisticated than is generally understood. After publication of my two previous art market books I was often asked for an explanation of some of these phenomena—the what, how and why. As an economist and academic I am supposed to know. Some phenomena I have come to understand; others still baffle me.

The field of behavioural economics offers some insights, which I have included throughout the book. Some are related to irrationalities in decision making. Other explanations involve efforts to nudge individual behaviour when marketing art. A *nudge* is influencing a choice by altering individuals' behaviour in a predictable way, but without changing their economic incentives. Putting fruit at eye level qualifies as a nudge. Banning junk food does not.

My favourite nudge example does not involve art, and may actually be an oft-repeated urban fable. It concerns Hurricane Sandy, which struck the New York City area in 2012. Hours before the storm's peak, police went door to door on Staten Island—an area just above sea level— warning residents they had limited time to leave. Many had decided to stay at home and defend against looters. The option of forcible evacuation was considered. Instead, police officers offered reluctant residents permanent-ink markers to write their Social Security numbers on their arms, for ease of identifying their bodies after the storm. Many thought for a moment, returned the marker and decided to evacuate.

In the world of art auctions, an obvious nudge is when an auction house lists the previous owners of a work on offer, the books that have illustrated the work and the museum shows that have included it. A more subtle nudge comes when auction rooms are repainted to provide the right setting for the material on offer. For the November 2012 Sotheby's Impressionist sale the salesroom was a flat off-white, intended to provide a neutral background to the art. Immediately after the sale the room was repainted a dark, semi-gloss blue, with the same colour slipcovers for the chairs. This was thought to provide a more appropriate mood for contemporary art.

Other auctions use a blue motif for contemporary sales, for openness, and chocolate brown for Old Masters, representing timelessness and

earth. A moderately disharmonious colour is used for highly abstract work, to elicit feelings of creativity. This is based on the intuition of auction specialists (who are reported to all be women). The research literature on colour indicates how different hues may affect social interactions, but not how colours influence the evaluation of objects. Most cultures assign meaning to colours, but different cultures assign different meanings. With the diverse cultural mix of collectors in an auction room, it's hard to understand how one could choose the perfect colour to enhance sales.

An even less obvious nudge than colour is the quote at the beginning of this chapter: "To admire art is human. To acquire it is divine." This was the headline for a May 2015 Christie's full-page advertisement that ran in the Sunday *New York Times* at a cost of $114,000 (at publishers' listed rates) and in the *Financial Times* of London at about 60 percent of the NYT rate. Under the quote and in much smaller print, the ad said: "You may have heard about our recent record breaking week of sales in New York. This was an unprecedented way of bringing together some of the world's most celebrated work."

The headline was not intended to elicit thoughts of art, but rather of luxury. The goal of Christie's (and Sotheby's) advertising is not to announce the evening auctions. Any likely bidder is aware of the date and location, and has been approached by the auction house and received a catalogue. The intention of the ad is to reassure those with the resources to bid at a Christie's evening auction of the status and exclusiveness of the event. It reassures the bidder of what an acquisition from Christie's represents, compared to simply purchasing an expensive object.

Luxury has two value components: luxury for oneself and luxury perceived by others as unattainable. To sustain the latter perception requires that there must be many more people familiar with what the Christie's brand represents than could possibly afford to bid there. Think of Bonhams auction house, a purveyor of goods that are expensive but not considered as luxury. Few say, "Please come to dinner, I would like to show you my new painting which I purchased at Bonhams."

The next chapters discuss works sold at two extraordinary auctions, at Christie's in fall 2013 and at Sotheby's in spring 2014. Later chapters discuss art values, "the art of more," disruptions in the art market, the world of museums and how to game the art bubble.

When you read in the pages that follow about frantic bidding and **15**

record prices, keep in mind that in a rational world where there was agreement on the value of art, there would be less speculation. There should be an economic term for this "agreement" phenomenon; behavioural economists just refer to it as the Groucho theorem. Groucho Marx was not an economist; he was an American comedian, considered one of the funniest performers of his time. He died in 1977 at the age of eighty-six—and had his last performance a week before his death. The Groucho theorem is his declaration that he would never join any club with standards so low that it would accept him as a member.

The behavioural economics version of this would have two wealthy art speculators having an early dinner together prior to a Sotheby's evening auction. One, Michael, mentions that he plans to purchase a Franz West sculpture offered that evening for $4 million. The second, Neil, admits that he is the consignor of the West, and that $4 million is much more than the auction specialist suggested as a reserve price.

Both now reconsider. Michael knows Neil is a smart guy. Why is he selling? He does not appear to need the money. What inside information might he have? Neil thinks the same about Michael; if he is anxious to pay $4 million, it must be worth more.

Michael decides not to bid. It doesn't matter, because Neil withdraws the West from the auction a few minutes before it begins.

<p style="text-align:center">***</p>

One final note: Currency throughout the book is expressed in the original selling currency of the artwork, which means US dollars except where otherwise noted.

IS VALUE THE LAST PADDLE RAISED?

"It's really the quality of his work, interlocking with economic and social trends, that make him the signal artist of today's world. If you don't like that, take it up with the world."

—Peter Schjeldahl, art critic, on Jeff Koons[4]

"I want to play with the balloon," says John. *"Only venture capitalists can play with that balloon,"* says Mummy.

—Miriam Ella, *We Go to the Gallery*[5]

THE ORANGE BALLOON DOG

FOR EVERY EVENING AUCTION SEASON IN NEW YORK OR LONDON THERE IS A work that becomes the symbol of the sales. Its image appears in advertisements and newspaper articles, and on an auction catalogue cover. For the November 2013 contemporary sales in New York, that work was Jeff Koons' *Balloon Dog (Orange)* (see photo insert after page 96), offered at Christie's.

The sculpture is a 10-foot-tall (3.1-metre) scale representation of what results when a clown twists a balloon into a dog-like form. *Balloon Dog* was produced in an edition of five. One version had been exhibited on the rooftop of the Metropolitan Museum in New York, beside the Grand Canal in Venice and at the Palace of Versailles outside Paris. It was promoted as being potentially the most expensive work of art by a living artist ever sold at auction. Christie's estimate was $35 million to $55 million. The upper end of that range was 50-percent higher than the previous living-artist-at-auction record of $37 million set in May 2013 by a Gerhard Richter painting.

Balloon Dog (*Orange*) is constructed of tinted, high-chromium stain-less steel. It has deep colour and a flawless reflective surface. Koons said the meaning of the sculpture was that it recreates and celebrates the experiences that evoke a child's enjoyment of the world. It has also been described as a postmodern fertility symbol. It is part of a contemporary art tradition of enlarging something and re-imaging it in different materials— think of Claes Oldenburg's *Floor Burger* (1962) or Roy Lichtenstein's giant comic-book panels. Christie's displayed the Koons sculpture outside its Manhattan auction rooms in Rockefeller Center. It drew attentive crowds and lineups for iPhone selfies twenty-four hours a day.

Jeff Koons is the most successful American artist since Andy Warhol. As with Warhol, Koons' works are produced by technicians. Koons contributes the concept. His art "factory," which employs more than a hundred technicians, is near the Hudson Yards in the West Chelsea area of New York City. New work evolves on computer terminals running 3-D imaging programs. Software-driven lasers do the stone carving. The fabrication involves a lot of experimentation, and a long production cycle.

Koons had on two previous occasions held the title "most expensive living artist." His stainless steel *Hanging Heart* (1994–2006) brought $25.8 million at Sotheby's New York in 2007. That record improved in 2008 when his sculpture *Balloon Flower* (*Magenta*) (1995–99) sold for $25.7 million at Christie's London, and again when his sculpture *Tulips* (1995–2004) brought $33.7 million at Christie's New York in 2012. Each work came in a series of five.

Gerhard Richter regained the "most expensive living artist" title in May 2013, when his painting *Domplatz, Mailand* (1968) of Milan's Piazza del Duomo (Cathedral Square) brought $37 million. Six months later, *Balloon Dog* reclaimed the title.

Christie's was not reticent in emphasizing the status that would ac-crue to the collector who acquired the statue. The auction house sent out thousands of emails to announce to its clients "The stage is set to make history." Brett Gorvy, then chairman and international head of postwar and contemporary art at the auction house, said in a mass emailing:

> The *Balloon Dog* is the Holy Grail for collectors and foundations. In private hands, the work has always communicated the prom-inence and stature of its owner. To own this work immediately

positions the buyer alongside the very top collectors in the world and transforms a collection to an unparalleled level of greatness.[6]

The Christie's promotion was well received: 10,000 people attended the auction preview and 1,400 attended the auction, hundreds of them standing. For those requiring discretion, Christie's built an extra ground-level "skybox" with one-way glass. Journalist Kelly Crow described it in the *Wall Street Journal* as a duck blind.

The street outside Christie's headquarters at Rockefeller Center on auction night was described as curb-to-curb parked black, tinted-window Escalades with sacks of gold bars in their trunks. The attendees were variously described as bidders, obligatory fashion-draped appearances, hungry press, and chancers looking to bag a husband.

Unlike most expensive contemporary art, the value of *Balloon Dog* (*Orange*) does not flow from the backstory to the work—unless the bidder thinks that celebration of childhood is gripping. Rather, and as Gorvy emphasized, much of the value reflects the buyer's ability to join the short list of celebrated collectors who own other sculptures in the series.

The five versions of the sculpture each have a different colour. Hedge fund owner Steven Cohen has the yellow one. Los Angeles financier Eli Broad has the blue and Greek industrialist Dakis Joannou has the red. Christie's owner François Pinault has the magenta version. These are the "top collectors" Gorvy alluded to.

At the invitation-only Sunday preview brunch two days before the auction, waiters carried long poles hung with trays of champagne flutes. There was a buffet table with bagels and lox. One commentator described the preview crowd as "plastic surgery Expressionism."[7] A former Christie's vice-president (since departed) named Capucine Milliot coordinated the brunch.

On the day before the sale, Gorvy sent out another mass email on "Final Thoughts on Tomorrow's Sale," offering bidding advice and his version of "loser's regret":

It is the next morning, and you wake up, and you do not own the object that you had so desired to acquire. How much does that hurt? That is how much you need to bid. Otherwise the memory of the work and the hurt of the loss will be all that remain.[8]

22 Regret is a feeling that auctioneers understand and exploit; their "no regrets" comment when a bidder drops out is not just a figure of speech. During the auction process, a bidder's previously held values change. Bidders value a work more when they think they can own it. A more familiar example is an investor who holds onto a stock well past the point where fundamentals suggest he or she should sell.

Auction underbidders feel regret at losing an artwork they could have possessed. This reference point of "almost having the sculpture and losing it" is different from having the money and preparing to bid. This is what cognitive psychologists call an endowment effect. The bidder will go higher not to lose the prize.

When the bidder momentarily holds the high bid, the endowment effect cuts in. The bidder will pay more not to give it up and experience regret. Christie's auctioneer Jussi Pylkkänen plays to this: "Last bid ... are you sure ... no regrets ... are you back in ... not yours, sir ... don't let him have it." This is accompanied by gestures with extended arms, as Pylkkänen leans in the direction of the reluctant underbidder to elicit a response.

What the auctioneer does not want to hear is a jump bid. This occurs when the auctioneer has established a cadence, "I have a million three on the left side of the room, a million four on the phone, can I have a million five ..." and a bidder calls "Two million." The result may be other bidders concluding, "This guy will pay anything for the work, more than anyone else and more than it is worth. I will never have it. I will drop out." It spoils the cadence, but more important it erases any endowment effect that previous high bidders felt. It is a good strategy for the jump bidder.

A half-increment bid, made with the bidder holding one hand horizontally, is almost as unwelcome to the auctioneer. Whether or not the half bid is accepted, it signals that bidding is considered close to its limit.

Balloon Dog (Orange) had a guarantee in the range of $35 to $40 million. There had to be a guarantee. After all the promotion, the sculpture was too important to the auction house's reputation to be allowed to fail.

The sculpture came up as lot 12. Bids first rose in increments of $3 million, then $2 million. The first identifiable bidder was dealer David Zwirner. He raised his bidding paddle at $39 million, then through $2-million jumps to $51 million. Then his paddle stayed down.

There were no jump bids. *Balloon Dog (Orange)* was hammered

down at $52 million; with auction house premium added, the invoice was $58.4 million. The successful bidder was New York collector Jose Mugrabi, who placed the sculpture in storage in a New Jersey warehouse, anticipating future resale at a profit. To put the winning bid in context, it was almost exactly the us budget—across all health agencies—to develop an Ebola vaccine.

This brings into play another economic concept: the winner's curse. When many bidders compete for the same object, the winner is the person who most overvalues it. The bidder soon realizes that he or she just bid more than anyone else in the room or on the phone thought the object was worth. One manifestation is that about 5 percent of successful auction bidders later approach auction officials with some version of "Look, I got carried away, is there anything we can do?" The usual suggestion is that the auction house would be glad to re-offer the item after an eighteen-month period. The winner's curse probably does not apply to Mugrabi, who buys (and sells) so many artworks that he doesn't spend much time agonizing over any one. It certainly would apply to me.

It was assumed that Christie's must have made a lot of money on *Balloon Dog (Orange)*. It turns out that the auction house lost money, an example of the paradox that often the more expensive the artwork, particularly with contemporary art, the lower the profit the house earns.

Auction houses typically charge a commission to the seller and a buyer's premium to the successful bidder. For lower-priced works, the consignor's commission might be 10 percent and the buyer's premium 25 percent. For works of art above $1 million, sellers usually have the seller's commission reduced. Above $5 million, the commission is usually waived.

Without the seller's commission, the auction house is reliant on the buyer's premium for revenue. The buyer's premium above a paddle price of $2 million is about 12 percent. A consignor of a featured work might negotiate to receive a rebate of 4 to 7 percent of this buyer's premium, so would be said to receive "104 percent of hammer" or "107 percent," also referred to as "paddle-plus" or "enhanced hammer." A portion of the buyer's premium may go to a third-party guarantor, who has committed to a minimum price.

Reports by Graham Bowley of the *New York Times* on the consignment suggested that Peter Brant, the art collector who was selling *Balloon Dog*

THE ORANGE BALLOON DOG

(*Orange*), negotiated to receive the entire buyer's premium. Brant was quoted as saying that Christie's "certainly made no money" from him.[9] To obtain the consignment, Brant told Bowley, Christie's waived the seller's commission and rebated to him 112 percent of the hammer price. Christie's apparently would have received a portion of the buyer's premium only if the hammer price had been higher. Recall that the sculpture did sell for a world-record price for a living artist.

Christie's incurred substantial costs to promote *Balloon Dog* (*Orange*), certainly in the millions of dollars. It transported the sculpture from Brant's Connecticut estate to display outside its Rockefeller Center headquarters. It insured the sculpture and put a huge marketing push behind it, with full-page magazine and newspaper ads.

If the auction house were almost certain to incur a loss on the transaction, why would it seek the consignment? The primary reason is to prevent a top work (and market share) from going to a competitor. Christie's earned bragging rights, and the expectation that the presence of the work in the evening auction would help attract other consignors and raise the overall bidding level. World-record prices make other art on offer seem inexpensive. Christie's Gorvy has suggested another reason: "'We take a calculated risk' ... a high-value work with a guarantee, such as Koons's 'Balloon Dog,' may not generate a profit on its own, but it brings in buyers for other works who make the overall auction profitable."[10]

It was understood that at the Christie's auction and at the Sotheby's contemporary auction the following day, a lot of the art offered was being flipped. Usually art is sold because of "the three *D*'s": death, divorce or debt, or because collectors' tastes have changed. *Flipped* means it has been held for a relatively short time and is being resold in the hope of a quick profit.

Thirty of the works at the two auctions were known to be on offer from investors. These thirty made up a substantial portion of the estimated value of all the works offered. A single collector, Steven Cohen (owner of the yellow *Balloon Dog*), offered twelve works—all purchased at auction or at art fairs within the previous three years. These had a combined pre-auction estimate of $80 million. When insiders in any market start selling off holdings in bulk, other investors became concerned about price bubbles and the future of that market.

Cohen's multiple consignments reflect the difficulty in understanding

exactly why a collector might be selling. Newspaper accounts suggest he was facing high legal bills and possibly substantial financial penalties related to alleged stock-trading irregularities by his hedge fund. There was another likely explanation. Less than a year earlier he had purchased Picasso's *Le Rêve* from casino owner Steve Wynn for $150 million. Owners who sell fine art at a profit can defer tax liability on the profit if they purchase art of equivalent value within a year. Cohen might have been selling to defer taxes.

The next chapter describes another lot in the same Christie's auction as *Balloon Dog*. This one, a Francis Bacon triptych, attained the highest price achieved for a work of art at auction to that date, when not factoring in inflation.

"A painting is not a picture of an experience; it is an experience."

—Mark Rothko, artist[11]

THREE STUDIES OF LUCIAN FREUD

IN THE NOVEMBER 2013 NEW YORK AUCTIONS DURING WHICH *BALLOON DOG* (*Orange*) was sold, the offering with the highest estimate was Francis Bacon's *Three Studies of Lucian Freud* (1969) at Christie's (see photo insert after page 96). The triptych shows three images of Freud—a sometimes-rival painter of Bacon and the grandson of Sigmund Freud, the founder of psychoanalysis. It was offered with an estimate of $85 million. That amount was thought to be justified; Bacon has been called the greatest portrait painter of the second half of the twentieth century. *Three Studies* may have been the last major Bacon triptych from the 1960s in private hands.

Bacon painted the work as three panels intended to be displayed together. The triptych was first consigned to Galleria Galatea in Turin, which sold the panels separately without Freud's consent. The panels were reunited in 1989 by an Italian collector, identified in the *Wall Street*

Journal as lawyer Francesco De Simone Niquesa. One panel came from Paris, one from Japan. De Simone Niquesa already owned the third.

The owner received many offers for purchase or consignment in the intervening years. In early 2013 the triptych was purchased by an unidentified art investor, thought to be Mexican-born financier David Martínez Guzmán. It was consigned to auction with a guarantee of $85 million, which limited the risk to Martínez (he may have purchased the work for a higher amount). The guarantee allowed Christie's to both share in the possible upside profit and reap a huge publicity coup.

Several media reported that the panels had been reassembled in response to Christie's offer of a guarantee if the panels could be offered together. That would add to the rarity and appeal of the work. This is a more interesting backstory than the actual one; it may have been planted.

The triptych was originally listed as catalogue lot 32. Hours before the auction, Christie's alerted clients that the triptych would be moved up to lot 8A. That was unprecedented; catalogue positions never change once the catalogue is printed. Apparently an Asian client of the auction house indicated he was willing to bid above the estimate, but only if it carried a lucky number. It was repositioned with just such a number.

Auctioneer Jussi Pylkkänen opened the bidding at $80 million. Compare that to the former Bacon auction record of $83.6 million. Both the level of the starting bid and the increments asked by an auctioneer serve as nudges, an anchor point for bidders. If the auctioneer says "I would like five-million increments," you know that he has some serious bids in his "book," bids left with him in advance. He wants to get to the level of the highest bid quickly, and establish how highly the lot is valued and how much bidder enthusiasm exists.

Hong Gyu Shin, twenty-three-year-old director of the Shin Gallery in New York, bid the painting up to $100 million. "I'm out at $100 million," Pylkkänen said, referring to bids left with him. Dealer Larry Gagosian raised his paddle and offered $101 million. "Give me five, sir," Pylkkänen responded. Gagosian nodded yes to $105 million. Shin went to $110 million. Gagosian nodded "no." "Thank you for your attempt at bidding," Pylkkänen said to Gagosian.[12]

Shin was out at $124 million asked, producing no acknowledgement from Pylkkänen. A Mandarin-speaking auction house specialist on the

phone with a client—perhaps the one who wanted a lucky number—bid $120 million, then $124 million. When Pylkkänen said "Give me 26," a bidder held out his hand horizontally, offering a half-increment advance to $125 million. Pylkkänen responded, "Of course, a million dollars is a lot of money."

Dealer William Acquavella bid $127 million on the phone, and the bidding ended. With buyer's premium, the total was $142.4 million. Acquavella bid on behalf of Elaine Wynn, former wife of Las Vegas casino owner Steve Wynn and a co-founder of the Wynn Resorts. Ms. Wynn already owned another major Bacon work. The third underbidder, for whom Gagosian was bidding, was rumoured to be her ex-husband.

To put the Bacon purchase price in perspective, it is $4 million more than the 2013 budget for the American National Endowment for the Arts. The Bacon was, at the time of the auction, the only artwork ever to have been purchased for over $50 million and later resold at auction for a profit.

London dealer Pilar Ordovas was one of eight bidders for the Bacon; she got in one bid, at $96 million. Her reaction was, "I was bidding on the behalf of a collector, and I almost didn't get a chance to put my hand up ... In my 14 years with Christie's, I've never experienced anything like this."[13]

In an interesting footnote to the auction result, Christie's shipped the Bacon triptych not to Los Angeles, where Elaine Wynn is resident, but to the Portland Museum of Art. It was on display for fifteen weeks. Because the painting was shipped out of state, Wynn was not liable for New York sales tax. She could also avoid about $11 million in California use taxes because *Three Studies* was displayed and thus "used" in Oregon before being shipped to her home in Los Angeles. Whether she claimed the tax break is unknown.

Many American states levy the so-called use tax to catch residents who would otherwise avoid sales taxes by shopping in adjacent states. The use tax rate is the same as that of the sales tax. Buyers are supposed to calculate what they owe on their out-of-state purchases and remit the amount on an honour system. The tax was intended for items such as household furnishings rather than art, but it applies to all purchases.

If a newly acquired painting remains on display in a non-taxing state like California for a designated period—typically three to four months—the states regard the exhibition as being a "first use" of the item. The five states with no use or state sales taxes are Oregon, New Hampshire,

30 Delaware, Montana and Alaska. The transaction is then free of tax in both the exhibiting state and the residence state.

Many in the art world thought the price achieved for *Three Studies* signalled a contemporary art price bubble about to burst. The same New York–based collector who consigned the Bacon to Christie's also consigned Christopher Wool's *Apocalypse Now* (1988). This had been purchased in a private sale a few weeks earlier. Christie's gave it a low-ball estimate of $15 million to $20 million. It was hammered down at $26.5 million. The sale of *Three Studies* and of *Apocalypse Now*, the latter described in the next chapter, reinforced the idea of a bursting bubble.

"Apocalypse Now *is like an evil crossword puzzle filled in by the damned, the words breaking down with indeterminate angularity into chaos and confusion. The painting becomes a chant, a rant, a slogan, and a scream."*

—Jerry Saltz, art critic

"An elegant experiential treat, one that can teach a lot about pictorial power, the act of looking as exploration and the simple physical innovations that are basic to painting's evolution."

—Roberta Smith, art critic, on a 2013 Christopher Wool exhibition[14]

$26 MILLION FOR NINE WORDS

AT THE SAME NOVEMBER 2013 CHRISTIE'S AUCTION WHERE *THREE STUDIES* was offered, dealer Christophe Van de Weghe settled into a third-row seat and prepared to bid a record amount for lot number 8 in the catalogue. He was bidding on behalf of a client for the Christopher Wool word painting *Apocalypse Now* (1988).

The painting consists of thirty-three black boldface capital letters, SELL THE HOUSE SELL THE CAR SELL THE KIDS, with run-on letters in a grid seven spaces across and five columns down. It is stencilled on a 6-foot-11-inch × 5-foot-10-inch (2.1- × 1.8-metre) white-painted aluminum background. (See photo insert after page 96.)

Apocalypse Now had been purchased in a private sale a few weeks earlier. Christie's gave it a lowball estimate of $15 million to $20 million. The midpoint of that estimate was more than double Wool's previous

auction record of $7.7 million, set at Christie's London in February 2012. Van de Weghe was prepared to bid far more than that.

Van de Weghe did not have a formal contract with his client; he trusted that if his bid was successful, and even if he went over the discussed limit, the client would reimburse the auction invoice price plus a modest commission. Such informal arrangements are remarkably common in the art world. Van de Weghe was a long-time Christie's client; he bid on credit with the auction house.

The work has a powerful backstory. The phrasing is from the 1979 movie that bears the same name, an adaptation of Joseph Conrad's novel *Heart of Darkness*. The movie was directed by Francis Ford Coppola, with a cast that included Marlon Brando, Martin Sheen and Robert Duvall. The words are spoken by US Army Captain Richard Colby, who is on a mission to assassinate a rogue fellow officer. Colby is convinced he is also going to die. The wording comes from a six-line section of a letter from Colby to his wife. His letter says: "*Sell the house, sell the car, sell the kids, find someone else, forget it. I am never coming back. Forget it.*" The letter echoes the pessimism of the final days of the Vietnam War about the outcome of the conflict. Van de Weghe said of the Wool painting, "It is his masterpiece."[15]

Christopher Wool (born 1955) is known for his word paintings. Most are, like *Apocalypse Now*, black stencilled letters on white backgrounds. The artist first created these in 1987. The idea came to him in New York, when he saw the graffiti "luv" and "sex" spray-painted in black on a white truck.

Sometimes the phrasing on a Wool word painting is enigmatic, as with THE HARDER YOU LOOK, THE HARDER YOU LOOK (2000), stacked in six lines. Sometimes letters are missing, as with the 1989 *Trouble*, which is presented as TRBL, the letters stacked two over two. Some of Wool's letter paintings contain one long word. One that was auctioned at Christie's New York in November 2005 for $1.24 million had fifteen letters on aluminum spelling RUNDOGRUNDOGRUN in four lines. The word paintings have no imagery and no brushwork. They invite the question "Is that a painting?" Wool's work is not considered at the same exalted level of the contemporary art world as that of Jeff Koons or Gerhard Richter, but it has received critical acclaim.

A succession of distinguished collectors had owned *Apocalypse Now*.

The provenance is also part of the backstory. The painting was first shown in an April 1988 show at New York's 303 Gallery. Werner and Elaine Dannheisser, a collecting couple, bought all the works in the show. By their recollection they paid about $6,000 for *Apocalypse Now*.

Werner Dannheisser died in 1992. Four years later his wife offered to donate most of their collection to the Museum of Modern Art. MOMA accepted all but *Apocalypse Now*. There was one Christopher Wool word painting in the museum's collection, and the curator thought one was enough.

In 1999 Elaine Dannheisser gave *Apocalypse Now* to dealer Philippe Ségalot to consign to auction. Instead he swapped the word painting to Per Skarstedt, another New York dealer, in exchange for $150,000 and *Untitled*, a 1990 Wool word painting bearing the word FOOL. Christie's had estimated *Apocalypse Now* would sell between $60,000 and $80,000, so the swap was favourable for Dannheisser. Ségalot then offered FOOL for auction at Christie's on May 19, 1999 with an estimate of $40,000 to $50,000. It sold for $420,000.

Later in 1999, Skarstedt sold *Apocalypse Now* to collector Donald Bryant Jr. for $400,000. Two years later Skarstedt again brokered its sale, this time to François Pinault, owner of Christie's auction house and of fashion brands Gucci, Alexander McQueen and Yves Saint Laurent. The price was reported as $400,000 plus an unidentified painting. Pinault sold the work for $2 million in 2005, through Ségalot, to hedge fund owner David Ganek and his wife, novelist Danielle Ganek. *Apocalypse Now* is thought to be the model for the painting-with-huge-price-appreciation featured in her 2007 novel *Lulu Meets God and Doubts Him*.

In 2005 David Ganek joined the board of trustees of the Solomon R. Guggenheim, which was planning a Wool retrospective. The Ganeks became co-chairs of the Wool exhibit's leadership committee, and *Apocalypse Now* was to be the featured work; the museum catalogue devoted three pages to it.

Being chosen as a major work at a retrospective inflates the value of a work, often to several times its previous value. In mid-2013, after announcement of the Guggenheim show but prior to the opening, Christie's reportedly suggested to Ganek that he consign *Apocalypse Now* to the auction house's November 2013 Post-War and Contemporary Art Evening Auction. That timing would allow Christie's to build on the

publicity that accompanied the Guggenheim show. To encourage him to consign, Christie's proposed a staggering price guarantee, reported as $20 million and offered by a third party. Ganek said that he would consign, but he wanted to wait for the spring 2014 auction that would follow the Guggenheim show. Christie's said the guarantee was valid only for the November auction, so it could leverage the Guggenheim publicity.

Ganek told the Guggenheim of the offer and that the painting would be absent from the museum show for four days during Christie's auction preview. The museum apparently concluded that it should not be party to a commercial transaction. It removed the word painting from the retrospective. Ganek then resigned from Guggenheim's board of trustees. The contemporary art world has no concept of insider trading when it comes to purchasing art. That lack of concern may not apply to selling when a museum show is involved.

There are several versions of what happened next. The most frequently reported is that the Ganeks sold to a third party, financier David Martínez Guzmán, who then consigned the work to Christie's. Another version is that a sale to Martínez occurred prior to Christie's offer. In any case, *Apocalypse Now* left the Guggenheim and was hung at Christie's Rockefeller Center headquarters for the preview period. The Guggenheim replaced *Apocalypse Now* with a small study for the work, on loan from collector Peter Brant.

Christie's again produced superlatives to promote the work. In a news release Brett Gorvy, then chairman and head of postwar and contemporary art at the auction house, stated:

> Christopher Wool's *Apocalypse Now* is the essential image of our times. Executed with a raw power and gritty directness that gave new purpose to the medium of painting in the 1980s, this legendary statement of absolute nihilism makes it one of the most seminal works of contemporary art. Its much anticipated appearance at auction firmly places Wool amongst the pantheon of great masters of the 20th century.[16]

An "essential image of our times," "raw power," "absolute nihilism" and "great master." Wow! Those descriptors provide a great story for a successful bidder to recount to friends.

On the evening that *Apocalypse Now* came up, Van de Weghe raised his paddle when the bidding hit $18 million. At that price three other bidders remained involved in the room, with one on the telephone. Van de Weghe kept raising his paddle until the hammer fell. The final price for catalogue lot number 8, including the buyer's premium paid to Christie's, was $26.5 million.

The price of the painting had increased 4,400 times in twenty-five years, the final spurt coming with the Guggenheim show and publicity about the backstory. The painting sold for three and a half times the previous Wool auction record. It sold for two and a half times the price Sotheby's achieved five months earlier for *The Garden of Eden With the Fall of Man* (1613), a painting by Peter Paul Rubens (who influenced the figures) and Jan Brueghel the Elder (the flora and fauna). It is considered one of the finest examples of Brueghel's Paradise landscapes.

After the sale the art world speculated about the identity of the players. The most common guess was that the guarantor was Pinault, not because he wanted to again own the painting, but to motivate its consignment. The most common speculation was that the purchaser was the Qatari Royal Family, acquiring it for a future museum.

A record price at auction has a positive effect on the next work offered, in this case *Three Studies*. If *Three Studies* had been moved to lot 8 and *Apocalypse Now* had been moved to 8A, would this have changed the relative prices? Reportedly one Christie's specialist argued for that switch, while Gorvy concluded that supporting *Three Studies* with a possible record price for *Apocalypse Now* was more important.

The *Three Studies* and *Apocalypse Now* auctions took place under what can be called the windfall gains irrationality. Financial traders (and all humans) treat windfall gains, like annual bonuses or lottery winnings, differently from predictable monthly incomes. That is one reason (income level being another) why so many contemporary art buyers are from the financial world. For November New York auctions, which come just before financial-sector bonuses are announced, both major auction houses and some dealers motivate potential buyers with the advice: "Bid if you love it, don't worry about cash flow; you can pay in January next year when your bonus cheque arrives."

The bonus does not change the buyer's expected lifetime income much. If the bonus were spread over a ten-year period, buying behaviour

would probably not change at all. But if the bonus comes in a lump sum it is a windfall gain; bidding high on a lusted-after new work may be irresistible. The bonus idea goes beyond that. Think of visiting a casino, starting with a winning streak and being "up $1,000." You treat this gain as "house money," and will gamble with it in a less careful way. You are less concerned about losing the $1,000 than you would be if you were already down $1,000.

Auction house specialists claim that some art buyers treat bonus money in this less-careful way. They are more willing to gamble on speculative art that they hope will double in price in a short time than they would be if investing their regular income. Bonus recipients are more susceptible to "this artist in our day sale is hot and will become more so."

Wool's word paintings are the perfect example of "Is this art?" and "Why those prices?" coming together. Perhaps value is whatever someone bids, or perhaps this is another signal of a looming price bubble. Or maybe it does not have great significance; art adviser Amy Cappellazzo said of the Wool sale that the collectors pursuing *Apocalypse Now* represented "trophy hunting rather than looking at an artist's career in an encyclopedic manner."

Apocalypse Now has made one other public appearance in the United States. When the Wool retrospective moved to the Art Institute of Chicago in February 2014, the new owner loaned the painting to that show.

The next chapter introduces another auction with a head-shaking price. This one was at Sotheby's New York, and involved casino owner Steve Wynn and a Koons sculpture of a cartoon character.

"Art is anything you can get away with."

—attributed to both artist Andy Warhol and
philosopher Marshall McLuhan

JEFF KOONS AND *POPEYE*

THE MAY 2014 CONTEMPORARY AUCTION WEEK IN NEW YORK COULD HAVE been called Jeff Koons Week. He was about to have a major retrospective of his work at the Whitney Museum of American Art. A few months earlier he had regained the auction record for a living artist for *Balloon Dog (Orange)*. Then his stainless-steel sculpture *Popeye* (2009–11), standing 6½ feet (2 metres) tall, was hammered down at Sotheby's New York for $28.2 million to casino owner Steve Wynn. Wynn was the only one to raise his paddle at the opening, below-estimate requested bid. Even with a sole bidder, the auction combined with the Whitney event reinforced Koons' position as the best known and most written about living contemporary artist.

The *Popeye* sale generated extreme adjectives from a hundred art writers. Popeye is an American cartoon character, remembered by those who were around in the 1950s and '60s (and earlier). He is a "sailor man"

with muscular forearms and a corncob pipe, known for his favourite saying "Well blow me down!" Koons had explored the Popeye character in paintings for a decade. His *Popeye* series includes stainless-steel sculptures of Popeye's girlfriend *Olive Oyl* (2004–09).

The Wynn *Popeye* sculpture is one of a series of three. The other two belong to Larry Gagosian and Steven Cohen. There is also a granite version of the *Popeye* sculpture; it also comes in a series of three. Koons offered the wonderful backstory for the Popeye sculptures that the sailor man's consumption of spinach to produce super-strength was a metaphor for the transformative power of art.

The Whitney show in 2014 was the first opportunity for North American audiences to see work from all three decades of Koons' career. Koons had more narrowly focused shows in Europe, the most publicized at the Palace of Versailles outside Paris, where he displayed one version each of *Balloon Dog* and *Pink Panther* (1988). The latter is a sculpture of a bare-breasted blonde hugging a panther. It was displayed at Versailles in front of a 1729 painting of Louis xv. *Pink Panther* and *Balloon Dog* were as well received in Versailles as at the Whitney show. What other contemporary artist's work could do that? Perhaps only that of English artist Damien Hirst and Japanese artist Takashi Murakami. After the Whitney show closed in late 2014, the Koons show moved to the Centre Pompidou in Paris, then to the Guggenheim Museum Bilbao in Spain.

Scott Rothkopf, the Whitney's associate director of programs (now chief curator) said at the time that the Koons show was the most expensive the museum had mounted. "Many of the sculptures are as delicate as Fabergé eggs."[17] The show's 120 works were said to be insured for half a billion dollars. The exhibit was shown over the museum lobby and on four other floors.

There were challenging technical hurdles. The Whitney's front doors had to be removed for an almost 8-ton granite *Gorilla* (2006–12) and a 4-ton granite *Popeye* to get in; each was too large for the museum's loading dock. *Gorilla* had to be lifted on an elevator rated for 7 tons. The manufacturer added additional chain hoists at a cost of $85,000. Installation of the show took three weeks, the removal another two.

The Whitney exhibition catalogue had a chapter on the exotic technologies involved in fabricating Koons' work, including CT scans and structured-light scanning. For each successful sculpture in stainless steel

or aluminum or granite there were many earlier failures. The translucent stainless-steel surface of *Balloon Dog* is so perfect that there is not a single visible seam or joint, or any suggestion of how the work was assembled.

The collectors who loaned work to the Whitney show represented a *Who's Who* of the art world: Los Angeles builder Eli Broad, New York hedge-fund founder Steven Cohen, Christie's French owner François Pinault, New York real estate developer Harry Macklowe and British artist Damien Hirst. Another interesting aspect of the Whitney show was its financing. Substantial but never-identified amounts were provided by Koons' dealer, Larry Gagosian, as well as Christie's and Sotheby's. Most if not all the lenders of major works were Gagosian clients. The only gallery name to appear on the wall text was Gagosian. At the opening press conference, Whitney director Adam Weinberg lauded the dealer. "I'm deeply grateful to Larry Gagosian for his tremendous support. Thank you, Larry. There are few dealers who would come to the forefront to support at this level."

While no one suggested that Koons was unworthy of a retrospective, the question always loomed as to whether the degree of dealer support influenced what works were shown. The perception is that dealer or auction house sponsorship affects curatorial choices. The retrospective certainly enhanced the value and potential marketability of the works shown, and of similar works in dealer inventory.

After the *Popeye* sale, Charles Moffett, then vice-chairman of Sotheby's (who took the winning bid) said Wynn would display the sculpture at his Las Vegas or Macau casinos. It turned out to be the Wynn resort and casino in Las Vegas. What no one assumed Wynn was doing at that purchase-price level was speculating. But when the statue was unveiled at the casino two weeks after the auction, it bore a plaque offering the artist's name, the title and the phrase "Price available on request." Wynn's asking price was reported as $60 million, more than twice the purchase amount. At time of writing, *Popeye* still resides at the Las Vegas casino, in a space just inside the front entrance, flanked by two football-lineman-sized guards. The *Las Vegas Sun* reported that there had been one offer to purchase, which Wynn rejected.

If *Popeye* does not sell and remains on display, Wynn could claim depreciation on the purchase price, treating the sculpture as "furnishings" for tax purposes. Exhibiting in Nevada could also take advantage

44 of a 2004 state tax exemption that Wynn had championed. Referred to as "Show Me the Monet," the tax change was intended to encourage public display of art. The provision substitutes a 2-percent sales tax for Nevada's usual 7.5 percent on works of art valued at over $25,000, so long as the art is publicly exhibited in the state for at least twenty hours a week for thirty-five consecutive weeks. The tax saving to Wynn would be $1.4 million. Nevada subsidized the "for sale" exhibit of *Popeye* to the extent of about $40,000 a week, or $5,700 a day for thirty-five weeks. The fact that the work was listed for sale did not affect the "exhibited" provision.

"Art is either plagiarism or revolution."

—Paul Gauguin, artist

LUDWIG'S
PLAY-DOH

THE MOST ANTICIPATED NEW WORK AT THE MAY 2014 WHITNEY SHOW WAS the one with the most compelling backstory. Jeff Koons' sculpture *Play-Doh* (1994–2014) (see photo insert after page 96) is a 10-foot-tall (3-metre) sculpture depicting a multicoloured mound of putty created by Koons' two-year-old son.

The backstory is as follows. From the late 1980s to 1991, Koons produced a series titled *Made in Heaven*, which included paintings and sculptures showing him and model Ilona Staller in explicit sexual positions. The series featured penetration, both anal and vaginal, with lots of semen.

Staller is a Hungarian-born Italian, a former porn performer and member of the Italian parliament. She was known as *La Cicciolina* ("little dumpling"). When asked about the overt sexuality in this art, Koons was quoted as saying, "What I really like about it are the pimples on Ilona's

ass. The confidence to reveal one's ass like that. That's like my reference to [Gustave] Courbet's *The Origin of the World*."[18]

The couple married in Budapest and then spent a year in Munich, where Koons completed *Made in Heaven*. The paintings did not sell well. Eager collectors apparently reconsidered when they visualized a large penetration painting hanging in their bedroom. Koons was reported to have wanted to destroy some of the unsold work.

Koons and Staller had a son, Ludwig, born in October 1992 in New York. Staller then attracted publicity with an offer to have sex with Saddam Hussein in exchange for his releasing foreign hostages held in Baghdad. Two years later Staller asked that she be permitted to resume her performing career. Koons objected.

Staller then moved to Rome, taking Ludwig with her. The marriage ended soon after the move. Koons spent more than a decade trying to get his son back, without success. A small Play-Doh sculpture was the last thing Ludwig played with before being taken from his New York home. (Play-Doh is a brand name for a child's putty-like material.)

Koons stored the child's sculpture in a small Plexiglas cube. In 1994 Koons tried to replicate his son's sculpture in grand scale as a way to let Ludwig know how much his father missed him and wanted him to return. That backstory, of loss, tribute and meticulous reproduction over a twenty-year period, became central to the marketing and value of *Play-Doh*.

As well as the aluminum *Play-Doh*, Koons' *Celebration* series about Ludwig involved his sculpture of a giant stainless-steel gold *Hanging Heart* suspended by stainless-steel ribbons (first mentioned in Chapter 2). This was the subject of one of the better art-flipping-for-profit stories. In 2006, collector and later dealer Adam Lindemann purchased a version of *Hanging Heart (Magenta/Gold)* (1994–2006) from dealer Larry Gagosian for what was reported at the time as $4 million. Lindemann later said in an interview that the purchase price was $1.6 million. In 2007, a year later, he sold *Hanging Heart* at Sotheby's for the then record-for-a-living-artist-at-auction hammer price of $23.6 million, yielding a profit in excess of $19 million. Gagosian repurchased it at the auction, for a client announced in the art press either as Los Angeles collector Eli Broad or as an eastern European oligarch. Based on that sale, Lindemann was quoted as saying, "the price of every 'Celebration' piece ... jumped almost 20 times in value."[19]

Back with the *Play-Doh* sculpture, Koons first intended to construct it from polyethylene but decided it had to be made of cast aluminum to produce a realistic surface. Fabricating a sculpture like that in aluminum was something no artist had done before. Koons tried three or four different techniques before finding one that met his standards. He was adamant about the need to use aluminum: "Look how sensual these forms are. When you rip Play-Doh apart and stretch it, you get these lines. It's like a Rodin sculpture."[20] Production of the sculpture required a half-dozen outside specialist companies. The Polich Tallix foundry in Rock Tavern, NY, did the fabrication. A Connecticut vintage-car restorer spray-painted the colours.

Koons' perfectionism has resulted in his losing money on early works that were pre-sold. Sometimes his dealer agreed to finance the new work, and lost money. Beginning with the series that included *Play-Doh*, dealer Larry Gagosian pre-sold sculptures to collectors Peter Brant, Dakis Joannou and Eli Broad, and to dealers Jeffrey Deitch, Anthony d'Offay and Max Hetzler. Koons would produce a terracotta model of a proposed sculpture and suggest an edition of three to five. Production began after down payments were received.

For later sculpture series the financing contracts were more detailed. When there were cost overruns (or for any other reason), Gagosian could return to purchasers and request additional capital. Purchasers had the option of agreeing to the new higher price, or offering the option for resale, or asking Gagosian to refund amounts already paid. For some Koons sculptures as many as three additional contributions were requested. Most buyers agreed to the higher price, rather than the resale or refund options, because current value was judged on the bidding for a Koons sculpture at a recent auction. If a customer requested repayment, Gagosian could seek a new collector to purchase the option at a higher price. In a *Guardian* article, Felix Salmon quoted a Koons collector as having offered to pay double the original asking price if Koons agreed to never come back and ask for more. Koons declined.

What the purchaser of a future Koons sculpture actually received was a security, a right-to-purchase option that included the "call for additional capital" provision. The security had minimal downside price risk; Koons' work had always increased in value. There was profit upside so long as the delivery option could be resold to a third party. There was **49**

a downside only if the market for Koons' work crashed and Gagosian or his estate refused to honour the repurchase commitment.

For his more recent work, Koons has restricted this "profit without taking possession" possibility with a contract provision that the option could only be resold to Gagosian, and only at the level of "funds already paid in." There was also a requirement that 70 percent of any profit Gagosian received on resale of a contract over the first two-year period be transferred to Koons.

The 70-percent clause meant that it was beneficial for Koons to make additional capital calls during the two years. He could cover unanticipated production costs, or force sale of the collector's option and profit from resale of the option.

Play-Doh is an extreme example of how long Koons' production cycle can be. An option on the sculpture was purchased in 1994 by Los Angeles television producer Bill Bell. Bell agreed to three price increases over a twenty-year period. His final purchase price was between $12 million and $15 million, with delivery taking place in 2014.

Koons works with Gagosian and two other über galleries, David Zwirner and Sonnabend. His retail prices are confidential; his secondary market resale prices are spectacular. In 2012–13 three works brought a combined $120.4 million. There was the $58.4 million for *Balloon Dog (Orange)*, $33.8 million for the stainless-steel *Jim Beam—J.B. Turner Train* (1986) (see photo insert after page 96) and $28.2 million for the stainless steel *Popeye*.

Given the size of his studio, Koons' output is limited. He has said, "We average 6.75 paintings and 15 to 20 sculptures a year."[21] That output is sufficient to support the studio, to pay his employees and outside fabricators, to provide commissions to his dealers and to make Koons wealthy.

What we see with *Balloon Dog, Three Studies, Apocalypse Now, Popeye* and *Play-Doh* is the huge sums of money sloshing around the art world, much of it chasing art as an investment the way it might prime real estate. We see a great deal more financial complexity than might be anticipated. But there is also shifting of roles and functions in the marketing of art, and conflict between players. That is the subject of the next section.

THE ART
OF MORE

"You never change things by fighting the existing reality. To change something, build a new model that makes the existing model obsolete."

—Buckminster Fuller, pioneering global thinker and inventor

SOTHEBY'S AND THIRD POINT

BEHIND THE RECORD SALES ANNOUNCEMENTS AND CONSIGNMENT COUPS at auction houses, there is ongoing conflict within the firms and with shareholders. There are dramatic differences of opinion about what to sell, what lines of business to pursue, what strategies to follow and, above all, how to increase profitability and bonuses. Sometimes the debate surfaces on the front pages of newspaper business sections.

Over an eighteen-month period beginning in 2013, five activist investors acquired major share positions in the common shares of Sotheby's auction house, the oldest firm on the New York Stock Exchange. In August of 2013, Nelson Peltz acquired 3 percent of the stock through his Trian Fund Management. A few weeks later Mick McGuire of Marcato Capital Management acquired 6.6 percent. In September, Daniel Loeb purchased a 9.3-percent stake through New York hedge fund Third Point.

In early 2015, institutional shareholders Morgan Stanley and

BlackRock investment corporation between them increased their stake to 12.2 percent of Sotheby's shares. The five firms now controlled just over 31 percent of the stock. That is not a majority shareholding, but activist funds have disproportionate power because so many shareholders are passive. Institutional investors, pension funds and mutual funds often do not vote their shares. Given this passivity, an activist investor with the support of the other four could take effective control of Sotheby's.

Third Point manager Daniel Loeb is such an investor. In October 2013—in the midst of the auction events mentioned in the previous chapters, he delivered a barbed letter to Sotheby's, reminding the firm he was now its largest shareholder and calling the auction house "an old master painting in desperate need of restoration."[22]

The Loeb letter questioned the competence of Sotheby's board members, accusing them of not making proper use of the internet and of not accomplishing enough in the Chinese art market. Much of the criticism was of chief executive officer William Ruprecht. Loeb said that Ruprecht presided over an organizational culture where expenses for marketing, salaries and administration were out of control. Profit margins shrank as commissions were waived and consignors shared buyers' premiums. There was criticism of the company's weak operating margins and deteriorating market share relative to Christie's.

Activist American fund managers have for years tried to create change through investments in what they considered to be underperforming firms. Loeb's was the first attack on an auction house. Usually funds take small stock positions, typically around 5 percent, and then submit a shopping list of demands to management. They often publicize their demands to win support from other shareholders. Demands may include representation on the board of directors, replacement of senior managers, cost-cutting, change of strategy, divestment of underperforming subsidiaries, returning cash to shareholders or suggestions of a merger partner.

Loeb's practice has been to acquire a stake in a company, demand strategic change and then sell when the share price rises. His first move, as with Sotheby's, is often a letter addressed to management and provided to the press. It offers embarrassing facts dug up by his analysts. Loeb was quoted in *Bloomberg Markets* magazine as saying, "Sometimes

a town hanging is useful to establish my reputation for future dealings with unscrupulous CEOs."[23]

One of Loeb's suggestions was that Sotheby's should be competing on service quality and expertise rather than on price. Another was that the firm should act like an art merchant bank, combining advising and financing functions and taking ownership positions in artworks—which would mean purchasing from clients and reselling at a profit. Loeb claimed that Sotheby's market focus was on "top clients" and on high-value lots, with too little attention paid to lower-value lots. He said Christie's had captured the lower-value end by using new technologies. The Loeb letter made one telling point; in spite of Sotheby's purported high-end focus, the firm trailed Christie's in market share for items over $1 million.

There was no mention that Sotheby's stock price had increased from its 2008 market crash low of less than $7 to almost $50 at the time he wrote the letter. It had reached $57 before the crash, and had never returned to that level.

To put Loeb's accusations in context, it is necessary to understand how major competitors Sotheby's and Christie's make money at evening contemporary auctions. The firms auction a few lots under $200,000, but these lots are not very profitable. Each lot requires due diligence on authenticity and provenance, and many of the same cataloguing, marketing and display costs as multi-million dollar lots that generate ten times the commission.

Sotheby's and Christie's offer a few lots over $10 million; as mentioned earlier, these may also not be very profitable. On these lots the consignor's commission of 10 percent typically is waived, and the buyer's premium may be shared with the seller as part of the consignment arrangement.

That leaves the middle market. Works with estimates of $2 million to $10 million produce most of the auction houses' profit. On these lots, Sotheby's and Christie's may waive part of the consignor's commission, but keep most or all the buyer's premium. But to win consignments in the $2 million to $10 million range, the auction house must also offer above-$10-million consignments like *Balloon Dog (Orange)* and *Three Studies*, which attract media coverage and high-end bidders. And the auction house must offer the low-end lots that come as part of taking on an estate, or are needed to complete their target of a seventy-lot auction.

The middle market is what makes Sotheby's and Christie's such

55

potentially promising companies. It has the potential to increase profit because middle-market lots have low incremental costs. Once a few trophy works have been attracted with waivers of commission or guarantees, it should be possible to offer additional middle-market works with little or no additional promotion.

The fallout from Third Point's attack came quickly. In November 2013 and following the Loeb letter, Tobias Meyer announced that he was leaving the firm after two decades. Meyer was the firm's chief auctioneer and head of contemporary and modern art. His final auction with Sotheby's, nine days earlier, had totalled $381 million, a house record. Meyer had a series of employment contracts. The last expired at the end of 2013. Meyer did not "resign," but rather announced he was not going to renew.

Meyer has never said publicly whether his departure was related to the Loeb letter and to imminent expense and compensation cuts. The auction house did not disclose his salary and bonus, but he could certainly earn far more as a private dealer. Another theory is that Meyer felt constrained by Sotheby's extensive bureaucracy and asked for and was denied more decision-making freedom.

It is hard to overemphasize Meyer's importance to the auction house or the shock of his departure. He had auctioned three works of art for more than $100 million each: Edvard Munch's *The Scream* in 2012, Andy Warhol's *Silver Car Crash (Double Disaster)* in 2013 and Pablo Picasso's *Boy with a Pipe* in 2004. Meyer, rather than Ruprecht, was the public face of the house and chief dealmaker. Many of Sotheby's major clients had primary allegiance to Meyer's advice. The loss involved more than his clout. Some collectors relied on a default option, doing what had minimized uncertainty before, relying on Meyer's advice and Sotheby's brand when a major consignment or purchase was involved.

The default option is also in play in the way collectors tour an auction preview. Meyer was responsible for specifying Sotheby's New York auction preview layout; where the location a work is hung signals its status. The feature works face the gallery entrance, to the centre or left, or are hung in an alcove to the right of the main entrance—usually with works in that order of importance. Collectors always found Meyer standing just to the left of the entrance. They would view works in the order of their importance, as signalled by location.

Less important (and less expensive) work at Sotheby's preview was

grouped in separate galleries to the extreme left of the entrance or at the back of the room, and shown by other auction specialists. Meyer seldom ventured to the back of the room.

More casualties followed. In November 2014, William Ruprecht announced his resignation. That was probably inevitable; Ruprecht represented the traditional culture of Sotheby's, the auction world version of a gentlemen's club. Loeb represented the business culture of town hanging.

Two weeks after Ruprecht left, Christie's CEO Steven Murphy announced he was leaving his position, nominally at the end of December but in effect immediately. Murphy had occupied the position for three years and had been responsible for investing $50 million in Christie's online presence and for negotiating the company's entry into China— the actions that Ruprecht was criticized for not taking. The obvious connection between the two departures was that lavish guarantees and rebates of buyers' premiums had defended the auction house's market share and gained media attention but produced little profit. A secondary explanation for Murphy's departure was that his restructuring created irreparable animosity within the firm.

Murphy was replaced by Patricia Barbizet, who is also the CEO of François Pinault's holding company Artémis. She is vice-chair of the board of Pinault's luxury goods holding company Kering, and a director of French groups Total and PSA Peugeot Citroën. Barbizet was seen as a caretaker CEO. In December 2016 she ceded the role to Guillaume Cerutti, president of Christie's Europe.

After a four-month search following Ruprecht's departure, Sotheby's appointed forty-nine-year old Tad Smith as his successor. A Harvard MBA, Smith had been CEO of Madison Square Garden. Before that he was an executive in media company Cablevision. He had no background in the art world and no known role as a collector. US Securities and Exchange Commission filings indicated that Smith was offered first-year compensation worth a potential $20 million, most in the form of stock options dependent on how the firm's shares performed through 2020. The award was potentially three times Ruprecht's compensation in his final year. Until Smith, the most famous art-world outsider to enter the executive ranks of the auction business from the entertainment sector was Steven Murphy, who came from EMI Music.

In a letter to employees, Smith said: "I ask you to embrace the possibility **57**

that lessons from creative industries may be applied to Sotheby's." New York dealer David Nash of Mitchell-Innes & Nash characterized the statement as "an example of thinking of auctioning as a merchandising machine, when the CEO can't tell the difference between a Manet and a Monet."

In February 2014 both sides agreed to end their legal and public relations campaigns. Sotheby's announced it had spent $20.1 million defending itself against the Loeb assault. There must have been a lot of well-compensated New York lawyers. As part of the settlement, Sotheby's granted seats on the auction house board to Loeb and two of his associates.

In January 2015, Smith announced that he had paid $85 million to acquire Art Agency, Partners (yes, with a comma), a two-year-old art advisory firm founded by Amy Cappellazzo, former co-head of contemporary art at Christie's, and Allan Schwartzman, a former dealer and adviser. Cappellazzo and Schwartzman were made co-heads of the fine arts division, ranking above all the auction house chairmen worldwide.

The purchase amount included $50 million paid immediately, essentially as a signing and retention bonus. There would be additional payments up to $35 million if financial targets were met over a five-year period. Analysts found it hard to understand how the house could make money on the purchase, given the huge upfront payment.

In a conference call with analysts and investors, Tad Smith was joined by Cappellazzo and Schwartzman. They said the acquisition was part of a larger strategy to increase the auction house presence and revenue in advisory services, to expand its services in art consulting, private purchases, art-related estate planning, asset portfolios and art investment. Cappellazzo later added, "Now we're just a big transactional organization that has an advisory division, kind of like Goldman Sachs and UBS and all those guys."[24] Sotheby's has more than three hundred employees; the idea that it did not already have the in-house skills to perform the functions for which AAP would now be so well compensated is telling. The stock market approved of the acquisition—Sotheby's stock rose 7.2 percent on the day of the conference call.

The purchase was innovative, apparently motivated by an art world where the richest 1 percent of Sotheby's art customers purchase as much as the remaining 99 percent. It was not clear how the new fees involved

would be received by a 1 percent that previously received the services free. How valuable the advice would be, coming from advisers who were seen as biased toward transactions through Sotheby's auctions and private dealing, was also not obvious. The wording of the announcement suggested that on occasion, Cappellazzo or Schwartzman might purchase a work for a client from Christie's. Schwartzman said that possibility was understood and accepted by Sotheby's.

As an interesting aside, when Cappellazzo was at Christie's one of her major clients—perhaps the most important—was Dan Loeb.

The AAP expansion gave Sotheby's a potential fourth leg to its revenue stream: auction commissions and fees, private sales, income from financing and now advisory fees. The assumption seemed to be that the latter three would be high-margin, to compensate for the auction business which would be the public face of the company but remain low-margin. There is a stumpy fifth leg, revenue from the secondary market art showrooms in London and New York. These remain minor revenue sources.

One of Sotheby's first responses to Loeb's criticisms was to negotiate more capital for its finance unit, for use in auction lot guarantees and art loans. In August 2014, Sotheby's doubled its credit line from $300 million to $600 million. In June 2015, the auction house paid GE Capital, Corporate Finance, a $2.7-million fee to increase Sotheby's borrowing limit to $1.3 billion. Sotheby's Financial Services was in 2016 the largest asset-backed art lender in the world. Bank of America (US Trust), J.P. Morgan Private Bank and Citi Private Bank were bigger asset lenders overall, but much of their lending was against a portfolio that included art with other assets. Christie's art lending is well below Sotheby's; it does some art-secured lending but prefers to refer clients to other financial firms.

Sotheby's great advantage in art lending is that it is not bound by the same strict compliance rules as banks, and so can move quickly. Sotheby's doesn't have to examine financial statements or tax returns, or inquire as to the source of funds that paid for the art. It lends money—much of it to dealers, collectors, and executors of trusts and estates—against the value of the art. If the loan is not repaid the auction house sells the collateral and takes a full commission on the sale.

In December of 2015, Tad Smith announced a 9-percent drop in third-quarter revenue, and called for 80 employees (of 1,600) to take

59

voluntary redundancy so the house could achieve "efficiencies." He said if not enough employees accepted, there would be "involuntary separations." There were enough voluntary buyouts within ten days. Smith then announced an expensive coup. He hired Marc Porter, chairman of Christie's Americas and former head of the private sales department at Christie's, to join Sotheby's after a year's non-compete period. Porter had been with Christie's for twenty-five years.

In December 2016, without warning, Christie's postwar and contemporary chairman Brett Gorvy announced he was leaving that auction house after twenty-three years to co-own the rebranded Lévy Gorvy with former Christie's executive Dominique Lévy.

The settlement with Loeb focused attention on two issues. Much of Sotheby's value comes from the fact the auction house is perceived as a seller of luxury goods, involved in what has been called the Moët-and-beluga trade. In auctioning high-end contemporary art everywhere but China, the firm competes only with Christie's. Bonhams, Phillips and others auction high-priced goods but are not perceived as luxury brands.

Assume that as Loeb suggested, Sotheby's cut back on offering buyer rebates and implemented expense-cutting. At the time of the Loeb letter in 2013, Christie's was almost certainly spending more than Sotheby's on rebates and promotions, both in absolute terms and as a percentage of sales. If Sotheby's cut back, would Christie's follow? If Christie's did not follow, how would consignors and collectors react? If the result was a dramatic increase in Christie's market share, would Sotheby's in three years still be viewed as a luxury brand? Would Sotheby's be considered equal to Christie's if the latter's auction sales were consistently two or three times the dollar value of Sotheby's? Would Sotheby's then become just a seller of high-priced goods?

Christie's said in 2014 that there were about 150 people in the world who might bid on a $10-million painting. Sotheby's estimated the number at "about 100." These are the people who are served Moët and beluga, have trophy art delivered to their homes for private preview and are sometimes offered first-class air tickets to attend an auction. Sotheby's had better be as willing as Christie's to do whatever is required to capture those collectors.

The second issue that now attracts attention is internet sales, an area also emphasized in the Loeb letter. The internet is well adapted to

fashion and prestige brands, not so much to luxury. Easy accessibility is a negative for luxury goods, which require time and effort to be deserved. Luxury means that the purchaser has overcome the constraints of daily life and entered into a privileged world of the aesthetic, the cultural and the hedonistic. That privileged world—and any mention of prices—is not found on the internet.

Can you offer luxury online, and also mention prices? What other luxury good does that? Not Rolex or Lamborghini. Not Gucci, Cartier or Dior. Chanel sells cosmetics online, but not fashion. Miuccia Prada was quoted in *Vogue*, "We think that, for luxury, it's [e-commerce] not right. ... Personally, I'm not interested."[25] But Christie's has sold Hermès Birkin bags and Elizabeth Taylor's multi-million dollar estate jewellery online. Ex-Christie's CEO Steven Murphy had predicted that the auction house's business would evolve to one-third live auctions, one-third private sales and one-third online.

The final question was whether the fight over Sotheby's would result in a takeover battle and a new, private owner. David Schick, then managing director of investment management firm Stifel Nicolaus and now with Consumer Edge Research in Washington, DC, led the argument that Sotheby's needs a single owner like François Pinault: someone with wealth and a fascination for art and the art market. Most important, the firm needs someone with no requirement to maximize quarterly profits. Privately owned Christie's is immune from takeover threats, and does not need to make public its financial statements or the details of its deals. Perhaps equally important, Brett Gorvy can encourage those who work for Christie's to experiment with new initiatives and make their own decisions, without an occasional misstep risking their career or Gorvy's.

Sotheby's announced its 2015 sales were down about 7 percent compared to 2014. Christie's announced a 5-percent drop. Postwar and contemporary art for the two was down about 15 percent. Sotheby's commission margin—its revenue from commissions as a percentage of auction sales—dropped to 14 percent, compared to 21 percent in 2009. The decline was largely due to the auction houses' "paddle-plus" offers to attract consignments. Sotheby's dropped its dividend to conserve funds. Analysts predicted that 2016 sales for the two auction houses would be down a further 10 to 11 percent from 2015 levels.

In April 2016, Cheyenne Westphal—Sotheby's worldwide head of contemporary art—became the latest in an unprecedented exodus of executives from the auction house. Westphal had been with Sotheby's for twenty-nine years; Alex Rotter, her former co-head, had resigned in February. Westphal was considered one of the least likely all of all the firm's executives to ever jump ship.

Between the resignation of Tobias Meyer and Westphal's departure, there were thirteen other major departures from Sotheby's. The group had a total accumulated experience of 330 years. The mass departure was not interpreted as a vote of confidence for Tad Smith.

It was not apparent whether the shakeup and enormous loss of institutional knowledge that accompanied it stemmed from the demands of activist investors; the accession of Smith; the purchase of Art Agency, Partners; the new role of Amy Cappellazzo; or the decreased bonuses that followed from declining profits. (The executive turnover produced one historic result. Helena Newman, the new chairman of Sotheby's Europe, became the first female auctioneer to take a major evening sale in New York when she wielded the gavel for the November 2016 Impressionist and modern event.)

Sotheby's turmoil and financial performance were reflected in its stock price. In April 2016, Sotheby's shares dropped to $26.00, down from a year high of $47.28 and down 55 percent from their value when Loeb and the others purchased their stakes. The five activist investors had a combined paper loss of a little under $2 billion on their speculative purchase of Sotheby's shares. The stock price rebounded strongly later in 2016, but the five still showed a sizeable loss. Toward the end of 2016 Sotheby's agreed to buy back the Marcato shareholding for a price that was not announced, but was certainly well below what was paid in 2013. The losses and stock price drop meant Sotheby's credit rating was under scrutiny. If Standard & Poor's downgraded the company, its credit-line provisions might be breached and the auction house could face a financial crisis.

In mid-2016 the company had a market cap (total share value) of $1.7 billion; at the beginning of 2017 the cap was $2.2 billion. Either figure left the company within takeover range of a few. The most often-mentioned candidate was Bernard Arnault, a man with a long-term rivalry with Pinault. Arnault is the French owner of luxury brand house LVMH,

the former owner of Phillips and the donor of a new private museum in Paris Bois de Boulogne. He has a reported fortune of $37 billion. Other takeover candidates mentioned were the Qatari Royal family and China's Poly auction house, the third largest in the world.

In July 2016 an unanticipated suitor emerged. Chinese businessman Chen Dongsheng announced that Taikang Life Insurance Company, where he is chairman and chief executive officer, had become Sotheby's biggest shareholder. Taikang's controlling shareholder is China Guardian Auctions, a company that Chen co-founded in 1993 and the fifth-largest auction house in the world. Chen and Taikang have a long-term history in art; the insurance company runs its own gallery in Beijing's 798 art district.

Taikang acquired almost 14 percent of the shares through a series of small transactions. The significant acquisition did not significantly move Sotheby's stock price, even though the increased market volume alerted those watching the stock that something was happening.

By the fall of 2016 Chen had not issued any statement as to his intentions for Sotheby's, except to say that he desired board representation, that he viewed control of auctioneering as important to protect China's heritage and that he dreamed of recreating China's cultural aristocracy. In November Sotheby's announced that a representative of Taikang would join its board of directors, as part of a deal in which Taikang agreed to limit its stock purchaser to 15 percent of the shares outstanding.

Chen's involvement offers a strange bridge between the ultra-capitalism of the auction house and China's communist past. Chen is married to Kong Dongmei, the granddaughter of People's Republic founder Mao Zedong.

A "gladiator sport at the highest level."

—Brett Gorvy, formerly Christie's[26]

"If everything seems under control, you're just not going fast enough."

—Mario Andretti, former racing driver

FORAGING FOR COLLECTORS AND CONSIGNORS

PRIOR TO THE MID-1990S, MAJOR AUCTION HOUSES WERE MOST CONCERNED with attracting consignments. They searched out and charmed owners of important works. The inducements were the high prices being offered for similar works, the possibility of a catalogue cover and a lavish write-up identifying the consignor, and price guarantees. There is still fierce competition for consignments. But now there is more emphasis on persuading wealthy collectors to buy additional works, and finding wealthy non-collectors to convert.

Identifying potential bidders used to mean that senior people from Christie's and Sotheby's pursued social connections in New York, London and a few other major cities. That guaranteed they would encounter most of the collectors, agents and dealers who mattered. Now an auction specialist is expected to meet thirty new potential clients each year and learn their collecting preferences. As more important Impressionist and

modern art resides in museums and long-term collections, specialists have to find collectors to bid on what still appears at auction in order to keep annual sales totals growing. This is the Red Queen phenomenon, named after the character in Lewis Carroll's *Through the Looking Glass.* The Red Queen cautions Alice, "It takes all the running you can do, to keep in the same place. If you want to get somewhere else, you must run at least twice as fast as that!"[27]

Christie's Brett Gorvy said he has a client database that's updated from auction bidding and with leads from Christie's art specialists around the world. In 2015 most key customers on the list were in their forties and fifties and, Gorvy says, "ran their own companies." Twenty percent were from Asia, most of those from China. Twenty years earlier, 90 percent of those on a comparable list would have been in their sixties and seventies, with inherited wealth or positions as senior executives with major corporations. Most would have been resident in the United States and Western Europe. Christie's has said that at its various auctions in 2014, it took bids from collectors domiciled in 170 countries, twice the number that competed in the 2014 Winter Olympics in Sochi. The potential is considerable; Christie's noted in 2015 that 43 percent of billionaires are based outside traditional Western countries. In July 2015, *Skate's Market Notes* estimated, based on its data mining, that only 11 percent of global citizens with assets over $100 million were currently invested in art.

The process of prospecting for new buyers is highly personal. Kelly Crow of the *Wall Street Journal* quoted Giovanna Bertazzoni of Christie's as saying that specialists from both auction houses host birthday parties for collectors' children. The hope is that the kids invite their school friends and that the friends' parents stay for the party. It is said that in 2014, Sotheby's hosted a children's birthday party in London with an art-themed scavenger hunt. Thirty eastern European families attended, some of whom became new clients.

Gorvy says that in 2014 he flew to China for one day to attend a birthday party for a major collector. Patty Wong, chairman of Sotheby's Asia, reportedly flew to Japan for one day to attend a museum exhibit with an important collector.

The most discussion-worthy promise came from Alex Rotter, then co-head of contemporary art worldwide, and Simon Shaw, then co-head of worldwide Impressionist and modern art, both at Sotheby's. In a

New York Times interview about obtaining consignments they were asked whether they would help get a collector's child into college to score a success. Both "laughed and nodded yes."[28]

Kelly Crow also reported that in May 2014, Christie's invited a group of eighteen Chinese collectors to visit New York. The auction house had identified some of these potential new bidders at their Shanghai and Hong Kong auctions. After vetting from Christie's specialists, the collectors travelled to New York as guests of the auction house. They were taken on visits to the Museum of Modern Art and the Frieze art fair, then hosted for dinner at Christie's Rockefeller Center headquarters. The auction house seated them in two skyboxes in Christie's main auction sale room at the two-day sales of Impressionist, modern and contemporary art. The skyboxes both signalled respect on the part of the auction house and prevented other auction houses or dealers from photographing the collectors and researching identities.

Bidding took place by telephone from the skyboxes, relayed via Christie's contemporary art specialist Xin Li. Xin's clients bid on six of Christie's highest-estimate contemporary works, which together sold for what *W Magazine* reported as $236 million—half the evening's sale total. Gorvy clarified that Xin was bidding on behalf of clients from Malaysia, Taiwan and Indonesia as well as China. François Curiel, employed at Christie's for thirty-five years, said he had never seen one specialist account for that high a proportion of a sale.

One sale to a skyboxed Chinese client was Jeff Koons' sculpture *Jim Beam—J.B. Turner Train* (1986) a 9½-foot-long (2.9-metre) stainless-steel train filled with bourbon (see photo insert after page 96). It sold for $33.8 million. The sculpture was produced in an edition of three, plus one artist's proof. A different edition of the train had sold in 2004 at Christie's for $5.5 million.

Xin offers a great backstory to Christie's efforts to find new Chinese clients. She is six-foot-one, a former professional basketball player from China's Manchuria region, near the North Korean border. After she left China she spent a period as a Paris fashion model. In 2008, after a stint at modelling (and at the advanced age, for a model, of thirty-two), she asked her new acquaintance Diana Widmaier Picasso, granddaughter of the artist, how she might gain a foothold in the art world.

Picasso introduced her to Emmanuel Di Donna, then worldwide **67**

vice-chairman at Sotheby's, who hired Xin as a trainee. She moved to Christie's in 2010 when that firm offered a position as director of Asia business development. Xin won't talk about what incentive triggered the switch, only that she was "presented an opportunity that I couldn't refuse."[29] She was quickly promoted to deputy chairman of Christie's Asia.

Xin says much of her time is spent with "about five major Asian collectors who can each spend $100 million [in] a single season on art."[30] That is annual expenditures, not lifetime. In 2014 and 2015, Xin was probably the most publicized auction specialist in the world. To complete the started-in-Manchuria story, in June 2015 the then thirty-nine-year old, never-married Xin announced her engagement to music mogul Lyor Cohen, CEO of 300 Entertainment. She met Cohen in December 2014, on a yacht at the New Year's gathering of the art world in St. Barts.

Another tale of what is done to find customers and consignors involves Loïc Gouzer, who also started at Sotheby's, then moved to Christie's in 2011. He was described in a July 2016 *New Yorker* article as "The Daredevil of the Auction World."[31]

Gouzer is now Christie's deputy chairman of postwar and contemporary art, best known as a pioneer of themed auctions. These combine known and less-known works, with the hope of imposing a reflected glow of significance and value on the less-known. For example, the 2015 "Looking Forward to the Past" themed auction combined contemporary works by John Currin and Peter Doig with those of Picasso, Monet and Giacometti. The auction totalled $706 million.

A few years earlier, Gouzer—then a mid-level specialist at Sotheby's—was trying to expand his collector connections. He jumped at an opportunity to accompany über collector Adam Lindemann on a surfing trip to the Maldives, even though Gouzer had never before tried the sport. He survived. Lindemann has been quoted as saying that since then, Gouzer had sold many works for him. On another occasion, reported in the *New Yorker* article, Gouzer—then at Christie's—sought consignment of a painting owned by a Manhattan plastic surgeon who had a long-standing relationship with Sotheby's. Gouzer made an appointment to have a mole removed, and spent the appointment in a conversation about consigning. He lost the mole; there is no indication of whether he gained the consignment.

Christie's auctioneer Jussi Pylkkänen claims that for a major work

coming to auction, his in-house intelligence is such that he almost always knows prior to the auction the identity of the final three competing bidders. Sometimes there are huge surprises. In the November 2015 Christie's "Artist's Muse" auction of twentieth-century works in New York, the featured work was Amedeo Modigliani's *Nu couché* (1917–18) (see photo insert after page 96). This is a painting of a nude woman with red cheeks and a red coverlet. The work is highly sexual, considered a trophy painting because of its bright colour and dramatic impact. It had been featured in shows at the Musée National d'Art Moderne in Paris, the Tate Gallery in London and MOMA.

Christie's needed an iconic work as a centrepiece for Artist's Muse. *Nu couché* was perfect. It had been in the collection of Italian art historian Laura Mattioli Rossi and her father for sixty years. Christie's hurdle was that Rossi would consign only if she were offered a $100-million guarantee. That amount was considered incredibly risky. Modigliani is not among the top ten modern artists on almost anyone's list. The former record for a Modigliani was $70.7 million in 2014 for his sculpture *Tête* (1911–12).

Christie's reportedly countered with a guarantee offer of $70 million. Rossi held firm; Christie's finally agreed to the higher amount. The auction house then offered generous terms to any investor willing to take on some or all of the guarantee risk. Apparently a contract was signed on the afternoon of the sale, with three third-party guarantors assuming 50 percent of the risk.

Holding out for a huge guarantee is not uncommon, although this was an extreme case. It is another example of the endowment effect. Because she owned it, Rossi valued the Modigliani higher than she might have if someone else had owned it. If we had gifted Rossi with $70 million, it is unlikely she would invest it in a Modigliani. As it turned out, Rossi would have netted more money had she accepted the $70-million guarantee. Once she knew Christie's was willing to offer $100 million, she should have gone with the lower figure and negotiated a better revenue-sharing arrangement.

An everyday example of endowment may be more relevant to those who do not own a $100-million painting. During the Toronto Blue Jays frenzied playoff run with the Texas Rangers in October 2016, I gave my daughter Elizabeth a pair of tickets for good seats. They were hers; she

69

could do with them as she wished. She could use them to take a friend, or could sell the pair online for $600.

Elizabeth would never contemplate paying $600 for a pair of Jay tickets herself. But the endowment effect made the tickets in her hand more valuable than the money, or the new winter coat and boots she might have purchased with it. She took a friend to the game. The Jays won.

If I had given her $600 instead of the tickets, would she have spent it on Jays tickets? Not likely. Traditional economic theory would regard Elizabeth's decision—and that of Laura Mattioli Rossi—as irrational. Given the endowment effect, such outcomes are common.

The Modigliani was positioned as lot 8A, in the hope that it would be desirable to a Chinese billionaire. The successful bidder was Liu Yiqian, the Shanghai resident mentioned in Chapter 1. Liu is has been characterized in the Chinese press as a former taxi driver and handbag seller turned billionaire art collector. That is factually accurate but somewhat misleading. It neglects to point out that the handbag business was family-owned and that in the 1980s and '90s Liu invested in pharmaceutical companies and real estate to achieve a worth of (depending on the source of the estimate) $1.5 billion to $2.8 billion.

Liu and his wife, Wang Wei, were well known to the auction houses, but not for modern art. In 2014 they spent $45 million at Christie's Hong Kong for a fifteenth-century *thangka*, a Tibetan silk tapestry, and $36 million at Sotheby's for a Ming-period porcelain cup. Liu owned a Jeff Koons sculpture, but was always classified by auction specialists as a collector of modernist and classical Chinese artworks. Liu bid for *Nu couché* on the telephone with Elaine Kwok, Christie's director of education for Asia, rather than with Xin Li.

When the Modigliani came up there were six bidders. There were four still in at $100 million. Bidding from Liu and another collector on the phone with Loïc Gouzer stalled at $140 million. The identity of Gouzer's bidder was known in advance; that is why he was with Gouzer.

Then there was a surprise bid from the room, from New York–based Korean art dealer Hong Gyu Shin. He was seated, not in a skybox, or in one of the sections reserved for important collectors, but in auction-room suburbia, near the back of the room. (He was an underbidder for *Three Studies of Lucian Freud*, discussed in Chapter 3.) He placed a single bid of $142 million, then dropped out. The final invoice amount

was $170.4 million after addition of the buyer's premium. *Nu couché* beat the former artist record by almost $100 million, to become the second most expensive work ever sold at auction.

Liu may not have been expected to bid, but as the commercial says, wealth does have its privileges. He is reported to have paid with an American Express Centurion Card, with a one-year payment option. Wang Wei told the *New York Times* that she and her husband would pay off their charge within the year. "If we had to pay cash upfront, that would be a little difficult for us. I mean, who has the money for that?"[32]

Known as the black card, the Centurion is made of anodized titanium and advertised as having no pre-set limit. It is the card with which you can buy anything. Liu did; his purchase reportedly earned 132 million frequent flyer miles. Christie's would have paid just over $3 million in credit-card charges. The Modigliani was thought to be the largest single charge ever made to an American Express card—the company refused to confirm or deny, but seemed to welcome the publicity.

Pylkkänen was right on only one final bidder of three. That is less-than-perfect bidder intelligence, but still a passing grade for the second most expensive work at auction.

FORAGING FOR COLLECTORS AND CONSIGNORS

"Art dealers who focus less on business and more on art are generally the dealers who become the most successful and influential."

—Jeffrey Deitch, art dealer[33]

"The space and architecture that a gallery chooses, and its location in the city, tells you a lot about its approach. Some collectors may never come to the gallery itself, but they still want to know it exists."

—Marc Spiegler, director, Art Basel[34]

LISSON GOES TO NEW YORK

LISSON IS ONE OF THE WORLD'S TOP CONTEMPORARY GALLERIES. WHEN founder Nicholas Logsdail decided to open a branch of the gallery in New York after forty-eight years of art dealing in northwest London, he was going against the norm. It may not seem like an earth-shaking decision, but for a decade galleries have expanded from New York to London. There is not much history of London galleries going to New York: the best-known are Marlborough, Timothy Taylor (which opened in New York in 2016 as "16 × 34"); Almine Rech; Hauser & Wirth (to open in 2018); and Haunch of Venison (which lasted only a few years).

Logsdail's decision permits a look at some less obvious advantages and problems of gallery expansion, and at cultural differences in art dealing in the two art world capitals.

The fact that relatively few London galleries make the move to the United States is strange because of the dominance of the New York

market in contemporary art, relative to London. Art writer Isaac Kaplan has calculated that of the hundred artists whose works are the most expensive sold at auction, 56 percent set their records in New York versus 25 percent in London. Each of the top-ten sales came in New York.

In my 2014 book *The Supermodel and the Brillo Box*, I included a list of the top contemporary galleries, assembled from responses of thirty art-world people who were asked to name the top contemporary galleries. The question turned out to be interpreted, not unreasonably, as "which are the top selling." Lisson was listed as number twelve, just behind White Cube and Paula Cooper. The ranking reflected the reality that the Lisson brand was less well known in the US than in the UK and Europe.

My use of a single metric was misleading. There are several distinct types of galleries. If a ranking system is used, each gallery should be ranked against others with the same objectives. Some galleries show only secondary (that is, previously owned) art, and do not represent primary artists. Other galleries focus on a niche market, promoting art from a particular movement or geographic area or time period.

The largest galleries focus on the markets and collectors they serve. There is no single focus to what they do; they promote artists whose work sells, and may drop those whose work does not sell well in two consecutive shows. Most art-world observers would agree that this group includes Gagosian, Pace and Zwirner. I intend no value judgment by this characterization; it is the model followed by most businesses, in or outside the art world.

The final category of gallery I will call artist-centred. Their focus is on commitment to a group of artists and belief in their work, rather than a calculation of future profitability. Artist-centred galleries do not always survive for a long period. Those that do tend to have the long-term loyalty of their artists. Lisson is in this category, as would be Marian Goodman and Gladstone from my earlier list.

After the 2008 art market meltdown, many galleries shrank their space or closed and their principals became private dealers. Logsdail maintained his London gallery space and continued to show artists at major fairs. This reflects both the artist-centricity of the gallery and its financial ability to weather the art market recession.

Logsdail attributes his early interest in art to the influence of his uncle, the novelist and children's writer Roald Dahl (*Charlie and the*

Chocolate Factory). From the age of seven, Logsdail accompanied Dahl on art-viewing expeditions to the Tate and National galleries and to Cork Street dealers. He recalls driving back with a Francis Bacon painting in the trunk of the car. Then he got to help hang it.

Logsdail sampled a couple of art schools, and in 1967 attended the Slade School of Fine Art. In his second year he was asked to leave because, he says, in the previous three months he had spent too much time away from classes organizing a selling exhibition of work by fellow students. The show was held at his new and somewhat derelict Bell Street home in northwest London, purchased in 1966 for £2,000 (then about $5,600) on a "pay in three years" contract.

Derek Jarman and other Slade students cleaned the place up and painted it. Logsdail calls the student show—one of the first outside the Cork Street gallery area in London—a "proto-Freeze," predating by twenty years the more famous Freeze warehouse exhibition organized by Damien Hirst and the Young British Artists, the yBas. The show attracted "bohemia," including John Lennon and Yoko Ono, and was written up in the London press as much for its innovative location as for its result. To the amazement and delight of the artists represented, the show almost sold out. The success determined Logsdail's future as art dealing rather than art making, as well as the location of his gallery.

He has since purchased seven properties on the street and incorporated them into two separate gallery spaces at 27 and 52 Bell Street. Lisson remains in an area of very mixed retail—next door to 27 Bell are storefront funeral directors, Ronald P Sherry & Son, "Serving the Community for 130 Years." Next to that is Nuts About Nuts, a Lebanese store selling sweets and nuts. This is not an area of jewellers or high-fashion shops. It is a fifteen-minute cab ride from the cluster of ninety galleries in Mayfair and St. James's, in central London. Collectors make the effort to visit Lisson.

The gallery has presented the first exhibitions in London and Europe of conceptual and minimalist artists Sol LeWitt, Carl Andre, Donald Judd, Dan Graham, Robert Mangold and On Kawara among others. In the 1980s, Lisson introduced British sculptors Tony Cragg, Richard Deacon, Shirazeh Houshiary and Anish Kapoor. When many London galleries in the 1990s featured the hot yBas—Damien Hirst, Chris Ofili and others, Lisson stayed with the artists it had. In 2016 Lisson represented fifty-

75

one artists, including Marina Abramović, Ai Weiwei, Tatsuo Miyajima, Jonathan Monk and Ryan Gander. (See photo insert for another Gander work, after page 96.)

Lisson sees its role as an international gallery in London rather than a London gallery showing international artists. The concept from the beginning was to take on young artists and develop them. Half the artists would be foreign, half British, with a bias toward the interesting sculpture being done in the US and UK.

From 1984 to 1999, Lisson artists accounted for fourteen Turner Prize nominations. The prize, named after English painter JMW Turner, is presented annually to a British artist under the age of fifty (originally under forty). It is the United Kingdom's most sought-after art prize. Five Lisson artists have won: Richard Deacon (1987), Tony Cragg (1988), Anish Kapoor (1991), Grenville Davey (1992) and Douglas Gordon (1996).

Forty-eight years after opening on Bell Street, Logsdail made the decision to expand to New York. In May 2016 the gallery opened an 8,500-square-foot gallery in the Chelsea area. The space at 504 West 24th Street is in a new building located under the High Line, between 23rd and 24th Streets. The choice of a Chelsea location represents a diametrically opposite philosophy to the London site. Chelsea is a short walk from über galleries Gagosian, Luhring Augustine, Andrea Rosen, Mary Boone, Matthew Marks and Barbara Gladstone, and close to the new Whitney museum.

Lisson's other non-London venture was opening a small, 1,500-square-foot gallery in Milan in 2011. The Milan space is used to test-market new artists or new styles of painting or sculpture by existing ones. The building is adjacent to the Castellini family's Palazzo degli Atellani, the gardens of which are used for Lisson's sculpture exhibitions.

Why after such a long period did Lisson expand? There are several answers; each illustrates something about today's contemporary art market. With fifty-one artists, and with two London locations plus Milan, the limit of six to eight shows a year at each made it difficult to provide each artist a solo show every twenty-four to thirty months. A space in a new city allows the gallery to take on more artists and to better show current ones.

New York is still by far the centre of the contemporary art collecting world because of the concentration of artists, dealers, auction houses,

wealthy collectors and art publications. New York galleries are based on the sale of American and international art to the world. London by comparison is not a hotbed of contemporary artists, nor does it have a large pool of affluent collectors who are permanent residents. In September 2016, only sixteen of the fifty-one Lisson artists were resident in the UK. Over the life of the gallery, 90 percent of sales have been to non-British collectors. Just over 50 percent of art purchased at Lisson's London galleries goes to the United States. The gallery knows where the art ends up, because it ships directly in order that the purchaser not become liable for UK taxes.

Another reason for the new location is to expand opportunities for those current artists without New York representation. Equally important is to keep gallery artists from being poached by dealers offering greater international exposure. Successful artists are seduced by the reach and pricing power of multinational galleries. Artists want their work to have wide exposure; some will switch galleries to get it. Dealers say this concern is behind most international expansions by galleries. Emmanuel Perrotin said his principal reason for expanding from Paris to New York in 2013 was defensive. He had artists who wanted to be seen in New York; if he didn't show them they would switch dealers. "We are driven above all by a fear of losing artists if we don't develop at their rhythm."[35]

Lisson has lost only three or four artists to poaching over several decades, but the gallery is always vulnerable. It does not have formal contracts with artists, only a letter of agreement. Logsdail says he would not try to restrict an artist who insisted on moving, and does not think that a contract could be enforced in any case.

Fifteen Lisson artists had dealer representation in New York at the time of the expansion—this includes performance artist Marina Abramović with Sean Kelly, Anish Kapoor with Barbara Gladstone, Ai Weiwei with Mary Boone, and Lawrence Weiner with Marian Goodman. It is always interesting to see how artists end up being represented after an expansion. Usually expanding dealers say they will respect the relationship an artist already has with a foreign gallery, that the new location will exhibit other gallery artists. Logsdail said that when he announced the New York move, artists asked him, "So when are you going to ask me if I will switch to you in New York?" He said he was not going to ask; if the artist wanted to move to Lisson, the artist would ask him. When I asked

77

a prominent art writer about this approach, she responded, "Logsdail may be too nice a person to succeed in New York."

In practice there are lots of examples of switching and a few of dual representation. Michael Werner opened his new gallery in London with a show of paintings by Peter Doig. Doig was at the time represented in London by Victoria Miro, and remained so after the Werner show. It is not common for artists to show at different galleries in the same city, but it does happen. Gallerist Emmanuel Perrotin is one of the few dealers to state openly that he is willing to consider an "open marriage" with artists—that is, multiple partners. Perrotin warns of the difficulties, for example which gallery gets first choice of artworks for a show or an art fair.

A common secondary motive for foreign gallery expansion is to service one or more hot artists. When an artist's work is successfully promoted, the economists' concept of supply and demand is reversed. Artists who are shown in multiple cities and at successive art fairs attract more publicity, higher demand and better prices. Each gallery show, each appearance at an art fair and each feature article in an art magazine adds to demand. The reassurance of the dealer brand is reinforced by the enthusiasm of collectors in multiple countries.

Multiple gallery locations are thought to help in securing admission to top art fairs and in securing a good booth location within the fair. Lisson does not have to worry about admission to art fairs. In 2016, *The Art Newspaper* ranked the twenty most active galleries by attendance at what the newspaper deemed the forty "top international art fairs" over a five-year period. Lisson was sixth on the list (with 50 appearances, an average of 10 a year), ahead of Pace (48 over the five years) and Gagosian (40), and just behind Marlborough (58) and Zwirner (56). But the number of fairs attended and placement at each fair is always a concern with a gallery. Having your booth in a cluster with Gagosian, Pace and Zwirner at Basel Miami or Frieze New York is a signal of your status and the prestige of your artists. Artists understand the desirability of working with a dealer who secures these locations.

For a branded dealer able to show in-demand artists, the financial risk from expansion may be minimal. When art sells for $50,000 and up, a few sold-out shows can cover the cost of leasing and refitting a new gallery. Larry Gagosian once used the throwaway line that his lavishly

expensive gallery expansion in Athens would break even with his first four sold-out shows.

The real downside of foreign expansion may be wear and tear on the gallery owner. For many dealers the owner is the brand—think Gagosian or Zwirner or Goodman. That is also true with Nicholas Logsdail in London. With expansion, the dealer spends less time at the home gallery, and artists and collectors get less face time. In the mid-1990s, Marc Glimcher—then president of New York's PaceWildenstein—opened galleries in Los Angeles and London. He closed both a few years later because they and the home gallery suffered without his presence. There is a major exception to this wear-and-tear rule. That exception is Gagosian. Glimcher said that "Larry has a special talent; clients don't expect to see him, they are happy just getting the aura of Larry."

For Lisson the absentee problem was not a concern. The face of the New York operation is Logsdail's son Alex, who headed Lisson's New York representative office from the time it opened in 2012.

The art cultures of London and New York are very different. Angela Choon, senior partner at David Zwirner, has been quoted as saying the culture of buying art in New York is "People come, they look and ask how much it is, negotiate, and it's done." In London, by comparison, "People don't rush to the opening. They want to take their time, look at the work ... understand it and really have a dialogue about it."

There are differences in what is sold. London has historically been seen as a market that preferred pictures of horses, hunting dogs and deceased family members. For contemporary art, London is a market for primary work rather than secondary art. Lisson's market is 85-percent primary art and 15-percent secondary, the latter of artists both currently and previously represented by the gallery. The standard for New York galleries is 50-percent primary, 50-percent secondary, with the latter segment being by far the more profitable.

Another difference brings into question how receptive New York collectors will be to some of Lisson's European and other international artists. The Irish-American painter Sean Scully was quoted in the *New York Times* (in the context of what museums show) as saying that global art "plays in London; it doesn't play in America." America was made "in an entirely different way," he said. "It hasn't colonized two-thirds of the globe, like the British did."[36]

A failed auction lot in November 2015 suggested another interpretation of what art is acceptable. Christie's New York postwar and contemporary sale offered *Naked Portrait on a Red Sofa* (1989–91), British painter Lucian Freud's sexually suggestive reclining nude image of his daughter Bella, which was burdened with a very high estimate of $20 million to $30 million. There were only two bids, nothing close to the reserve price, which was thought to be $16 million—even though the world-record price for Freud had been set in New York. The consensus after the auction was that it would have been better to offer *Naked Portrait* in London, because a British auction room would not have the "puritan and repressed American mores" that were triggered by the incestuous implication of the painting.[37]

Lisson's move to New York in 2016 came a few years after a rush by New York galleries to expand to London. David Zwirner has a 10,000-square-foot gallery in Mayfair, Pace has a 9,000-square-foot space behind the Royal Academy in Burlington Gardens, and Gagosian added a third space to his existing galleries on Britannia Street and in Mayfair. These and other expansions to London focus on visitors and on the city's ultra-rich, wealthy and minimally taxed non-domiciled Russian, Asian and Middle Eastern collectors. Nearly a third of London's six thousand residents with a net worth of more than $30 million (£18.5 million) are non-doms, including collectors Roman Abramovich (net worth £6.2 billion to $7.5 billion) and Victor Pinchuk (£1.2 billion to $1.4 billion).

A final potential benefit of multiple locations is pricing. Gagosian can charge a price premium, even on entry-level art (which his gallery only occasionally handles), because in making a purchase, the collector acquires both the art and the Gagosian brand. That is also true of other über galleries, although perhaps to a lesser extent.

Lisson's opening a new space in New York can be expected to improve the overall brand and image of the gallery such that the total return to a collector is greater. Can the value of the Lisson brand move to somewhere between Lisson now and Gagosian now? Will moving to New York improve how the gallery's current collectors feel about their past purchases? Will they now be more likely to say, "I bought this at Lisson?" Will auction houses be more likely to list Lisson in the provenance of the work being auctioned?

Economic theorists would say that Lisson's expanding to the centre

of the New York art world should increase consumer satisfaction and thus allow higher prices. A non-collector reading this will think the idea crazy; why would a post-expansion art purchase now provide greater satisfaction, or come at a higher price? The high-end collector understands the concept perfectly.

"You don't just buy your art, you buy your advisor and the advisor tells you what to do."

—Adam Lindemann, collector and dealer[38]

"When I think about private sales, I think about matchmaking–it's literally about arranging love."

—Amy Cappellazzo, former art agent[39]

THE ART ADVISER

AMY CAPPELLAZZO WAS FOR THIRTEEN YEARS CHRISTIE'S CO-HEAD OF POSTwar and contemporary art, and a top dealmaker. In 2014 she left the auction house to become an art adviser. She thought it worthwhile to step back from the pinnacle of the art world for an undefined profession already populated with more people offering consulting services than the market seemed able or willing to support.

She wanted to be more than an adviser. "Auction houses can never fully represent a collector's interests," Cappellazzo was quoted in *Vogue* as saying.[40] She continued, "What I want to do is build the best possible full-service business—not just one that makes the most money but one that can look after you the way Bessemer Trust or Guaranty Trust looked after your family."[41]

Cappellazzo wanted to perform some of the same functions as a sports agent: negotiate contracts and product endorsements, place art,

market the artist and create a client brand. She would help manage public relations, including websites and Twitter accounts; arrange finances and retirement planning; and file taxes in the multiple jurisdictions in which artists work. Perhaps most important, she would communicate and negotiate issues of importance with dealers, collectors and museums, as sports agents do with team owners, managers and coaches.

The professional sports agent analogy is apt. Think about artists rather than of athletes in any description of the role of the sports agent and ask, "Would this model find acceptance in the art world, at least with artists?" It would accomplish one thing it does for athletes: free them to focus on what they do best. But if an agent could arrange shows and art fair appearances and negotiate private deals, would an established artist need a dealer? Could Cappellazzo persuade artists to try a new arrangement, to change the structure of the art market?

She graduated from New York University in 1989 and did graduate work in architecture at Pratt Institute. In 1995 she moved to Miami to work as a curator at Miami Dade College Museum of Art + Design. She wrote art criticism, then briefly became a traditional art adviser. She worked with Don and Mera Rubell in setting up their art foundation, then had a role in starting the Basel Miami art fair.

In the late 1990s, Marc Porter of Christie's made her an offer she couldn't refuse. From 2001 she and Brett Gorvy ran the postwar and contemporary art department at the auction house. She became the public face of Christie's contemporary art. Her high-profile clients included Daniel Loeb, Dakis Joannou and Marc Jacobs. In a 2006 interview she offered the notorious "town bully" observation about her work at Christie's: "We're the big-box retailer putting the mom-and-pops out of business."[42] In a later interview she said she worked directly with 666 clients. To some that sequence of sixes would seem ominous, but if she included herself (she is a collector), the figure would be 667.

In 2011 she withdrew from co-managing the department with Gorvy to focus on finding new sources of revenue. She negotiated Christie's 2012 partnering with the Andy Warhol Foundation for the Visual Arts to sell the foundation's remaining inventory of Warhol art. "We basically said, 'We're now representing artists' estates.'"[43] Christie's then offered most of the Warhols online.

After resigning from Christie's in 2014 she joined adviser Allan

Schwartzman in Art Agency, Partners. Schwartzman was responsible for Bernardo Paz's Brazilian art park Inhotim, where he serves as creative director. He also assembled major collections for Howard Rachofsky, Nicolas Berggruen and Penny Pritzker. This chapter could as readily have begun with Schwartzman's role as an agent—except that the vision of a dramatically different model was first articulated by Cappellazzo.

Cappellazzo on occasion sounds like an investment banker. She cited Robert Rauschenberg as a profit possibility: "In the business world, you'd say Rauschenberg is an arbitrage buy right now, because [his] prices are so much lower than the potential value. His record at auction is about $14.5 million. Isn't that scandalous?"[44]

Many advisers have more traditional practices. One is Annelien Bruins at Tang Art Advisory in New York, Miami, London and Hong Kong. She consults on transactions and manages collections. "We save our clients time and money by doing the legwork for them," she has said, adding, "We keep up to date with artists, we source works for our clients, we perform price research and due diligence, we negotiate the transactions, and we have the works installed in our clients' homes."[45] That is a pretty good description of what most art advisers do now. Tang's fee structure is fairly traditional; for mid-level transactions, the firm charges a commission rate of 10 percent. For asset management there is a negotiated fee.

Another traditional adviser is Sandy Heller of Sanford Heller Art Advisory in New York. He is known for his work with Steven Cohen, Roman Abramovich and David Ganek. In 2006 he advised Cohen to purchase (from David Geffen) Willem de Kooning's *Woman III* (1952–53), for the then-astonishing sum of $137.5 million (see photo insert after page 96). Heller called it "the most important postwar painting that is not in a museum."[46] He also negotiated Cohen's 2007 loan to the Metropolitan Museum of Damien Hirst's stuffed shark, *The Physical Impossibility of Death in the Mind of Someone Living* (1991).

Several other high-profile auction personnel have started advisory firms that might alter the traditional model. In 2012, Simon de Pury left Phillips New York auction house, where he was an auctioneer and part-owner, to form de Pury de Pury, an advisory and curating consultancy. (The second de Pury is his wife, Michaela.) In Germany, Matthias Arndt founded Arndt Art Agency in 2015 to manage artists' careers and

85

advise collectors and museums. Two others who in 2015 founded firms offering private dealing and advisory services were Thomas Seydoux, who had managed Christie's Impressionist and modern art department, and Stephane Connery, who had headed Sotheby's private sales group.

High-profile advisers lever their connections with other collectors, dealers and auction houses to locate work coming to market—or not on the market at all. "Very sophisticated advisers will find you a [Jasper] Johns, they will find you a [Cy] Twombly … They're very quickly turning into dealers," collector Donald Marron has said.[47] They also have the clout to do more in verifying authenticity. A seller may reveal the identity of past owners of a work to an adviser who agrees to keep the information confidential.

Some galleries attempt to "place" work with collectors they trust not to immediately flip the work at auction. Many galleries say they will refuse to deal with and will blackball buyers who acquire a work and then flip it at auction for a profit; this harms the careers of the artists involved. There are two exceptions to "blackball for flipping." One is branded collectors too important to ignore. The second is important art advisers. The gallery is not willing to risk the future business they bring.

Advisers exploit another aspect of collector (and consumer) behaviour. When we are asked to choose among too many options for a product, we are sometimes overwhelmed and walk away. Collectors often face a "too much choice" situation at an auction preview or an art fair opening. Advisers say they never offer a collector more than three options for artwork at a time. "Sometimes less than three, never more." We are prepared to choose among three, but have a hard time with twenty.

There are many new advisers who carry a lower industry profile than those listed above; they were wonderfully described in *The Art Newspaper* as young girls with Louboutins and a Gmail account. The influx is driven by the needs of two client groups. The first are those from the financial world and start-ups who are wealthy but super-busy and use intermediaries to do their search and negotiation. The second are the Russian oligarchs, Chinese industrialists and Emirati collectors who treat art as an investment or at least as an asset class. They are perceived to require the same professional advice on this opaque market as they would on a stock or real estate investment.

Advisers (including dealers) are perhaps best understood as helping

collectors deal with the problem of information asymmetry. This is best illustrated with an example. Assume there are "great" Basquiat paintings that sell for $10 million (a huge underestimate, actually) and "ordinary" Basquiats that sell for $5 million (because even if ordinary, they are after all by Basquiat). If a collector can tell great from ordinary, no problem. If she cannot tell the difference, and the seller can, there is information asymmetry, and a problem. The collector might think she can hedge her potential loss by offering $7.5 million, but the seller will never sell at that price if the painting is great, only if it is ordinary. The seller will happily sell either a great or an ordinary for a $10-million bid.

So the collector finds it worth the cost of an adviser to reassure her about great and ordinary status; the adviser's fee is less than the almost-certain loss. There is also huge potential for an intermediary to purchase an "ordinary" for $5 million, if the intermediary can persuade a potential purchaser that it is really a "great." Or that there is potential for an über dealer or an auction house to brand the painting "great" based on personal or house reputation.

Some advisers are paid a flat fee, others are on retainer at an hourly rate, but most work on commission. Art writer Kenny Schachter says commissions on work above $20 million to $30 million are typically 2 to 4 percent of the purchase price. One higher agent fee became public as a consequence of the Bernie Madoff fraud trial. Ben Heller, who acted as an adviser to financier and collector J. Ezra Merkin (who had invested with Madoff), earned a $26.5-million fee in 2009 for negotiating the sale of the Merkin collection of Mark Rothko paintings to Qatar Museums. This represented about 8.5 percent of the reported acquisition price. With prices in the tens of millions of dollars for trophy art, any of these percentages can produce an exponential increase in income for former Christie's or Sotheby's specialists

Another agent fee became public in court documents involving the sale in 2015 of Picasso's *Buste de Femme* (Marie-Thérèse) (1931). There was controversy over ownership of the sculpture; one reported sale for €38 million ($42 million) was to Sheikh Jassim bin Abdul Aziz al-Thani, husband of Sheikha al-Mayassa of Qatar. The commission on that, paid to the now-dissolved art agency partnership Connery Pissarro Seydoux, was €4.5 million ($5.5 million), or 11.8 percent.

In this crowded field, Cappellazzo envisioned a full-service model **87**

for artists and dealers, museums and galleries, collectors and speculators, unlike anything that then existed. I describe her vision in the past tense, because as mentioned above, in a January 2016 move that surprised the auction world, Sotheby's announced it had acquired her Art Agency, Partners as a wholly owned subsidiary of the auction house. There were tie-up contracts for Cappellazzo, Schwartzman and third partner Adam Chinn. Chinn is not from the art world; he is a co-founder of the investment bank Centerview Partners and a former partner at the law firm Wachtell, Lipton, Rosen & Katz.

The purchase amount was $85 million—with $50 million paid upfront, essentially as a signing and retention bonus. There are additional payments up to $35 million if financial targets are met over a five-year period. The shock aspect of the announcement involved the amount. Sotheby's had just completed a round of buyouts in which about eighty people left the auction house. It was hard to understand how the house could make money on the purchase, given the huge upfront payment.

In a conference call with analysts and investors, Sotheby's CEO Tad Smith was joined by Cappellazzo and Schwartzman. They said the acquisition was part of a strategy to increase Sotheby's presence and revenue in advisory services, to expand its services in art consulting, private purchases, art-related estate planning and art investment.

This was a bold approach, motivated by an art world where the richest 1 percent of Sotheby's art customers purchase as much as the remaining 99 percent. It wasn't clear how such fees would be received by a 1 percent that previously received services free from the auction house. How valuable the advice would be coming from advisers who are seen as biased toward transactions through Sotheby's auctions and private dealing was also not obvious. Finally, Sotheby's has upward of three hundred employees; the idea that the auction house did not already have the in-house skills to perform these functions well is telling.

AAP's investment fund, which had raised $125 million and invested just over half that in artworks, was achieved in less than two years, and probably had made AAP the second-largest art investment fund in the world—an indication of Cappellazzo and Schwartzman's connections and clout.

Although AAP would no longer offer full-service advising as an independent agency, other agencies were certain to try to fill the gap,

particularly given the favourable response to Sotheby's acquisition and because Art Agency is now out of the artist-representation field. When Brett Gorvy left Christie's in December 2016 to partner with dealer Dominique Lévy, the new Lévy Gorvy dealership was described as a "new bespoke advisory," working closely with artists' families, foundations and estates. The press release read like a cross between a dealer and Cappellazzo's agency model.

Most dealers were understandably unenthused about Cappellazzo or anyone else taking taking on the role of advising their artists (or their collectors) on how to achieve career goals, and would be less happy if an auction house tried to. If a super-agent can provide these services to Jeff Koons, or even to established, mid-level artists, what remains for the traditional dealer? The über dealers—Gagosian or Pace or Zwirner or Hauser & Wirth—can all afford to lose an artist without threat to their individual galleries' future.

The threat is greater when a mainstream dealer loses a mid-level successful artist. The profit model for the mainstream dealer is that for every ten new artists she represents, on average four will not be well received by collectors and will leave the gallery after one or two shows. Three will show for a few years before dropping out. Two will have long, moderately profitable careers. At best, one will be well received. The one well-received artist has to generate enough profit to justify the dealer's investment in the other nine. If that one artist moves to an adviser (or is poached by an über dealer), the mainstream gallery's profit model is threatened.

The concern most often floated about advisers, and especially about the new model, is that they will also act as private dealers, recommend the work of artists that they represent or sell work from their own inventory. When advisers also act as dealers (or in Cappellazzo's case as an employee of an auction house), they transgress one of the rules of the Association of Professional Art Advisors. That involves avoiding the perception of possible conflict of interest.

The agent-who-is-also-a-dealer problem was the subject of one of the most talked-about art disputes of 2015, one that at the time of writing was being shopped as a movie. The case involved Yves Bouvier, a Swiss freeport warehouse owner and art adviser/dealer, and Dmitry Rybolovlev, a businessman from the Urals region of Russia and one of

89

that country's wealthiest persons. Rybolovlev is almost a caricature of the popular image of a Russian oligarch living in the West—one reason why this saga might make a good movie. In recent years he purchased Donald Trump's Palm Beach mansion through a limited liability company for $95 million, Sanford Weill's Manhattan condo for $88 million and then the Greek island of Skorpios from the Onassis family for an undisclosed amount. The latter two transactions were via a trust owned by his daughter Ekaterina. In 2016 he had the 61,000-square-foot Trump French provincial Palm Beach home—which he had never occupied—torn down. Over the same period, Rybolovlev's former wife, Elena, was awarded a reported $4.5 billion after a seven-year divorce battle.

Using offshore companies, Rybolovlev spent $2 billion over an eight-year period to purchase forty works of art through Bouvier—by Picasso, Modigliani, Rothko, Leonardo da Vinci, Gauguin, Matisse and Rodin. The Rybolovlev-Bouvier feud that ensued has several components. One is the accusation by the Rybolovlev's family trust that Bouvier, as part of assisting in the acquisition of art, overcharged by just over $1 billion for the purchases. Read that again and be awed: a collector sued because he was overcharged $1 billion on $2 billion of art purchases.

Rybolovlev says he believed Bouvier was acting as an agent in the transactions, negotiating the best price and charging a 2-percent fee. Bouvier claimed it should have been clear he was functioning as a private dealer, purchasing art and reselling to Rybolovlev for whatever he could negotiate.

Another allegation is that Bouvier misled Rybolovlev about the acquisition cost of a Modigliani painting for which Rybolovlev was charged $118 million. Rybolovlev said that he encountered art adviser Sandy Heller over lunch during a Caribbean vacation. He asked Heller the normal opening question in such an encounter, "What was the last lot you sold?" Heller mentioned the Modigliani. Rybolovlev asked the selling price, and after checking for permission with his principal, Steve Cohen, Heller responded that it was $93.5 million. This implied that Bouvier had taken the difference, $24 million, as an undisclosed profit. In January 2015, Rybolovlev filed a criminal complaint in Monaco, asserting fraud and other misdeeds; the case was ongoing as this was written.

Less dramatic than fraud is the concern that an adviser might take two fees on arranging a sale, one from the client and another from

the seller. Dealers reveal that agents previously unknown to them call asking for assurance that a fee will be paid if they introduce a client. Unspoken is the outcome: no prior fee arrangement, no client. Some galleries agree in the hope of reaching new collectors. Nicholas Logsdail takes an extreme position. He requires any agents requesting fees to sign an undertaking that they have informed their clients of the fees and the amount.

If advisers don't disclose a third-party fee to clients—with or without a written undertaking to do so—they may have breached their fiduciary duty to reveal a possible conflict of interest. Fiduciary duty requires the dealer to act solely in the other party's interests. Auction houses and galleries are fiduciaries to their consignors (but not to buyers). Primary dealers are fiduciaries to their artists. Museum directors and trustees are fiduciaries to their institutions.

Annelien Bruins says of her approach, "[We] never get remunerated by both parties of one transaction ... We don't operate on two sides of one transaction." If both parties to a transaction were clients, "We would ensure that one of our clients is referred to a colleague art advisor and/ or an art lawyer, and we would be completely open to both of our clients about the situation."[48]

Amy Cappellazzo was not a member of the art advisers' association; she said she disagreed with the concern about owning art for resale. She insists one can both advise and own. "I don't think you can eliminate conflicts in the art world, all you can do is to be transparent."[49] Presumably this is the position she is taking at Sotheby's.

The other disruptive innovation in the art chain is the 2015 decision by the United Talent Agency to go into the business of representing fine artists. UTA represents actor Harrison Ford and film directors Joel and Ethan Coen, among others. What can UTA do for fine artists that it already does for these individuals? "I'm interested in artists who are re-envisioning the way to make art and re-envisioning how people experience it," said Joshua Roth, the lawyer-turned-agent who is developing the fine-arts area at UTA. "We want to help find opportunities for artists outside of the gallery."[50] Think of an even broader version of the sports agent model, promoting an artist's brand across markets like a basketball star—or a fashion brand.

UTA is involved in film finance, film packaging, branding, licensing, **91**

endorsements and representation of production talent. It owns UTA Brand Studio, a brand strategy group, and broadcast news agency Bienstock. United Talent's first fine-arts project was *Maurizio Cattelan: The Movie*, a documentary about the Italian contemporary artist by filmmaker Maura Axelrod. The Cattelan documentary is what the agency refers to as cross-pollination of art. UTA arranged financing and acted as a sales agent at film festivals. Cattelan has gallery representation with Marian Goodman in New York and Emmanuel Perrotin in Paris.

United Talent is not the first agency to represent visual artists. William Morris Endeavor represents artist Takashi Murakami for TV and films. Creative Artists represents New York artist Daniel Arsham for films; its first movie venture for Arsham, *Future Relic*, premiered at the Tribeca Film Festival in 2015.

Will the new role of adviser disrupt the existing artist-dealer relationship? One dealer predicted a likely ménage à trois, absent the sex but with many of the same complications. Another dealer suggested that many current galleries would simply become exhibition spaces.

TEARS IN THE MARKET FABRIC

"The rule [on purchasing art] is caveat emptor, repeated twice."

—Supreme Court of New York, 2015

PERELMAN V. GAGOSIAN

THE TIGHT AND COZY HIGH END OF THE CONTEMPORARY ART MARKET would seem to be a place where disputes would be worked out quickly and quietly, over a glass of good wine and with assurances of absolute discretion and no publicity. Not always so. Some disputes are settled through expensive and public litigation. As a low-end estimate, there are sixty lawyers and litigators working on art cases in New York City at any given time—on transactions, art-related disputes, taxation issues, or researching legal and cultural status. If even sixty lawyers with their support teams bill more than $1 million each a year, the annual amount spent litigating and settling art disputes in one city exceeds the value of annual art sales in Canada.

This chapter is a tale of two transactions and two legal skirmishes, and of the different standards that apply in the parallel universe that is the contemporary art market. Both skirmishes involved the same parties,

96 New York collector Ronald Perelman and dealer Larry Gagosian. Each case presented conflicting views of the art market, held by individuals wealthy enough to pursue the matter in a public forum. Each litigant was famous enough that the cases attracted media coverage. The outcome of each case was almost exactly what the contemporary art world thought it would be. Not should be, but would be.

Partial disclosure: I served briefly as an adviser to one party in one of the two cases mentioned. The information below comes solely from public statements by the parties, from court filings and decisions, and from comments in news reports.

Ronald Perelman is the CEO and sole owner of the holding company MacAndrews & Forbes. The companies in MacAndrews' portfolio include Revlon, Scientific Games, and Flavors. In 2014, Perelman ranked fifty-fourth in the Bloomberg list of the world's wealthiest individuals, with a reported net worth of $15.2 billion. Perelman collects art. According to the *New York Times*, his collection is valued at over $1 billion and includes Andy Warhol, Cy Twombly and Roy Lichtenstein. Some of the art hangs in his office, some in his Manhattan townhouse, some in his East Hampton estate and some on his 257-foot yacht.

Although I (and most media reports) refer to Perelman as the art buyer in the transactions discussed below, the actual purchaser was the MAFG Art Fund, a limited liability company used by the MacAndrews corporate group to invest and trade in art. The fund has a curator. The fund and Perelman are very much art-world insiders.

In 2012 and again in 2014, Perelman said that he wanted to expose what he called the "dirty" side of buying and selling high-end art, and that he would do it through lawsuits involving his dealer, Larry Gagosian. Perelman's first lawsuit, in September 2012—which I will call the *Popeye* suit—accused Gagosian of concealing material information and manipulating art prices in regard to Perelman's purchase of a granite version of Jeff Koons' *Popeye* sculpture. (This is another version of the *Popeye* that was shown in Koons' retrospective at the Whitney.) Later, in what I will call the *Paphos* suit, Perelman accused Gagosian of defrauding him in an exchange of paintings.

Perelman said in the first suit that he and Gagosian had been friends and business partners for many years. They visited each other's homes, attended the same social events and invested together in the Blue Parrot

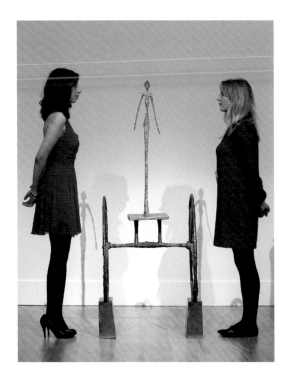

‹

Alberto Giacometti, *Chariot* (1950).
Painted bronze on wood base,
57 × 26 × 26 inches (145 × 66 ×
66 cm), base 9¾ × 4½ × 9¼ inches
(24 × 12 × 24 cm). © Estate of
Alberto Giacometti/sodrac (2016).
Sotheby's London employees pose
next to *Chariot* during a 2014 press
preview. Photo by Carl Court/
Getty Images.

∨ Amedeo Modigliani, *Nu couché* (1917–18), oil on canvas, 23.6 × 36.2 inches (60 × 92 cm),
photographed at Christie's sale, New York, November 9, 2015. Work is public domain, image
accessed through Wikimedia Commons.

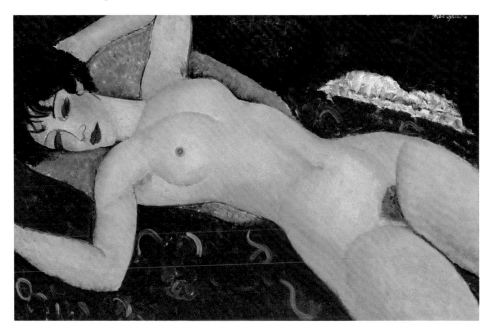

▲ Adrian Ghenie, *Nickelodeon* (2008), oil, acrylic and tape on canvas (in two parts), each 94 × 82 inches (238 × 207 cm), overall: 94 × 166 inches, (238 × 414 cm). © Adrian Ghenie, courtesy Pace Gallery. Photo courtesy Galeria Plan B, Berlin.

▼ Jeff Koons, *Balloon Dog (Orange)* (1994–2000), mirror-polished stainless steel with transparent colour coating, 121 × 143 × 45 inches (307 × 363 × 114 cm). One of five unique versions (Blue, Magenta, Orange, Red, Yellow). Courtesy of the artist, © Jeff Koons, photo Tom Powel Imaging.

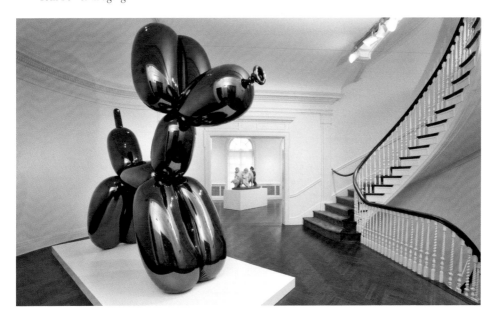

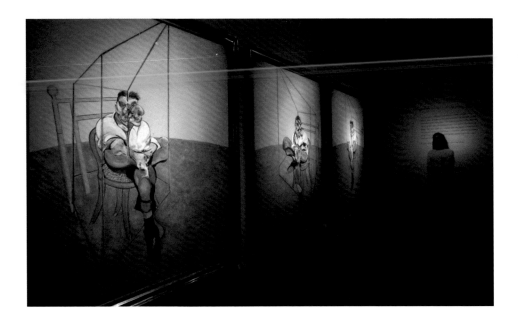

∧ Francis Bacon, *Three Studies of Lucian Freud* (1969) (titled and dated '3 studies for portrait Lucian Freud 1969' on the reverse of the centre panel) triptych, oil on canvas, each: 78 × 58 inches (198 × 147.5 cm). © The Estate of Francis Bacon. All rights reserved. DACS/SODRAC (2016). A member of Christie's staff with *Three Studies of Lucian Freud* in 2013. Photo credit Peter Macdiarmid/Getty Images.

‹

Christopher Wool, *Apocalypse Now* (1988), enamel and flashe on aluminum, 84 × 72 inches (213 × 183 cm). © Christopher Wool. Courtesy of the artist and Luhring Augustine, New York.

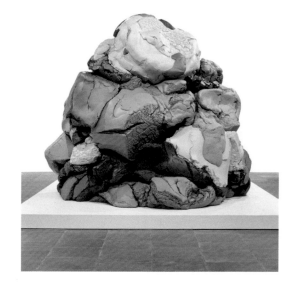

> Jeff Koons, *Play-Doh* (1994–2014),
> polychromed aluminum, 123 ×
> 152.25 × 137 inches (312 × 387 ×
> 348 cm), courtesy of the artist, © Jeff
> Koons, photo Tom Powel Imaging.

Jeff Koons, *Jim Beam–J.B. Turner Train* (1986), stainless steel, bourbon, 11 × 114 × 6½ inches (27.94 × 289.56 × 16.51 cm), shown prior to an April 2014 auction at Christie's New York. Each of the seven train cars holds a fifth of bourbon. Credit Christie's, Andrew Cowie/AFP/ Getty Images.

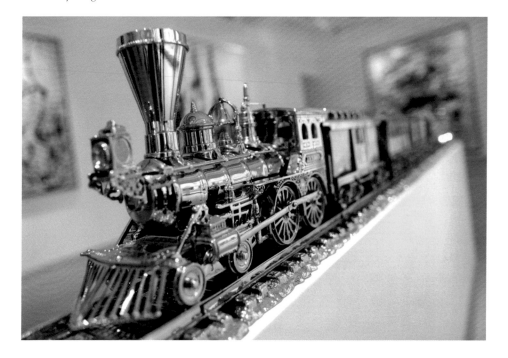

▲ Ryan Gander, *Your Bolstered Voice* (dramaturgical framework for structure and stability) (2016). Stainless steel, brass, aluminium wire and plastic sleeving. 73 × 47 × 10 inches (186 × 120 × 26 cm). From the exhibition *I see straight through you* at Lisson Gallery New York, 2016. Photo credit Jack Herns, image courtesy Lisson Gallery, London.

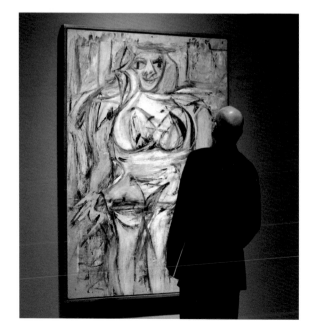

❮
Willem de Kooning, *Woman III* (1952–53), oil on canvas, 68 × 48 inches (173 × 123 cm), one of six paintings by de Kooning done between 1951 and 1953 in which the central theme was a woman. Photo is from a media preview in April 2009 of an exhibition at Sotheby's New York entitled *Women*. © Estate of Willem de Kooning/ SODRAC (2016). Photo credit Timothy A. Clary/AFP/ Getty Images.

▲ *Chanel Mobile Art*, 700 sq. m, 165,000 kg building for mobile art by Chanel. Designed by Iraqi-born British architect Zaha Hadid, shown in central Hong Kong in 2008. Photo credit Stefan Irvine/LightRocket via Getty Images.

▼ *Converse Campbell's Soup Can Sneakers* (2015). Sneakers are part of Spring 2015 Converse Chuck Taylor Andy Sneaker and Apparel Collection. Photo by Converse.

∧ HyunRyoung Kim, *Untitled 15* (2013), acrylic on canvas, 48 × 36 inches (122 × 91 cm), image and photo courtesy HyunRyoung Kim.

∧ Jean-Pierre Roy, *Entopticon 1* (2016), oil on linen, 48 × 48 inches (122 × 122 cm), image and photo credit Gallery Poulsen Copenhagen and the artist.

∨ Bernard Arnault, Fondation Louis Vuitton museum in Paris (2014), architect Frank Gehry. Credit Fondation Louis Vuitton, photo Andia/UIG from Getty Images.

Damien Hirst, *The Golden Calf* (2008), glass, gold, gold-plated stainless steel, silicone, calf and formaldehyde solution with Carrara marble plinth, 157 × 138 × 66 inches (399 × 351 × 168 cm) including plinth. © Damien Hirst and Science Ltd., all rights reserved, SODRAC 2016. Photo credit Prudence Cuming Associates. The title refers to the Exodus account of the Israelites' idolatrous worship of a Golden Calf during Moses's absence. As in traditional artistic depictions of the idol, Hirst's calf is crowned with a sun disc of solid gold, a symbol of pagan deification.

Edwin Long, *The Babylonian Marriage Market*, oil on canvas (1875), 68 × 122 inches (172 × 304 cm). Photo is public domain, accessed through The Yorck Project: 10.000 *Meisterwerke der Malerei*, distributed by DIRECTMEDIA Publishing GmbH, licensed under the GNU Free Documentation License.

restaurant in East Hampton, New York. Perelman said Gagosian had been an art adviser and mentor to him; he said that over a thirty-year period he had purchased or sold two hundred works of art through Gagosian and traded fifty works in "exchange transactions." He said he trusted Gagosian because of their long history and the dealer's "unparalleled knowledge and dominant position in the art world."[51] The value of commissions involved with that number of transactions suggests that a dealer should make extraordinary efforts to retain his customer's goodwill.

Larry Gagosian, the long-time friend, is the world's most dominant art dealer—whether ranked by influence, number of galleries or annual sales. He has galleries in New York, London, Paris, Los Angeles, Rome, Geneva, Athens and Hong Kong. Gagosian represents seventy-four artists, and "works with" twenty-nine others—meaning he shares them with other dealers. His galleries have about $1.1 billion in worldwide sales annually, $3 million for each working day of the year. He accounts for about 2 percent of the world contemporary art market, and 10 percent of the high end of that market.

Central to the Perelman argument in the *Popeye* case is the assumption that Gagosian branding added to that of an artist means ever-increasing prices. Other than that, it is unclear how Gagosian's power might translate when it comes to a collector as knowledgeable and wealthy as Perelman. Power for a dealer is the ability to ignore a collector who wants to acquire a work, or to rank the collector low on a waiting list for a hot artist. Neither is likely to be exercised against a collector of Perelman's stature.

In the first, May 2010 suit, Perelman claimed that his art fund had committed to pay Gagosian $4 million, in five $800,000 instalments, for Koons' granite *Popeye*. The sculpture was to be created in a series of three; this would be number two. The estimated—but not guaranteed—delivery date was December 2011. Like all of Koons' recent sculptures, this had been pre-sold prior to fabrication. Koons gave Gagosian the right to sell version one, and New York's Sonnabend Gallery the right to sell version number two. The intermediary for version three was not revealed; it might have been an agent.

It was later revealed that at the time of the purchase agreement with Perelman, Gagosian had already sold the version Koons had allocated to him. Gagosian acquired the Sonnabend version two and a half weeks after

97

executing the sales contract with Perelman. The payment terms on which
Sonnabend sold the sculpture to Gagosian were disclosed in a court
filing. They were identical to those in the agreement between Perelman
and Gagosian: $4 million to be paid in five instalments of $800,000.

In January of 2012, eight months after the Popeye sale agreement,
Gagosian disclosed to Perelman a new feature of his contract with Koons.
Gagosian had agreed to rebate to the artist 70 percent of the profit from
any resale to a third party at more than the original sale price. The con-
dition was valid for two years after signing the contract with Koons. For
a further five years, a resale through Gagosian required that 50 percent
of the profit be paid to Koons.

The Sonnabend purchase agreement also included the "70 percent
rebate-on-resale" provision. This became binding on Gagosian with the
purchase. The Sonnabend agreement also allowed Koons to change the
completion date for *Popeye* "due to delays in fabrication or other reasons."

Perelman claims that when he learned that Koons would miss the
scheduled delivery date he decided to exchange the sculpture for a paint-
ing. He argued that *Popeye* was worth as much as $12 million on comple-
tion. That estimate turned out to be low by at least 50 percent. Perelman
asked Gagosian for a credit of between $4 million and $12 million on
return of the sculpture, to reflect his period of ownership. Essentially
Perelman wanted to flip the sculpture for a profit during the period Koons
was still completing it.

Gagosian told Perelman that he had little incentive to take back the
rights to *Popeye* so long as the profit-sharing arrangement was in effect.
Perelman argued that Gagosian knew Perelman bought works as an in-
vestment and might have been expected to want to flip *Popeye*. He said
Gagosian was the preferred source for Koons works, that sales through
other channels brought lower prices, and that the rebate arrangement
prevented him (Perelman) from getting the best possible price on resale.

Perelman claimed that Gagosian used the profit-sharing arrangement
to justify a trade-in value for *Popeye* of "only" $4.25 million. Gagosian
resold the option to an unnamed buyer for $4.5 million, credited $4.25 mil-
lion to Perelman, and presumably forwarded either $350,000 (70 percent
of a half-million profit) or $175,000 (70 percent of $250,000) to Koons.

New York State Supreme Court Justice Barbara Kapnick ruled that
while Perelman might have assumed he would be able to resell *Popeye*,

nothing in the original sale created an expectation that Gagosian need be involved. "In essence, plaintiffs' breach of contract action alleges that, 'with the benefit of hindsight, [he] appears to have entered into a bad bargain,'" Kapnick concluded.[52]

The more publicized of the two legal battles concerned Perelman's second claim, about a blue Cy Twombly painting, *Leaving Paphos Ringed with Waves* (1) (2009). According to court filings, this chapter of the saga began with Perelman visiting the Gagosian gallery on Madison Avenue in April 2011. Perelman asked about *Paphos*; Gagosian said it was available for $8 million. An opening offer to a long-term client would usually be subject to negotiation; Perelman counter-offered a reported $6 million.

A week later, Perelman approached Gagosian with a higher offer. Gagosian said the painting had been sold, but did not identify the purchaser or price. Gagosian told Perelman that if he still wanted the work it might be available at $11.5 million. Four months later Perelman offered $10.5 million. After obtaining agreement from the new owner, Gagosian accepted.

The first purchaser was later identified as New York's Mugrabi family, known to be collectors and private dealers on a massive scale. They acquired *Paphos* through a corporation in the Cayman Islands. The Mugrabis were reported to have purchased it for $7.25 million, payable part in cash and part by relinquishing their share of art co-owned with Gagosian. The resale price meant that the Mugrabis and Gagosian shared $3.25 million in profit and commission.

Perelman claimed that the sale to Mugrabi was a sham, aimed at jacking up the price: "The striking jump in price, the lightning-fast chronology of events and the absence of a typical invoice for the sale, all call into question the propriety and bona fides of the sale."[53] Gagosian's lawyers responded that the Mugrabi purchase was an "arm's-length transaction"[54] that was supported by invoices and documentation. Perelman said Gagosian had claimed that the asking price of $11.5 million for *Paphos* was supported by recent sales but Gagosian had not produced any market data.

Perelman's lawyers issued subpoenas to Gagosian and to Jose, David and Alberto Mugrabi. All gave depositions. The lawyers apparently also subpoenaed auction houses Sotheby's, Christie's and Phillips. None of these interviews took place. Investigators from Perelman's law firm

99

questioned other dealers and some of Gagosian's artists. The *New York Times* estimated that Perelman had spent $3 million on lawyers and investigations.

Whether they sympathized with Perelman, Gagosian or neither, many dealers, collectors and art-world media were intrigued by the legal proceedings. Some hoped a release of documents in the case would provide insight to the contracts and conditions that characterize the high end of the market.

Those following the case also hoped it would clarify the degree to which the legal assumption of an implied covenant of good faith and fair dealing applies to high-end art contracts. There was no clarification. Good faith means that neither party to a contract takes actions to frustrate the other's benefits from that contract—for example, Gagosian entering into a contract with Sonnabend that might limit Perelman's resale price. The final court ruling on *Paphos* dealt only with the issue of fraud. It did not make public any of the confidential documents.

In February 2013, Justice Kapnick dismissed five of the six claims in the *Paphos* case, including deceptive business practices and breach of fiduciary duty. She said Perelman had more than twenty years' experience in art investing; his advisers were "experienced and sophisticated business investors who entered into negotiated, arm's-length transactions." Given this history, their "subjective claim of reliance" on Gagosian's expertise did not produce a trust relationship.[55]

She allowed a single fraud claim to go forward, that Gagosian had misrepresented the value of works of art sold to Perelman. Justice Kapnick said that the allegation that Gagosian and his gallery had "superior and unique" knowledge of the art world was enough for the fraud claim to be heard in a trial.

In December 2014 a five-judge appeals court panel dismissed this final fraud claim and precluded a trial. The judgment said that the parties had negotiated at arm's length and did not owe fiduciary duties to each other. Most important for future art transactions, Associate Justice David Friedman wrote in the opinion, "As a matter of law, these sophisticated plaintiffs cannot demonstrate reasonable reliance because they conducted no due diligence ... They did not ask defendants, 'Show us your market data.'"[56] The MAFG Art Fund sought permission from New York's highest court to appeal the Friedman decision. In March 2015 the motion for

leave to appeal was denied without reasons, affirming that the court found no error in Justice Friedman's decision.

The *Paphos* outcome is as applicable to moderate-price art sales as to those by Gagosian. An art dealer apparently cannot be successfully sued over a statement about the value of a work of art, irrespective of how inaccurate the statement is, so long as due diligence is possible. For most artists, price data exists on previous sales, either online or in the hands of the seller.

The *Popeye* and *Paphos* cases highlight the role that trust plays in the decisions that collectors make—and the consequences when there is no longer trust. The next chapter highlights the repercussions when there is misplaced trust—victimizing collectors, dealers and museums—and the degree to which the art market relies on reputation and status.

"What few art professionals seem to want to admit is that the art world we are living in today is a new, highly active, unprincipled one of art fakery."

—Thomas Hoving, former director of the Metropolitan Museum of Art[57]

"Produced ... by the hands of a genius."

—FBI statement on art forger Qian Pei-Shen

THE
KNOEDLER
FAKES

THE SUBJECT OF THIS CHAPTER IS ONE THAT FEW IN THE ART WORLD WANT to talk about: a master forger and his long-undetected fakes. I include this in a book about authentic contemporary art because understanding art crime—the perpetrators, collaborators and victims—says a lot about the environment where art forgery takes place.

In 2016, Chinese artist Qian Pei-Shen was exhibiting at the BB Gallery in Shanghai. He worked for many years in Woodhaven, in suburban New York City. In 2013 he was one of the most-talked about artists in the United States, better known there than he was in China.

His sudden fame came with the discovery that Qian had created, over a fifteen-year period, at least sixty-three works in the style of nine different American abstract expressionist artists: Willem de Kooning, Franz Kline, Lee Krasner, Robert Motherwell, Barnett Newman, Jackson Pollock, Mark Rothko, Clyfford Still and Richard Diebenkorn. Forty

104 of Qian's paintings were sold through Knoedler & Company, an Upper East Side New York gallery that closed permanently and without notice in November 2011 after 165 years in business. Another twenty-three paintings were sold through Julian Weissman, a New York dealer who had previously worked at Knoedler. All sixty-three were represented by the selling gallery as authentic. The fakes illustrate how much easier it is to replicate twentieth-century abstract and expressionist styles than it is to copy earlier styles and materials.

In September 2013, New York private art dealer Glafira Rosales pleaded guilty in US federal court in Manhattan to knowingly selling Qian's fake art to the two galleries. She also pleaded guilty to evading taxes on at least $12.5 million of proceeds from her sales. Without the guilty plea, prosecutors would have had to prove both that the works were fake and that Rosales knew they were.

It is not illegal to copy paintings, or to add a signature, or to possess a fake, or to sell one. What is against the law is offering a fake for sale as an original when you know it is not. Rosales was scheduled to be sentenced in mid-2014, and faced a possible thirty-four-year jail term. As of late 2016 there had not been a sentencing. One New York lawyer told me that there was more interest in postponing it, keeping the Rosales case alive in the hope co-conspirators could be brought to justice.

Rosales said as part of her guilty plea that the works were created "by an individual in Queens [New York]."[58] She did not name the artist; a *New York Times* article identified him as Qian Pei-Shen. Later, Qian admitted creating the art but he said he had no knowledge of the fraud. He returned to Shanghai, where he has had several shows of his own signed work.

Knoedler was founded in 1848 as a subsidiary of the French lithographer Goupil & Cie and located on East 70th Street. By the beginning of the twentieth century, the gallery was a major dealer in Old Master paintings. The Getty Museum in Malibu, CA, refers to Knoedler on its website as "a central force in the evolution of an art market in the US." (The Knoedler Gallery's archive was gifted to the Getty in 2012.) In the 1950s, Knoedler began to sell Impressionists. The gallery received some publicity in 1958 when then director E. Coe Kerr advertised a 1948 Matisse that turned out to be by the famous forger Elmyr de Hory.

Rosales met Ann Freedman, the then-new president of Knoedler, in

1994. In early 1995 Rosales offered Freedman a Qian Mark Rothko for $200,000. Freedman bought the work herself and later purchased from Rosales a Motherwell for $20,000 and a Pollock for $300,000. All three prices were well under auction values for similar works at the time.

Freedman and later Weissman were told that Rosales was acting as an agent for Mr. X, a Mexico City and Zurich resident who wanted to dispose of his collection quietly. Over time the story expanded to say X inherited the art from his father, X Sr., who had assembled his collection through New York dealer David Herbert with whom he had a homosexual relationship. Herbert died in 1995. There was a second Rosales version that the owner was John Gerzso, son of Mexican artist Gunther Gerzso who died in 2000. The person who helped assemble the collection was then identified as Filipino painter Alfonso Ossorio, a Jackson Pollock patron. There was no other provenance for any of the works brought to Knoedler.

Rosales paid Qian between $5,400 and $7,000 for each painting he created. The sixty-three paintings that Knoedler and Weissman sold brought a total of at least $80 million. Rosales was said to have grossed $33 million on the sales. The dealers received $47 million. Agents who introduced buyers received several million in commission from dealers. It was stated in court that Freedman received $10.4 million as her share of gallery profits on the Qian sales, this in addition to her average yearly base salary of $300,000.

Victims of the fraud included several dealers, many prominent collectors and two museums. In 2007 John Howard, who runs private equity firm Irving Place Capital, paid Knoedler $3.5 million for a Qian de Kooning. Knoedler had paid Rosales $750,000. Rosales had paid Qian $7,000. Howard defended his logic: "Here I am dealing with the Knoedler gallery, one of the most prestigious galleries in the US ... If this person was selling these things on the street, we wouldn't buy it. But this is the Knoedler gallery."[59]

Knoedler lawyer Charles Schmerler countered in court filings that Howard and other purchasers did not authenticate the paintings on their own, contrary to their "obligations as sophisticated art collectors." He said the gallery provided an opinion on the provenance only to assist buyers, who were expected to make their own inquiries.

Howard responded that the Schmerler/Knoedler argument was that **105**

"their victims are themselves to blame for trusting [the gallery]." Lawyer Peter Stern offered an analogy: "If I go to Tiffany's and buy a diamond, I don't expect to have to take it to a gemologist."[60] The issue is whether buyers—knowledgeable or not—can rely on a dealer's due diligence and the information made available prior to a sale. It is a variation of the issue raised in the Perelman-Gagosian case.

Art adviser Jaime Frankfurt acted as an agent in the sale to Howard. When Frankfurt learned of the alleged deception he returned his $500,000 commission, which was about seventy times what Qian had been paid for creating the work. Dealer Richard Feigen was also an intermediary in selling a Knoedler fake. He also returned his commission, then sued Knoedler and Freedman. That case settled privately.

Howard and others filed nine other lawsuits against the gallery and Freedman. Other publicly identified plaintiffs include Domenico De Sole, the retired CEO of Gucci and current chairman of Sotheby's, and his wife, Eleanore. They paid $8.3 million for a Rothko. Nicholas Taubman, the former US ambassador to Romania, paid $4.3 million for a Clyfford Still. Knoedler had paid Rosales $950,000 for the Rothko and $600,000 for the Still.

Ann Freedman stated in a court filing that she showed the paintings brought by Rosales to "approximately fifty renowned art experts." She said that some "unambiguously conveyed that the works were genuine."[61] She on several occasions cited Robert Motherwell's wife, the artist Helen Frankenthaler, as viewing one of the fakes and saying "Yep, it's Bob."[62]

The other experts Freedman listed (without identifying the some who agreed "the works were genuine") included E.A. Carmean, former curator of the National Gallery of Art, and Mark Rothko scholar David Anfam. Anfam, an expert on abstract expressionism and author of the Rothko catalogue raisonné, later stated that he had never authenticated the works but had written a positive email to a Buffalo museum that was considering acquiring what turned out to be a Qian Barnett Newman. The Dedalus Foundation wrote in 2007 that it would include a Motherwell in its next compendium of that artist's work. Two years later it wrote to say the work would not be included.

The De Soles said in a pretrial statement that "every independent witness ... confronted with [the statements Freedman cited] ... denied making them."[63]

The late art dealer Ernst Beyeler authenticated two of the Qian Rothkos, describing one as "sublime," and exhibited them at the Fondation Beyeler in Basel. David Mirvish, a Canadian collector and former dealer, brought artist Frank Stella to Knoedler to see the paintings. Freedman in her court testimony quoted Stella as concluding that each painting looked too good to be true, but seeing them in a group, in context, convinced him that they were authentic.

Scholars requested some of the paintings for exhibit. Fifteen works were shown at leading art fairs. The Solomon R. Guggenheim Foundation borrowed what turned out to be a Qian Barnett Newman, for exhibit in 2007–08 at the tenth anniversary show of the Guggenheim Bilbao Museum. Two Qian Pollocks were stamped with the Pollock-Krasner Foundation copyright, meaning that the foundation had verified them. These were included in a book about the artist, published by Taschen.

Jack Flam, president of the Dedalus Foundation—which updates the Motherwell catalogue raisonné—said he told Freedman in December 2007, "We believed ... [the Rosales Motherwells] were not authentic."[64] Several other experts questioned individual artworks or their backstories. The Richard Diebenkorn Foundation challenged several works, and later informed the Kemper Museum of Contemporary Art in Kansas City that a Diebenkorn acquired in 1997 for $110,000 was not authentic.

The fraud was confirmed when a Qian Pollock purchased by Pierre Lagrange for $17 million was submitted to the Orion Analytical lab in New York for testing. The lab found that the oil paint contained a pigment not commercially available until 1970. Pollock died in a car crash in 1956.

The De Sole case went to trial before a Manhattan jury in January 2016. The plaintiffs asked $25.3 million in compensation for the fake Rothko, including damages. The central issue was whether Freedman knew, or that circumstances were such that she should have known, that the works she sold were fake. The allegations against Freedman, the gallery and its owner, 8-31 Holdings, included fraud, deceptive trade practices, breach of warranty and false advertising. Charges were filed under the *Racketeer Influenced and Corrupt Organizations Act*, which was originally intended to prosecute organized crime and allows for monetary judgment up to three times the amount lost. The defendants continued to deny knowledge of the fakes.

Three weeks into the trial, Freedman settled with the De Soles. **107**

Freedman would still have to testify as to her state of mind at the time of the sales. The next day Knoedler and 8-31 settled with the De Soles, ending the lawsuit. Lawyers would not disclose the terms. This left unanswered questions that a jury verdict might have resolved: Do sophisticated buyers have a greater obligation to research authenticity on their own? What steps must galleries take to establish due diligence in regard to fraud? Was Knoedler justified in ignoring the red flags that seem to have appeared?

Where are the Qian paintings now? Two are in museum storage, others are with known collectors. Other works were resold with no records available. One Qian Motherwell is in the possession of the FBI, which is keeping the work "for educational purposes."

Who is this genius forger? Qian Pei-Shen lived in China during the Cultural Revolution, and generated notice for his paintings of Mao Zedong. He moved to New York in 1981 to attend classes at the Art Students League. To support himself he worked as a janitor, then as a street artist on West 4th Street. He charged $15 for a portrait.

One day a passerby brought him a picture and offered him $200 to reproduce it as a painting. The customer was José Carlos Bergantiños Díaz, who later introduced Qian to Rosales. An FBI investigator said Bergantiños was the one who was said to have forged artist signatures and treated the canvases to age them. He was arrested in Spain in 2014 on fraud charges. The US government sought to extradite both Bergantiños and his brother Jesús Ángel Bergantiños Díaz.

Rosales and Bergantiños operated King Fine Arts, a modest gallery on West 19th Street in Manhattan. They almost certainly could not have sold the paintings through their King gallery; they needed the Knoedler history and brand to made the offering of undocumented works plausible.

In a 2014 interview with Diane Sawyer of the ABC News program *Nightline*, Qian said he had created the paintings but did not know that they would be sold with attributions to other artists, that Bergantiños told him the paintings were for art lovers who could not afford the real thing. "I made a knife to cut fruit. But if others use it to kill, blaming me is unfair." Qian said that he now lives in a one-bedroom apartment in Shanghai, surrounded by hundreds of paintings signed in his own name. In late 2016, a book was in preparation about his life and work.

The Qian story is incredible in part because the conventional path

to faking another artist's work is for the forger to study the artist and the artist's life, to "become" the artist. David Stein, who created work attributed to Matisse, Chagall, Picasso and Degas, has said, "You have to know intimately the artist you are imitating ... when I painted a Matisse, I became Matisse, when I painted a Picasso I was Picasso."[65]

Qian did none of these. He just stood at an easel and mimicked the style of an artist whose work he saw in an art-book illustration. Qian did not produce copies, but new compositions containing components of original paintings. One week he did a Rothko that fooled Rothko experts. The next week he produced a Motherwell that fooled other experts.

The most surprising aspect of the Qian story is the misplaced reliance on dealers, curators and other art experts to certify authenticity. Buyers relied on the Knoedler brand, that of the less well-known Weissman gallery and the story of Mr. X as a substitute for a documented history for each artwork. In many cases they purchased without consulting a lawyer or an art adviser. One reason was that buyers feared losing the opportunity to purchase through the delay that involving a third party would produce.

But consider: no one would purchase a $10-million property without a condition report and a search of legal title. In the art world, some sophisticated buyers will acquire a $10-million artwork lacking documentation, perhaps not from King Fine Arts on West 19th Street but with the reassurance of a better-known dealer brand. Even experienced gallerists did this. Richard Feigen was quoted as saying, "I overly depended on Knoedler's reputation ... I didn't examine it with the care I would have with an individual or gallery with less of a reputation."[66]

Buying from an auction house is not necessarily safer than buying through a dealer. Auction houses perform their own due diligence; however, they limit their liability. The "Terms and Conditions" in an auction catalogue state that the auction house warrants only the description for an item in boldface or italics, not the other information provided. To cancel the sale, a buyer must generally bring proof to the auction house within four years of purchase that a work is fake. However, many buyers do not learn there is a problem until they attempt to resell.

A detailed, traceable provenance is one reassurance of authenticity for buyers. However, previous owners often do not want to be identified. Evidence of prior ownership can be forged. This makes due diligence **109**

problematic. One partial solution is for a buyer to sign a confidentiality agreement if the gallery will disclose the previous owner's name and any other information it has on the history of the work. The agreement is that information provided can be disclosed only if there is subsequent evidence of fraud, or on resale to a buyer who executes a similar agreement. Auction houses will not do this.

A unique art authentication case—and another example of the litigious world of contemporary art—surfaced in mid-2016. Peter Doig, a fifty-seven-year-old British-Canadian artist living in London, was shown a photograph of a 1976 painting thought by the owner to be by Doig. The artist said the work, signed "Doige," was not his.

The owner was a sixty-two-year old retired Canadian prison officer named Robert Fletcher. When Doig disclaimed the painting, Fletcher sued, asking for a court declaration of authenticity plus $7.9 million in damages and costs. Although Doig was in England and Fletcher lives in Thunder Bay, ON, the suit was filed in a Chicago court—because the painting was then in the possession of a dealer in that city who helped to fund the lawsuit. The claim was that Doig took art classes at Lakehead University in Thunder Bay for a year as a teen, and was later incarcerated in that city on a drug charge. Fletcher said the painting was done in 1976 while Doig was in jail; Fletcher later purchased it for $100.

Doig said in his response that he had never been in Thunder Bay, either as a student or an inmate, that he grew up in Toronto and attended art school in England. Doig was sixteen or seventeen when the painting was created. He attempted to gather documentation to prove his whereabouts in 1976, a task many would find challenging.

The concern about authenticity was understandable. One authentic Doig painting brought $26 million at auction.

Doig's lawyers asked the Chicago judge, Gary Feinerman, to dismiss the case because an artist should not be required to prove a painting was not done by him, and certainly should not be required to disprove it forty years after creation of the work. How would you do that for a good fake? Doig's lawyers also argued that there was no basis for the case being heard in Illinois. To the amazement of everyone, probably including Fletcher's

lawyers, the judge initially allowed the suit to proceed to a jury trial in United States District Court for Northern Illinois.

In August 2016, at a hearing and after seeing evidence of Doig's whereabouts at sixteen, Judge Feinerman ruled that Doig "absolutely did not paint the disputed work" and that the creator was Peter Edward Doige, a carpenter and amateur painter who had since passed away.[67] Feinerman dismissed the case.

Legal claims are sometimes filed by a collector against an expert who has refused to authenticate a work of art. The Doig case raises the possibility of an artist filing suit against an expert who has authenticated a work that the artist disclaims, or against a museum that shows a work and attributes it to the artist.

What would a Fletcher "win" in the Chicago suit have accomplished? If the artist and his dealer both claim the work is not authentic, it is unlikely a potential purchaser would give much weight to a legal opinion by Judge Feinerman that it *is* authentic. But then there seems little apparent logic to much of the litigation that takes place in the curious world of contemporary art.

"The purpose of a just government is to prevent plunder, not facilitate it."

—Glenn Beck, political commentator[68]

GOVERNMENT-PLUNDERED ART

WHEN YOU THINK OF ART THEFT, IT IS PROBABLY IN THE CONTEXT OF famous events such as the Rembrandt and Vermeer robbery of the Isabella Stewart Gardner Museum in Boston in 1990. If you think of theft by governing groups, the ISIS looting of historical sites in Syria and Iraq may come to mind.

Less commonly recognized is state involvement in art theft. The example of the late Maria Altmann is recounted in the movie *Woman in Gold*. This is a 2015 British-American drama starring Helen Mirren and Ryan Reynolds. Altmann was a Jewish refugee in Los Angeles. For a decade, she and lawyer E. Randol Schoenberg petitioned Austrian officials to reclaim her family's *Portrait of Adele Bloch-Bauer I* (1907), Gustav Klimt's painting of her aunt. The Klimt painting shows the face of a Viennese aristocrat. It is highly recognizable, perhaps because it reminds the viewer of Klimt's more famous work *The Kiss*, also painted in 1907.

The Nazis took *Adele* and five other Klimt paintings from the Altmann family's Vienna home in 1938. When Altmann's uncle Ferdinand Bloch-Bauer died in November 1945, he left his estate to her, a nephew and another niece. Within a year of his death the Austrian government claimed ownership of five of the paintings. They were put on display at the Austrian Gallery Belvedere.

Initially Altmann asked the Austrian authorities for three Klimt landscapes to be returned. She was prepared to donate two works to Austria: *Portrait of Adele Bloch-Bauer* I and another Klimt portrait of Adele from 1912. Her offer required the government to acknowledge her family's ownership. The Austrian government ignored her.

Altmann took her legal battle to the United States Supreme Court. In 2004 the court ruled in *Republic of Austria v. Altmann* that the Austrian government was not immune to a lawsuit. The dispute was then referred to a three-person Austrian tribunal, which unanimously awarded her four of the five paintings.

The Austrian government lost a final appeal. Altmann reportedly then offered *Adele* to culture minister Elisabeth Gehrer, who had referred to the painting as Austria's *Mona Lisa*, plus two of the other paintings. Altmann asked a below-market value compensation of $90 million. Another version of the story is that after the arbitration loss, Austria was entitled to keep the paintings if it paid Altmann fair market value, and that $90 million was Altmann's opening offer. Altmann required the compensation to pay her extensive legal fees. Randol Schoenberg and his colleagues had represented her on a contingency-fee basis of 40 percent of the value of what was recovered. Gehrer rejected Altmann's offer, calling the requested amount "extortionate."

The four paintings were shipped to the US in March 2006. *Portrait of Adele Bloch-Bauer* I was sold to cosmetics heir Ron Lauder for $135 million, at that time the highest sum known to have been paid for a painting. Since July 2006, *Adele* has been on public display in Lauder's Neue Galerie in New York City. The other paintings sold at auction for $190 million. Together with *Adele Bloch-Bauer* I the total was approximately $325 million, which after Schonberg's fee was divided among heirs and charities.

Gehrer's "extortionate" $90-million rejection seemed at the time a huge political and economic misjudgment. The political cost to the party in power in Austria of paying $90 million and keeping the paintings

would, in retrospect, have been less than the cost of not paying and losing part of the country's cultural heritage. Whether there was economic misjudgment is less clear. The selling price of *Adele* and the other works was certainly inflated by the well-publicized backstory of the underdog overcoming the Austrian government.

Altmann died in 2011, a week before her ninety-fifth birthday. Her story had a decent, if long-awaited ending. But there are other state-plundered artworks, some of them contemporary and most with less happy outcomes.

<p style="text-align:center">***</p>

The story of art plundered by the Nazis from 1935 to 1945—including the works reclaimed by Altmann—is well known. Less well known is art plunder in the 1970s and '80s by the Stasi, the East German secret police. Their motive was not to remove "degenerate art" or to build a national collection, as with the Nazis, but rather to raise hard currency to help the German Democratic Republic's communist regime (GDR) purchase oil and raw materials on global markets. The GDR produced few goods that were in demand by hard-currency countries. Western exporters did not accept the Ostmark currency. Selling art abroad was one source of convertible currency.

Between 1973 and 1989, Kunst & Antiquitäten GmbH, the state corporation involved in art sales, seized 220,000 objects—including 10,000 paintings. Sales of art were reported as having generated $40 million a year. The corporation's other enterprises included sale to the West of church relics and historic books from libraries, and ransoming of political prisoners to cross to West Germany. In total these activities brought $1 billion in Western currency. After the collapse of the GDR regime in 1990, the Stasi's compulsive documentation of its activities provided detailed accounts of the seized art.

In 2014, reports in the *New York Times* described the evolution of a seized-art case working its way through German courts. In March 1982, the Stasi entered the home of seventy-nine-year-old Dresden art collector Helmuth Meissner. The agents carted off almost anything of value. The justification was that any citizen with more than a few works of art must be an unlicensed art dealer, thus a lawbreaker. Meissner had not paid **115**

dealer taxes, so the state was due 90 percent of whatever value an official placed on his collection. When Meissner protested the seizure, the Stasi had him committed to a psychiatric hospital.

Beginning in 2013, Meissner's son Konrad—then seventy-six—attempted to reclaim six paintings seized from his father. The most significant was an oil-on-wood, *Four Chestnuts* (1705), also known as *Still Life with Chestnuts*, a still life by Dutch artist Adriaen Coorte (1665–1707). In support of his claim, Konrad offered a photograph of the painting when it was hanging in the Meissner home before the Stasi seizure. In 1988, Kunst & Antiquitäten consigned *Four Chestnuts* to Christie's Amsterdam; the work sold for $77,000. The buyer, Swiss dealer David Koetser, resold it to New Yorker Henry Weldon shortly thereafter for $145,000.

In 2013 Weldon's widow, June, petitioned a Munich civil court to uphold her title to the Coorte, arguing that her family had purchased it in good faith. At that point the painting's value was estimated at $2.2 million. Weldon died in 2014; her heirs were pursuing the case as this book was being written.

Weldon's lawyer Anthony Costantini offered the argument that the Stasi seizure was a legal action by a sovereign government. The action might be repugnant, but under East German law it was legal. Whether Christie's, or Koetser or the Weldons knew of the seizure—and June Weldon said she and her husband did not—was irrelevant. The seizure "was done ... as a tax forfeiture proceeding." Costantini said, "This is not like a Nazi like Goebbels taking something and placing it on his wall."[69]

So compensation for owners or their heirs of Stasi-seized art is not assured. Some museums and individuals have voluntarily returned about 1,800 of the paintings to claimants. For the 8,000 remaining paintings and most of the other objects, recovery has appeared unlikely.

Then there are five decades of art seizures by the Cuban government. That government maintains that on the day it took power in 1959 it nationalized all private property in Cuba, and that at that point everything belonged to the state. The seizures began immediately; "people's street courts" were set up to try citizens who had associated with the previous regime. Some were permitted to avoid execution (or trial) and board an

exile ship to Florida if they first signed over their homes, businesses and personal possessions to the new state. In later years paramilitary groups raided Cuban homes and seized art and other valuables.

The best of the twentieth-century seized art went to Cuba's museums, notably to the Museo Nacional de Bellas Artes in Havana. Jesús Rosado Arredondo, former registrar of the Museo, reportedly claimed that 60 to 70 percent of its fifty thousand artworks came from confiscations after the revolution. Other seized paintings were hung in state buildings or in the homes of government officials. Some were sent to the West for sale, mostly to Europe and usually consigned to auction by Cuban embassy officials.

After the Soviet Union cut its support to Cuba in 1988–89 there was a time of austerity which Cubans call the *período especial*. This brought an increase in sales of seized art. Most was sold in Europe. One consignment was a Jean-Léon Gérôme painting, *Entry of the Bull* (1886), from the Museo. In November 1989 it was sold at Christie's London for £330,000 ($504,000). The auction catalogue included the notice, "United States citizens are advised that the sale and purchase of this lot may contravene US regulations in regard to property emanating from Cuba."

Some art was sold to tourists or diplomats through state galleries in Havana. In 1992, while my son Neil and I were on vacation in Cuba, we wandered into one of these state-run enterprises where there was a large and spectacular René Portocarrero on offer for $40,000. This was well below its market value in the West. I thought at the time the asking price must have reflected a concern as to authenticity.

The most publicized attempt to recover seized Cuban art had the Memorial Library at the University of the State of New York as a plaintiff. The library promotes education about the Holocaust. In 2016 it was seeking to recover works taken from the Havana home of Olga Lengyel, an Auschwitz survivor who passed away in 2001 and bequeathed her estate to the library. She had works by Picasso, Degas and Van Gogh, some which had not been seen for fifty years. Estimates of their 2016 value ranged from $200 million to $500 million.

Lengyel was born in Hungary, daughter of industrialist Ferdinand Bernat-Bernard, who assembled his art collection in Paris in the 1930s. In 1944, Lengyel and her family were arrested and sent to Auschwitz-Birkenau; she was the only family member to survive the camp. A book Lengyel wrote

after the war about her experiences, *Five Chimneys: A Woman Survivor's True Story of Auschwitz*, was thought to be the basis for William Styron's novel *Sophie's Choice* and the 1982 movie of the same name.

Lengyel moved to New York, became a US citizen, then moved to Havana in 1954. In 1960 she fled the Cuban revolution and returned to New York. She submitted a claim for the property left in her apartment, but received no response. If any of the art is ever moved outside Cuba, the library intends to claim title.

A longer-running example of recovery efforts comes with the story of Cuban art history professor Manuel de la Torre. His collection was seized after he left Cuba. In 2004, at age eighty-seven, he attempted to retrieve some of it, specifically *La Hamaca* (1941), a painting by Cuban artist Mariano Rodríguez. In 1971 the work had been sold to Spanish diplomat Jesús Navascués, who was posted to Havana.

After Navascués' death in 1997, his family consigned the painting for sale at Sotheby's. *La Hamaca* was purchased for $145,000 by New York art collector Violy McCausland. In 2001 she consigned the work to Sotheby's, with a published estimate of $150,000 to $200,000. Just before the auction, de la Torre saw an image of *La Hamaca* in a Sotheby's advertisement. He claimed ownership and then sued.

Sotheby's cancelled the auction and repurchased the painting from McCausland at the original price. The auction house claimed it had no evidence that the painting was stolen or acquired illegally by Navascués. De la Torre's son said Sotheby's offered to return the painting only on the condition that he and his relatives not discuss the case with representatives of the press, and that they grant Sotheby's exclusive future rights to auction the painting. The family refused.

There are two versions of the resolution of the case. One is that the painting was returned to de la Torre's family in 2005, after his death. The second is that Sotheby's made a cash payment to the family.

At the same time that Manuel de la Torre was suing Sotheby's, the Fanjul family—with a similar claim over the Joaquín Sorolla y Bastida painting *Castillo de Málaga* (1909)—tried a cute ploy. They filed a complaint with the US State Department citing the *Helms-Burton Act*, which provides penalties for executives of companies that traffic in confiscated Cuban property claimed by a US national. The family claimed that Sotheby's and its executives had established a pattern of "trading with

the enemy" through their sales of expropriated Cuban property. The outcome was quick. Sotheby's settled with the Fanjuls, and made a public commitment to not sell any nationalized Cuban artworks. Immediately after, Christie's made the same commitment.

In early 2015, with improved diplomatic relations between the US and Cuba, it was hoped the Cuban government might negotiate compensation for confiscated assets. This happened after eastern European countries abandoned Communism. However, Cuban officials simply restated their offer that claimants could apply to a Cuban court for restitution. No one viewed this approach as hugely promising. That left pending expropriation claims by six thousand US, Canadian and European nationals whose assets, or those of their families, were taken after the revolution.

The US government has told Cuban Americans that it cannot demand compensation for victims who were not US citizens at the time of the seizure. The difference between Cuban claims and those for Nazi-looted art is that no Western country ever recognized the Nazis as a legitimate government. The London Declaration of 1943 declared as invalid all transfers of property made under duress from the Nazi regime. Cuba had diplomatic relations with the United States at the time most art seizures took place, and the US government, under what is called the "Acts of State" doctrine, considers expropriation of property from Cuban citizens to be legal. The exception is expropriation where the art or other goods were owned by anyone who was at the time a US citizen.

Any such state-owned Cuban property entering the US in a cultural exchange and not given prior government immunity is subject to seizure. In 2016, the Bronx Museum of the Arts applied for a grant of immunity for art loaned by Cuban museums for an exhibition. The museum hoped for a Presidential Order granting immunity from any seizure of the art. It was determined that the president lacked authority to override an embargo affirmed by Congress.

Whether taken by the GDR, Cuba or any other government, there are tens of thousands of works of confiscated art. A purchaser must exert caution when reviewing provenance. Looted art may come with falsified provenance documents or there may be gaps in provenance—in 1933–45 for European art, or after 1960 for Cuban art. Art is like other property with regard to the need to research ownership, except that its mobility and value makes the effort more necessary.

119

"I doubt you've got a piece of paper wide enough to write down all the zeros."

—Nicholas Brett of AXA Art Insurance, on the value of art stored in the world's freeports[70]

"Art is transportable, unregulated, glamorous, arcane, beautiful, difficult ... Its elusive valuation makes it conducive to extremely creative tax accounting."

—Nick Paumgarten, art journalist[71]

FREEPORTS AND TAX PLOYS

ART COLLECTORS WITH ACCESS TO VIP LOUNGES AT THE ART BASEL FAIRS IN Basel, Miami or Hong Kong might wonder why the Luxembourg Freeport or the Singapore Freeport pay to become major fair sponsors. Each has a booth alongside more obvious sponsors UBS (Union Bank of Switzerland), BMW and Ruinart Champagne. Collectors also wonder what becomes of the high-priced art sold at fairs or at evening auctions. Often no publication reports either purchaser or destination. The answers to those questions are related.

Close to the main runway at Findel airport in Luxembourg is a warehouse that could be an Amazon Fulfillment Center. There is a private road linking the aircraft taxiway to the building. This is the Luxembourg Freeport. "Free" refers to Freeport users being exempt from local customs inspection, duties and taxes.

The Luxembourg Freeport, the one at Changi airport in Singapore,

and others in Switzerland and China are repositories for paintings, precious metals and data storage. Apart from private collectors, art-storage clients include auction houses, museums, galleries and art investment funds. Storage fees are not published. At the December 2014 Basel Miami fair, representatives of the Singapore Freeport told me it would cost $7,000 to $10,000 a year for a small space adequate for ten paintings.

The early version of the freeport was the bonded warehouse. This was used to house commodities and manufactured goods in transit to other countries. When applied to bonded warehouses, a tax exemption was valid only for goods making a brief stop before reshipment. In today's freeports there is no time limitation. A painting can be flown in from another jurisdiction and stored for decades without attracting taxation, so long as it does not enter the host country.

If customs officials require freeport users to document items moving in or out, it is usually only with a general category code—"artworks," "jewellery" or "gold." The only obvious concern is with storage of drugs or weapons. The former are identified by sniffer devices. Weapons are more difficult to detect without inspection, but the size and weight of the shipment may cause suspicion. Each freeport offers multiple layers of security, with access to rooms by biometric reading. Firefighting involves sucking oxygen from the air while releasing inert gas that does not damage art or other valuables.

Luxembourg's government says its freeport scheme is an important component of its efforts to support a population of 576,000 with an economy based in large part on the provision of unique financial services. Those include hosting close to 150 banks from twenty-seven countries, and being the registered tax headquarters for 40,000 companies—one for every eight citizens. The Deloitte Touche consulting firm team that negotiated the Luxembourg freeport arrangement offered the justification that the freeport would facilitate competition with London and New York in art finance, which involves corporate or personal loans with paintings as collateral.

Prospective buyers view art in a private gallery in the freeport. They finalize a purchase using electronic money transfer, then move the art from the seller's storage area to the purchaser's, or take it with them. Seller and buyer can arrive and depart without ever having technically entered Luxembourg. Sales or profit taxes are due in the destination country or the residence countries of the purchaser and seller, with self-reporting.

Swiss and Singapore banks exchange funds transfer information with other countries, but movement of goods into or out of freeports is not covered under international agreements.

The value of goods stashed in freeports is certainly in the hundreds of billions of dollars. Consider the size of the structures: the Luxembourg Freeport is the size of eleven football fields; Singapore's, seven fields; Beijing's, eighteen; Geneva's, ten. Most have expansions underway or planned. All except Beijing were close to full at the time of writing. When giving talks, I used to quote the accepted estimate that there were "a million" quality artworks stored in the major freeports. However in May 2016 a *New York Times* article quoted a Swiss audit estimate that there were 1.2 million artworks in the Geneva Free Port alone.

There are lots of reasons other than tax considerations to store art in a freeport. Having run out of wall space in the owner's several homes is one. Whatever the motive, even modest estimates of the amount of art in storage raise the concern that were any substantial portion to suddenly be offered for sale, it would be more than enough to trigger an art market implosion.

One major collection that has been publicized as stored in a freeport is that of the Nahmad family. They operate two galleries in New York and two in London. The brothers reportedly have 4,500 artworks valued at $3 billion in the Geneva Free Port. Another such collection is (or was) that of the Wildenstein family, fifth-generation operators of the Wildenstein Gallery in Paris, New York and London. Following the death of the father, Daniel Wildenstein, French tax authorities announced that among the Wildenstein assets uncovered at the Geneva Free Port were nineteen Bonnard paintings valued at €65 million ($80 million).

It was assumed that the Geneva Free Port always enjoyed extraterritorial status. This assumption was dispelled, initially with the Wildenstein search, for good in April 2016 when Swiss federal police raided the freeport and seized a Modigliani estimated to be worth $35 million, but with disputed ownership. The painting, *Seated Man with a Cane* (1918), was owned by David Nahmad through a Panamanian company called International Art Centre. It was the subject of litigation in New York Supreme Court over a claim that it had been looted by the Nazis during the Second World War, and that the rightful owner was Phillip Maestracci, grandson of the previous owner.

The Freeport of Culture at Beijing's Capital airport opened in 2014. It comes with an interesting backstory. When the Beijing facility was proposed, a similar freeport was planned for Moscow. Clients reported that they were comfortable with security and confidentiality in China, but would not be in Putin's Russia. The Moscow expansion was shelved. Other tax-free warehouses have since been planned or constructed in Shanghai, Chengdu and Xiamen.

Art stored in freeports creates a dilemma for insurers. Art is insured on a global basis, and insurers are not always informed when works are moved. Some insurers, concerned about a plane crash rather than theft, ask clients to report the identity and value of art they store in freeports.

At least one freeport (I was sworn to secrecy as to its location) may offer a quite different service. It is developing a proprietary blockchain software system to register art ownership and provenance. Blockchain is the technology developed to support Bitcoin, but its importance is considered greater than that of the currency. Think of a blockchain as an encoded ledger that records changes of ownership of an asset, with records spread over several computers and protected from tampering. It is a distributed account book that only authorized participants can access. It is not a blue-sky idea: Microsoft offered a blockchain service in 2015. Blockchains are considered secure; despite thousands of attempts by governments and individuals, Bitcoin has been successfully hacked on only two known occasions.

A blockchain would permit art in a freeport to be listed, along with its provenance and documentation, and sold, including overseas money transfer, without either seller or purchaser ever travelling to the freeport. The proceeds could be stored as a "virtual currency" in the blockchain, sort of an art-Bitcoin, for use in future transactions. Or the proceeds could be used to purchase gold stored in the freeport. If several freeports collaborated in the same blockchain, art could be transferred among them. The possibilities are intriguing.

How does someone wanting to acquire or dispose of art anonymously do so? One requirement is an agent, usually a lawyer who is legally entitled to offer client confidentiality. The hypothetical situation that follows is an amalgam of possibilities described to me by specialists, and information from testimony in a Florida hearing where the head of the wealth management division of USB was indicted for assisting Americans

he met at Basel Miami to launder money. (The indictment was dropped following an agreement between the US Internal Revenue Service and the Swiss government.)

Say we have an eastern European buyer, Ivan, who wants to purchase a $40-million Warhol. He considers it not a good investment in terms of rate of return on capital, but as a store of value, part of a portfolio of assets that could be easily and quickly liquidated if required. For political or tax reasons, Ivan desires to keep both the transaction and the source of funds confidential. Ivan retains a Swiss lawyer, Gerhardt, to arrange the transaction. Gerhardt retains art dealer Heidi to bid on the Warhol at Christie's London. Heidi knows only that the bidder is represented by the Swiss lawyer. Gerhardt provides Heidi with a letter of credit guaranteed by a private Swiss bank. She presents the document to Christie's and indicates her intention to bid.

Heidi bids and is successful. She arranges with Christie's for possession of the Warhol and transfer of title to a trust account to take place a few days later, timed to coincide with arrival of the painting on the taxiway beside the Luxembourg Freeport. As the plane rolls to a stop at Findel, funds are transferred from the Swiss bank to Christie's account in London. The plane offloads the Warhol, which goes into storage. Neither Christie's nor Heidi knows the beneficial owner of the work—nor do they want to. When it comes time to resell the Warhol the process works in reverse. Neither the auction house nor dealer knows the identity of the seller. Proceeds move to Gerhardt's trust fund, onward to Ivan's Swiss bank, then to an offshore account. Any profit from the transaction is taxable in Ivan's country of domicile. It is Ivan's responsibility to report the transaction and profit.

Gerhardt is bound to confidentiality by strict Swiss legal and banking codes; he is subject to both civil and criminal penalties for any violation. Swiss courts will not honour foreign court orders for Gerhardt to produce information.

Note, though, that David Hiler, president of the Geneva Free Port (which is partially owned by the municipality), announced in November 2015 that identity checks would be made on new and existing tenants. Anyone with a criminal record would be asked to leave. Gerhardt may now find a new role as nominee owner of Geneva Free Port spaces.

Readers who were intrigued by the April 2016 leaking of the Panama **125**

Papers and the subsequent Modigliani seizure in Geneva may assume that most offshore art deals—like my Warhol example—take place via Panama, with a shell company registered in the British Virgin Islands. Both Panama and the BVI have been used for decades to conceal assets, but not often art.

The Panama Papers are 11.5 million documents from Mossack Fonseca, a Panama-based law firm that specializes in wealth management. The documents were leaked to German newspaper *Süddeutsche Zeitung* and shared by the International Consortium of Investigative Journalists with media partners around the world. They reveal some of the offshore assets of several thousand people, including twelve presidents, prime ministers and monarchs, plus thirty people on a US blacklist for terrorism, for drug sales or for illegal trading with countries that the US has blacklisted. The Panama Papers have been interpreted as showing how the law firm helped clients hide money and evade tax.

The documents contain many revelations about the art world. They shed light on the Christie's auction of the Ganz Collection of modern art in November 1997. That sale totalled a then-record $206.5 million and included works by Picasso, Jasper Johns and Robert Rauschenberg. The Papers revealed that six months prior to the auction, many works in the collection had been sold for $168 million to a company called Simsbury International Corporation, which was registered in Niue in the South Pacific. The seller was listed as Spink & Son, a London auction house then owned by Christie's. Spink appears to have been acting as a broker for the Ganz family. The sale stipulated that the artworks would be offered at auction as the "Ganz collection." If they brought more than $168 million, Simsbury and Spink & Son would share the difference.

Another disclosure was that Dmitry Rybolovlev (mentioned in Chapter 10) stored $650 million in art in a sole-owned offshore company, Xitrans Finance, amid divorce proceedings with his wife, Elena, that began in 2008. The art included works by Picasso, Van Gogh, Monet, Degas, Rothko and Modigliani. A Rybolovlev family trust official said that "the structures were set up completely legitimately for the purposes of asset protection and estate planning."[72]

In my Warhol example, the "offshore account" that money comes from and returns to could be in the BVI, the Cayman Islands or one of a dozen other jurisdictions offering bank secrecy. A new option, one

increasingly used because of additional benefits, involves placing art or other assets in a trust based in the Cook Islands.

The Cooks cover 236 square kilometres—fifteen small islands in the south Pacific, 1,100 kilometres southwest of Tahiti. The largest island is Rarotonga. The Cooks have 12,500 citizens and English as the language of business. The Cooks judicial system is based on English common law; Cook trusts were designed for offshore asset protection trusts. Investment accounts, businesses, real estate, yachts, private aircraft and art can be registered in a trust. The trust assets may be located in a foreign freeport. Trust owners need not have ever visited the islands. Trust holders are guaranteed total anonymity.

The Cooks offer a potentially valuable additional benefit. In almost all cases the courts will ignore foreign court orders or government inquiries. Cook law prevents trust assets from being transferred when the owner is under duress; that specifically includes the owner being under arrest or involved in a legal case. Trust owners in either situation are unable to honour a court order requiring them to transfer assets in the trust, or even to obtain confirmation that they have a trust.

The International Consortium of Investigative Journalists, based in Washington, uncovered some details about Cook trusts in 2013. Reports in the *New York Times* based on this information identified one trust controlled by Denise Rich, divorced wife of convicted commodities trader Marc Rich. Her trust was reported as containing $100 million in assets, including a Learjet and a yacht. R. Allen Stanford, who was sentenced in 2012 to a 110-year term for running a $7-billion Ponzi scheme, had a Cook "Baby Mama" trust, the term indicating a mistress with whom he had children. The trust contained bank accounts in Switzerland and the Isle of Man, with Mama as the trust's beneficiary.

Freeports and Cook Island trusts have received little attention from Western regulators, perhaps because they are not under any country's jurisdiction. Art-world perception is that this will continue as long as freeports are diligent about screening terrorists or organized crime. Use of a Cook trust to shelter a valuable art collection has so far elicited little legislative concern in any jurisdiction.

"A black hole of bad art and superficial temptation."

—Nicolai Ouroussoff, *New York Times* writer, on the 2008 collaboration called Chanel Mobile Art[73]

"I don't think Mr. Murakami would have the reputation he does today if it weren't for the collaboration with Louis Vuitton."

—Mitchell Oakley Smith, art and fashion writer[74]

THE UNEASY MARRIAGE OF ART + FASHION

IN 1999 FRENCH FASHION SUPERSTAR BERNARD ARNAULT PURCHASED A controlling share of Phillips auction house for $120 million, through his publicly traded luxury goods holding company LVMH Moët Hennessy Louis Vuitton SE, known as LVMH. Stock analysts and the financial press were hugely critical of the acquisition because being identified as owner of an auction house, even one focusing on contemporary art, was considered detrimental to the aura around high fashion. The criticism was sufficiently intense that after a money-losing 2001, Arnault walked away from Phillips, essentially gifting the LVMH share of the auction house to partners Simon de Pury and Daniella Luxembourg, who owned the minority share.

In 2008, control of what was then called Phillips de Pury was sold to the two Leonids—Leonid Friedland and Leonid Strunin, who controlled the Russian luxury retail conglomerate Mercury (distributors of Armani,

Chopard and Tiffany). The Leonids argued that Phillips was a logical extension of their existing luxury and fashion empire.

The perceived compatibility of art and fashion changed a great deal in the years after Arnault originally purchased his controlling share of Phillips. Consider the following examples of the marriage of art + fashion, and reach your own conclusion as to whether these represent a threat to the way contemporary art is perceived.

The first example is an expensive promotion that took place just for the media coverage it was expected to produce. In 2007, the Chanel fashion house commissioned London-based architect Dame Zaha Hadid to design a flying-saucer-shaped display structure, a 7,500-square-foot, 180-ton building to be called Chanel Mobile Art (see photo insert after page 96). The structure was designed to be disassembled and moved to a new city every few months. The interior was designed by Karl Lagerfeld, Chanel's creative director. Mobile Art was filled with commissioned artwork inspired by the label's quilted, chain-strapped black leather 2.55 handbag.

French contemporary artist Fabrice Hybert contributed a quilted-leather s&m room. Swiss-born contemporary artist and sculptor Sylvie Fleury produced *Crystal Custom Commando*, a purple 2.55 handbag containing a large Chanel makeup compact showing a video of women with guns shooting at Chanel purses. Chanel Mobile Art opened in Hong Kong in February 2008, moved to Tokyo in July and closed in New York's Central Park that fall. It was withdrawn after only those three stops, and after expenditure of €12 million ($18 million). Chanel said the display had met its goal of emphasizing the artisanal nature of Chanel's products and their relationship to contemporary art.

Chanel Mobile Art probably did little damage to the careers of the artists involved. Fleury and Hybert were not well known at the time; their names would likely not be remembered by those who toured the display. For the artists it was a source of income, a chance to monetize their momentary market fame. It is understandable, given the frequency of promising artists suffering precipitous declines. Many artists with long careers still earn far more from their fashion affiliations than from the sale of their art.

For the two artists it also offered a brief admission to a world of publicity and glamour. Short-term advantages outweighed the reputational risk. It used to be accepted that artists jeopardized their authenticity

with almost any corporate collaboration. Today, artists cross their fingers and sign the contract. The larger question was whether the concept of contemporary art was damaged, given that art was being used like designer packaging or a television commercial, as burnishing for a cosmetic.

Those who did remember the names of the artists would thereafter think of them differently. A dealer friend provided an interesting analogy (referring to one of his own gallery artists): "The temptation is like a starlet being offered the chance to pose nude for a *Playboy* centrefold. It is profitable, and results in temporary fame. The net result may be good or bad, but the actress is never viewed the same afterwards."

A better-known art-to-fashion collaboration is that of Japanese artist Takashi Murakami with Louis Vuitton. At the fall 2007 Murakami retrospective at the Museum of Contemporary Art, Los Angeles (LAMOCA). curator Paul Schimmel made the controversial decision to host a 1,000-square-foot Vuitton boutique within the Murakami exhibition. The *Oval Buddha* sculpture, the feature exhibit of the show, is a 6600-pound, 18-foot-tall sculpture of a Janus-faced Buddha in a lotus position. Vuitton offered $960 handbags with Murakami's well-known cherry blossoms and fruit, or "jellyfish eye" illustrations plus the LV logo. Reportedly about ten handbags were sold each day. Art and fashion writer Elizabeth Currid described the venture as "a new kind of product, one that expands the economic horizons of all the parties involved."[75] The involvement of LAMOCA as a party took commercialization of art + fashion to a new level. Murakami titled his LAMOCA show "© Murakami."

Marc Jacobs then invited Murakami to help design other LV handbags. Several years later, Vuitton offered Murakami cherry-design handbags to coincide with the release of two versions of his sculptures of a smiling red cherry. Murakami later expanded from high fashion to low. The artist's company marketed T-shirts, key chains, mouse pads and phone caddies with art images. Murakami was quoted in the *New York Times* as saying that his art process is "more about creating goods and selling them" than about exhibitions.[76] His art, he says, is a hybrid of a commercial and an artistic product. He creates commerce; his commerce creates art.

Following Murakami came the Japanese artist Yayoi Kusama, who in 2012 produced a collection for LV featuring polka-dot handbags, plus window displays and interior store designs. The window display at the Selfridges department store in London featured her giant pumpkins. The

fashion house released the handbags in conjunction with the opening of Kusama's retrospective at the Whitney in New York.

The most publicized commercializer of his own art is Damien Hirst, particularly when it comes to his spot paintings and his sculpture *For the Love of God* (2007). The latter is a platinum cast of an eighteenth-century human skull, encrusted with 8,601 diamonds. At the centre of the forehead is a fifty-two-carat, brilliant-cut diamond said to have cost £4 million ($6.2 million). The work was constructed by artisans from the Bond Street jewellers Bentley and Skinner, with Hirst maintaining creative control. The skull was offered for sale at £50 million ($78 million). Hirst's dealer White Cube sold limited-edition silkscreen prints of the work priced at £900 ($1,400) and £10,000 ($15,500). The higher price was for a print sprinkled with diamond dust.

Hirst also launched a line of clothing featuring Levi Strauss black denim jeans with pockets featuring a Hirst skull or other symbols from his iconic works. For his 2012 retrospective at the Tate Modern in London, the museum store offered a £36,800 ($57,000) limited-edition plastic skull painted in household gloss. There were also rolls of spot wallpaper at £250 ($387) and a dozen other products based on his coloured dots. Later Hirst opened his own retail shop in Marylebone, called Other Criteria. It offered a different plastic skull. This also had glossy paint, and sold for £25,000 ($38,700). The London *Telegraph* reported that his shop had first-year sales of £7.5 million ($12 million). Hirst has said that seeing people buy his spot-themed wallpaper "makes me feel alive."[77] So how should the public consider Damien Hirst—as a contemporary artist or a fashion conglomerate that makes art? How should his work be perceived?

For her spring 2014 Milan show, Miuccia Prada commissioned six contemporary artists to create murals for the catwalk. The resulting imagery appeared on dresses and handbags in the collection. In December 2014, luxury jeweller Swarovski exhibited at the Design Miami fair, in a tent adjacent to Art Basel Miami. The company offered a Swarovski crystal–encrusted 10-foot (3-metre) sculpture of King Kong climbing the Burj Khalifa in Dubai. Priced at $520,000 each in an edition of seven, at least two sculptures sold during the fair.

Many art movements have a history of being "hot" and then at some point losing that status. Sometimes, as with trends in fashion, this has happened because the movement became extreme, or because a new

movement replaced it. Sometimes there was no apparent reason. Think of the relative loss of centuries-long interest in the art of the Renaissance after 1990, or on a smaller scale, of Dada after 1924 or surrealism after 1960, or op art after 1970. The social appeal of collecting almost any form of wall art declined in Britain for much of the 1800s, then returned.

Owning and displaying contemporary art became hot in Western countries between the late 1970s and the early 2000s, and in Russia, China and the Middle East toward the end of this period. In no country did someone say, "This is the thing that you should have to illustrate your cultural stature and wealth." In some mysterious way, the desire to acquire reached a tipping point among the wealthy of each country.

What could cause contemporary art to lose some of its current status? Not to lose its artistic appeal, but its social significance and speculative appeal? One factor could be the wilder attempts by fashion houses to cross-brand with art and artists. Another could be attempts by contemporary artists to diversify by marketing fashion products based on their art. The legitimacy of the current art market depends on the market retaining the belief that current distribution channels and price levels can sustain the social and cultural significance of collecting.

Fashion and art are collaborating to a degree far beyond the just-mentioned examples. Artists and art are incorporated in fashion promotion, targeted not only at the affluent who have traditionally been a market for both fashion and art but also at consumers under the age of thirty, the entry-level market for fashion. The fashion houses involved include Louis Vuitton, Chanel, Hugo Boss, Salvatore Ferragamo and Burberry. These firms try to absorb the desirable attributes of contemporary art in their own products. An art connection allows fashion and luxury goods to expand their brand image and sell at higher prices. Such brands are Veblen goods, where demand rises as goods get more expensive, because the goods now convey more status. The concept originated in 1899 with economist Thorstein Veblen. He famously defined luxury as a form of waste designed to confer status on an essentially useless class of people.

There has been a proliferation of fashion exhibitions in museums of fine art, in part because fashion is much less expensive to assemble, insure and show than painting; in part because fashion houses offer "generous support" for shows of their work; and in part because young museum patrons seek events rather than exhibitions (more about that later). **133**

Immediately after a Frank Stella retrospective, the Whitney museum in New York offered Proenza Schouler's fall showing of blazers, dresses and knitwear. In March 2016, the de Young Museum in San Francisco presented a retrospective of the fashion of Oscar de la Renta, "organized ... with the collaboration of Oscar de la Renta LLC."[78] At about the same time, the Cooper Hewitt museum in New York held an exhibition of Thom Browne shoes, showing fifty pairs of Thom Browne brogues coated with nickel. The distinctive red, white and blue brand labels on each pair were visible. Jason Farago wrote of the show in the *New York Times*, "This featherweight display is neither a show of decorative arts nor of fashion. It is something closer to an ad campaign."[79]

The risk to contemporary art (and to artists) has several components. Commercialization speeds the disappearance of the traditional standard of judging art by its quality and innovative aspect. This is replaced with a consumer culture norm—valuing art by its marketing and financial characteristics. Contemporary art becomes viewed in the same context as fashion footwear and watches. Fashion houses rather than dealers choose and promote artists, with the shock value of the art often being the criterion.

Fashion also wants to incorporate the motives attributed to purchasers of contemporary art. Acceptable motives in Western societies are evolving from "possessing" to "being," from "owning" to "experiencing." Fashion also seeks to be aspirational by adding a backstory to the product, ideally one that can transfer from art to fashion. Louis Vuitton's LV handbags have no backstory except the prestige of the brand. LV handbags with Takashi Murakami's characters and images may inherit a backstory. But does the handbag connection degrade the same backstory when it is later offered with Murakami's wall art and sculptures?

Art appreciation is usually seen as a sign of cutting-edge taste. When an art lover purchases art it is called collecting. When a woman buys an expensive frock it is called shopping and may be considered frivolous. The fashion industry has now adopted some of the language of art. Fashion stores "curate" their frock collections.

There are examples from the past where commercial collaboration was not seen as selling out. Elsa Schiaparelli partnered with Salvador Dalí in 1937 to produce a silk organza lobster-print gown. In 1965, Yves Saint Laurent made shift dresses patterned on Piet Mondrian canvases.

Both were huge successes for fashion, and produced greater recognition for the artist. But those were very different times for both fields.

Andy Warhol is an example of an artist whose work crossed to fashion. Warhol understood the importance of being selective in how and where his material was shown. In his book *Popism: The Warhol Sixties*, he detailed how careful he had to be about placement to maintain a blue-chip reputation.

Most commercialization of his work took place after his death, when the Andy Warhol Foundation began licensing his images. Snowboard manufacturer Burton produced a limited-edition collection of boards and boots featuring Warhol dollar signs, flower pictures and self-portraits. In 2006, Barney's department store in New York offered limited-edition Warhol Campbell Tomato Soup cans, containing condensed soup and bearing replica labels in the colours of Warhol's original art. In 2015, Converse partnered with the foundation to produce low-end sneakers with iconic Warhol images like his Campbell's soup can (see photo insert after page 96).

Another difference from the time of Schiaparelli and Warhol is modern society's concern with wealth inequality. This is a concern to fashion, because inequality is most visible through consumption. Wearing a $25,000 designer gown produces criticism; hanging a $25,000 painting reflects your status as a supporter of serious culture.

Fashion marketers enjoy great freedom in experimenting with art connections. Think of the Chanel example. This is possible because both fashion and the way it is promoted are controlled by a single creative director. The intent is that the fashion being marketed and the expanded meaning of the brand will shape the product preferences of elites, whom other consumers are expected to follow.

The publicity that results from art + fashion collaborations is intended to build the brand rather than just expand product sales. Chanel does not earn a profit from selling its catwalk pieces, and doesn't make much selling retail versions. Its profit comes from brand spinoffs. For example, while Chanel is known as a high-fashion house, it earns 50 percent of its revenue and 80 percent of its profit from lipsticks, other cosmetics and perfumes. Dior prices a one-of-a-kind runway dress at $25,000, but makes far more profit selling Dior logo belts.

Some of the wildest collaborations of art + fashion have taken place in **135**

136 China, which accounts for a third of the world market for personal luxury goods and fashion and 20 percent of the world market for contemporary art. The risk to contemporary art there is higher because of tipping points; brands and artists can lose their appeal quickly. Artistic collaborations in China also fill different needs. Demand for fashion and luxury goods slowed after leader Xi Jinping's anti-corruption campaign took off in 2014. Companies backed off from promoting fashion and luxury directly and instead emphasized their connections with art and artists.

Whether an association with fashion diminishes the perception and value of art remains to be seen. Collaboration with art may allow fashion to emphasize the artisanal features of rarity and uniqueness. In any case the marriage is a bit one-sided. Some customers may purchase a fashion label because of art. It is harder to imagine anyone desiring a work of art because of its association with a fashion label.

"[The art market] is a camouflage thing that is called the arts but it is money laundering. In the end it is just a business and a global currency."

—Martin Roth, director of the Victoria and
Albert Museum in London[80]

ART MARKET REGULATION

INTERNATIONAL BUSINESS AND POLITICAL LEADERS MEET AT THE WORLD Economic Forum in Davos, Switzerland, for four days each January to debate important issues. At the 2015 forum, New York University Professor Nouriel Roubini gave presentations in twelve panel discussions and dinner talks. Eleven were on macroeconomic policy topics like the European Central Bank's quantitative easing program and the Swiss decision to allow the franc to rise in value. His twelfth talk received more press coverage than the other eleven combined; in it, he argued that the art market needed regulation, and he recited every criticism made of that market over a decade.

When Roubini demands market reform, media and governments take note. Roubini has a Harvard doctorate and has worked for the Federal Reserve, the International Monetary Fund, the World Bank and the Bank of Israel. He has advised Bill Clinton and Timothy Geithner. In

both 2011 and 2012, *Foreign Policy* magazine named him as one of the Top 100 Global Thinkers. He is most famous—and earned the media designation "Dr Doom"—for predicting the collapse of the us subprime housing market that led to the financial crisis of 2008.

The Roubini talk that received so much media attention was at an event organized by the *Financial Times* and Julius Baer bank. Roubini said that, based on the size of the art market and because art is used as a portfolio investment, it must be considered an asset class and regulated as one. He continued with the obvious: that when people invest in art, some of their profit expectation comes from favourable capital gains taxation and some from the ease of tax avoidance when artwork is transferred across borders or across generations.

He cited the Mei-Moses index data on art price trends and concluded that returns on art are comparable to long-term returns on stocks. He ignored, as other commentators have, the high transaction costs and carrying costs of insurance, conservation, transportation and storage for art. He did not mention that Mei-Moses and other art indexes suffer from what economists call selection bias; they record only prices on artworks that are accepted for auction. Out-of-favour works rejected for auction are not counted. The best estimate for long-time returns on an art portfolio is about 3.2 percent a year, about equal to the predicted annual inflation rate, and well below the long-term return on stocks. However, this does not invalidate the "asset class" argument.

Roubini said that guarantees offered by dealers on auctioned work might lead to price manipulation. His concern was that a dealer would guarantee a record price, "purchase" the work for that price and thus establish a new price record for a gallery artist. Auction specialists say that no auction house would permit a dealer to offer a third-party guarantee for his or her own artist—although dealers do regularly bid on their own artists' work at auction. I have been unable to find anyone in the art world who admits knowing of such an abuse of the guarantee system, except perhaps in the Chinese market.

Roubini also cited the proliferation of art investment funds (by his estimate more than seventy) and attempts to combat the lack of liquidity for artworks by creating derivatives that track the underlying value of art market funds.

As an aside, he emphasized the lack of any fundamental pricing

model for art. Art produces no income stream, just a potential capital gain. In this sense art is more like gold than like stocks, bonds or real estate. The lack of a pricing model means that art is subject to fads, fashions and price bubbles—as occurred rather dramatically after 1990 and in 2008. It also means that an art investor must cover both capital and financing costs of art from some other funding source, while hoping that the asset appreciates enough to justify the expense. If the other source (stocks, real estate) is no longer available, the art asset may have to be liquidated.

Roubini ended with an obvious conclusion, that while online indexes and auction prices offer some price information, the art market is still opaque. "Inside information is considered standard ... In other markets, it is thought of as being illegal."[81] The market has to be subject to outside regulation "because it will not self-regulate, and its flaws would not be permitted in other financial markets such as equities." He concluded that regulation would be a net positive even for dealers, auction houses and other industry insiders that now oppose it.

A long list of questions arises from Roubini's catalogue of possible abuses. If the art market needs to be further regulated, what should be covered, and how? Roubini suggested an administrative agency to provide regulatory oversight and oversee ownership transfers. But would any government deem the art market important enough to justify further regulation above what currently exists in fraud statutes, or in tort or contract laws?

Melanie Gerlis is the art market editor of *The Art Newspaper* and columnist for the *Financial Times*. In her book *Art as an Investment?* she estimates the total amount of tradable art in circulation at any one point in time at $400 billion. As a comparison, the market capitalization of high-tech multinational Apple in July 2016 was $570 billion. More than half the value of tradable art is made up of the expensive works purchased, stored and sold by a small group of wealthy collectors. Would a government devote resources to protecting rich collectors who have ready access to expert advice from consultants, dealers, auction houses and each other? Recall the story of Ronald Perelman (Chapter 11).

How about Roubini's concern with the role of art in money laundering? The two largest art markets, New York and London, already have strict money-laundering laws. Their banks are not supposed to clear large-value transactions unless they are satisfied as to the source of **141**

the funds. Similar laundering protocols exist throughout much of the developed world. If there is a money-laundering problem, it arises with transactions negotiated in Western centres but finalized in jurisdictions like Luxembourg or Monaco, with electronic funds transferred from offshore banking centres. No art market regulation will change that.

Securitization of art—selling derivatives against the value of an art collection—would be an area attracting regulators' attention if the market for such art-backed securities were anything but minuscule. The only provider I know of is Pi-eX, based in London, which offers "Contracts on Future Sales." The contracts are derivative securities based on individual artworks being offered at upcoming auctions, when the value of the contract will be the hammer price of the work. Art owners can hedge their risk against the value achieved at the sale, while future art buyers can hedge against increased prices. Institutional investors can buy the contracts to build a portfolio of synthetic artworks as part of an asset diversification strategy. If this sounds like something written in Klingon, ignore it. The derivatives market for art, such as it is, comes within the purview of existing securities regulators who, I assume, will treat Pi-eX art securities no differently than any other derivative.

Given Roubini's list of trading on inside information, price manipulation through guarantees and tax avoidance on purchase and transfer of art, what would a newly regulated art market look like? Museum board members would no longer be comfortable purchasing artists who were scheduled for future retrospectives, but might continue to leak information about forthcoming shows to dealers and friends. The list of acceptable third-party guarantors for auctioned work would shrink, and probably exclude dealers and perhaps agents and major collectors. And dealers purchasing at auction for a client and required to identify that client would be more likely to cite a Swiss lawyer or a numbered company.

That leaves more focused concerns, for example dealing with information asymmetry by making figures available about reserves or guarantees. So far, every art market regulatory review that has looked at those problems has opted for the status quo. Regulators apparently conclude that the art market is a place for consenting adults to indulge in whatever irrational acts they choose, so long as no fraud or abuse of innocent third parties is involved—as, for example, was the case with Christie's and Sotheby's commission price-fixing arrangements in the 1990s.

The concerns Roubini expressed and the size and complexity of the art market will at some point attract the attention of some federal or state regulator wanting to be seen as protecting the gullible. If the experience of other markets is any guide, this will trigger further interest among art market participants to self-regulate so as to forestall government involvement.

So what would a defensive self-regulatory framework look like? One answer, if art is to be treated as an asset class, is that art advisers should be licensed the way investment advisers are—although what form the qualifying exam might take is not obvious. Another answer would be to deal with information asymmetry by making available data now controlled by dealers and auction houses that affects the value of art. One example is the volume of an artist's work that is available. Control of that information by market insiders produces a distinct advantage.

Market observers (myself included) were astonished to learn in 2010 that artist Damien Hirst and his technicians had produced 1,700 spot paintings (and some still argue that number is low). The price of his spots at auction dropped by about a third following release of this information, even though Hirst stated he had stopped producing the work. Other factors were certainly involved—one being that his spokeswoman said he might change his mind one day and produce more. As of late 2016 the prices for his spot paintings made after 1984 had not recovered; those made from 1978 to 1984 had held their value.

A more controversial answer would be to reveal what many insiders know, or think they know, about works in high-end evening auctions. In order of most to least likely, these include: First, how were the price estimates made? Did the auction house provide guarantees (in which case the house may be amenable to a lower offer after the auction)? Were guarantees offered by a third-party collector of an artist's work, or by a consortium of investors in partnership with the auction house? Has a work been offered for sale elsewhere (by a dealer or by private dealer) over the past year? In the "would never happen" category are questions such as: What is the reserve price below which the consignor will not sell? What is the guaranteed price? Who is the consignor?

The most commonly suggested reform is that secondary-market resellers reveal their costs, their commissions and the names of whoever received any part of the commissions. Many dealers already do this. **143**

144 London dealer Pilar Ordovas tells buyers the amount of the selling price that is her commission. The standard objection to this is that no other retailer outside the financial sector is required to disclose markups.

When a dealer or auction house offers a work, should the seller be obligated to reveal whether specialists have ever expressed doubts about its authenticity or provenance? Think of the Knoedler fakes (Chapter 12), where the opinions of specialists who doubted the authenticity of individual works were disclosed only during litigation, in some cases a decade after they might have been of use to potential buyers. Should a repository of all authenticity reports be available, perhaps online, with the qualifications of those giving each report also available? Experts might not want to be identified as declaring a work fake for fear of being sued, but the lack of availability of their reports permits fakes to be sold and resold. Legislation recently proposed in New York to protect experts from suits would help.

Other activities affect auction prices. Museums play a complex role in the market. When a museum offers a major retrospective for an artist, how was that artist chosen? Did the artist's dealer contribute to the cost of the retrospective? Did that dealer play any role in choosing which works were borrowed or displayed? Was there a contractual undertaking that the works shown would not be auctioned or sold privately for a period of time following the retrospective?

Two examples of museum shows being used as selling exhibits are the exhibitions of Charles Saatchi's collection at the Royal Academy of Art in London. The first was *Sensation* in 1997, which later showed at the Brooklyn Museum. The second was USA *Today* in 2007. In each case Saatchi contributed to the cost of the show and chose the work to be displayed, much of which he owned. The circumstances around these shows were widely reported and understood by the market. What came later were market transactions, with consenting buyers and Saatchi doing their thing.

A less persuasive but very real counter-argument to disclosure is that the existence of insider roles contributes to the aura and attraction of the contemporary art market. The arcane rules of auctions, fairs and dealer openings may be as important to art market success as what is offered and then reported in the *New York Times*. To bring total transparency would make art more of a commodity and lessen the glamour of

the market process. If your friends knew exactly how much you paid for your new painting and how little of the backstory was true, they might be less interested in viewing, and you might be less interested in purchasing.

Would any of the suggested rules serve to forestall the bursting of the art bubble? Not likely. That is based on buyer optimism and a wilful ignoring of negative market signals. Neither of those human attributes can be legislated.

AN UBER
FUTURE

"Online art sellers are like the knight in a chess game; they move forward one square, then two to one side or the other."

—Source unknown

ART IN AN UBER WORLD

BEYOND ATTEMPTS TO REGULATE THE ART MARKET, THERE IS ONE OTHER dramatic disruption that cannot be ignored. That is the growth of sales on the internet, with its potential to replace many of the market's intermediaries and to democratize the world. Art markets are adapting to their own Uber world—with *Uber* used in the sense of the cellphone app transportation service that is replacing traditional taxis. Markets are also adapting to über dealers and collectors, but that is a different subject.

Los Angeles art speculator Stefan Simchowitz cites the origins of Lutheranism as an analogy for art in an Uber world. Martin Luther said that it wasn't necessary to enter a cathedral and tithe to the priest, the bishop or the cardinal in order to talk with God. Rather, you could sit in a beautiful field and commune through prayer. Simchowitz says that you no longer need to visit a pretentious dealer and tithe through lower-value purchases in order to get the art or the art information you

seek. You can bypass the dealer and take your laptop to a beautiful field to search online for what is available, what has been purchased and for what prices. You can see a thousand times as many works on Instagram as any dealer could assemble.

The Hiscox *Online Art Trade Report* estimated total 2015 online sales at $3.3 billion (3 to 4 percent of the world contemporary art market by value), up from $2.6 billion in 2014 and $1.6 billion in 2013. Those figures are certainly underestimates; they don't include the Chinese market. Tracking the impact of the Uber revolution on the art market requires following a rapidly growing but moving target. Consider what happened with the appearance of the transportation Uber. In 2010, no one imagined being able to use an app on a cellphone (or watch) to arrange a ride with an unlicensed stranger. In 2015, forty-five million Americans did so. That figure is expected to double by 2017. Who thought we would ever be able to use an online site to find a potential life partner, or a vacation residence (through Airbnb), or a dog walker? How many (me included) argued that serious collectors would never trust online sellers enough to purchase expensive art in cyberspace?

Taxi drivers resisted the incursion of Uber; many launched traffic-stopping demonstrations in their city centres before accepting the inevitable. Art dealers and the previous Sotheby's management team may have seriously disliked the concept of selling art online, but changed their view as the opportunities and lower transaction cost realities could no longer be ignored.

Uber and other non–bricks and mortar competitors strive for what business strategists call disruptive innovation, a concept articulated in 1995 by Harvard Business School Professor Clay Christensen. His idea was that established companies often don't notice when innovative newcomers begin to rewrite the competitive rules for a business. New entrants start with new technologies and business models, and offer a less expensive alternative to mainstream offerings. Established firms lose some low-end customers, or some curious to try a new thing, but they ignore the new competition because the lost customers were just not very important.

Over time newcomer technology gets better, and incumbents bleed more of their customer base. Established firms face a dilemma: to invest more heavily in their traditional business model, or invest in technology to catch up to the disrupters.

Translate the disruptive innovation concept to the art market. If online selling is less expensive or more efficient than selling through dealers and auction houses, the online model will first get adopted at the low end of a market. This happened with art sales on eBay, Saatchi Art and dozens of other sites. Initially this worked best with prints, low-priced multiples and entry-level art, much of which migrated to online sites. Users became more familiar and comfortable with the concept of buying art online. Sales moved upmarket to harm established competitors. As sales moved up, online competition nibbled enough revenue from some existing competitors to push them toward insolvency.

The question has always been: What would happen beyond entry-level art? Would collectors purchase even medium-priced art online—say, above $10,000? If a collector is buying from a trusted source and is comfortable with a JPEG image, is that enough? Art adviser Amy Cappellazzo points out that people have been buying from auction catalogue images for years without seeing the artwork. Between a quarter and a half of the best works at Art Basel or Basel Miami are sold via JPEGs prior to the VIP opening of the fair. In each case, collectors trust the auction house or dealer, and are comfortable with an image and a description. In the case of the art fair, they fear losing out if they don't move quickly.

Cappellazzo notes the shifting comfort level that took place with other online buying. There was a period where buyers were apprehensive about purchasing a $30 book from Amazon or a $15 collectible from eBay, because that required sending credit-card information into the void. Year by year they became more comfortable with online purchasing at higher price points; eBay has auctioned at least fifteen items at prices above $1 million.

The implementation part of an art-selling start-up is more difficult. Art never looks quite the same in front of you as it did on the computer screen; buying online is wishful guesstimating if you want to live with the artwork. Two recent online start-ups illustrate this and other implementation glitches.

Tim Goodman's online art auction house Fine Art Bourse went live at the end of June 2015. FAB was founded as an online platform intended to disrupt the traditional fine-art auction industry. Goodman said FAB would be a game-changer, a direct challenge to the duopoly of Sotheby's and Christie's in auctioneering. "It will take others at least a year [to

copy] ... it's taken me three years ... It's a complex thing to do both legally and technologically."[82] FAB retained twenty-one "consulting specialists" around the world; Goodman said he planned to increase the number to sixty. His goal was to achieve $280 million in sales by 2019. He projected this as 3 percent of the world art market.

FAB planned to charge much lower fees than the established auction houses—a buyer's commission of 5 percent plus a $330 "fixed lot buying fee." A five-year, money-back guarantee to buyers would cover authenticity or title.

FAB was based in London, with plans to open offices in New York, Hong Kong and Beijing. Auctions would be online and run from Hong Kong, where there were no sales taxes, resale royalties or copyright fees. That left the unanswered question: If the art consignor (and the artwork) were in one country, the bidder in another and the auctioneer in Hong Kong, what legal system and forum would be used for resolution of disputes?

Goodman has a distinguished art-world pedigree. He was executive chairman of Bonhams & Goodman Australia, then executive director of Sotheby's Australia. In 2009 he purchased Sotheby's Australian business, and by 2011 owned four Australian auction houses which together accounted for almost half the Australian market. He sold the four to work on the FAB "game-changer."

In August 2015, a month before FAB's first scheduled sale of fifty paintings, several of FAB's financial backers withdrew. No others stepped forward, and the company went into receivership. The consulting specialists and staff in London and Hong Kong were terminated. FAB had burned through investor capital exceeding €4 million ($5.5 million).

What happened? Financial backers cited both over-budget costs and concern about the inability to physically inspect a work before bidding. You can sell $5,000 art on the basis of a JPEG, and you might sell $25,000 art that way. They doubted whether Goodman could sell a $250,000 or $2-million work if the image and artist and seller were not already well known—a Warhol flowers silkscreen consigned by a known collector with an unquestioned provenance, for example.

The same week that Goodman announced FAB, Simon de Pury announced an online venture called De Pury, backed by German venture capitalist Klaus Hommels. De Pury left Phillips de Pury in 2013; the

company name reverted to Phillips. His new venture would combine online auctions with a physical location. In October 2015, de Pury held its first auction—350 works of contemporary art and design from the Geneva-based Lambert Art Collection, consigned by his friend, the late Baroness Marion Lambert. The catalogue was available only online. The auction was to be at Ely House in London, the eighteenth-century showroom of British dealer Mallett. Bidders could come to the showroom or bid online.

Several weeks before the sale, de Pury decided to hold the pre-auction exhibition at Ely House, and the sale at Christie's King Street salesroom. This apparently allowed him to secure a few guarantees or irrevocable bids for the work. The online sale was shown simultaneously on the websites of both Christie's and De Pury.

De Pury's original idea was to charge a 15-percent buyer's premium up to $2 million and 12 percent thereafter, with vendors paying 9 percent. For this first auction, de Pury charged the same 25- to 12-percent sliding scale as Christie's and Sotheby's. But online auctions held in a showroom were pretty much what Christie's and Sotheby's were already doing. If format and commission models were the same, and with fewer (or no) guarantees, how would the de Pury model with an online catalogue, a physical exhibition and a live auctioneer, draw high-end works from Christie's and Sotheby's —or from Phillips?

The most successful online auction model is peer-to-peer through an intermediary—think of eBay or Saatchi Art or Amazon. These charge some combination of a listing fee plus a commission, and allow buyers and sellers to negotiate directly. The idea of peer-to-peer is to make images and full information available in one place, to eliminate the traditional middleman and to minimize fees. The most successful example is Saatchi Art (www.saatchiart.com). Founded by collector and dealer Charles Saatchi as Saatchi Online, the site is now owned by Demand Media, Inc. The site claims to offer the world's largest selection of original art: half a million original paintings, drawings, sculptures and photographs by fifty thousand artists from one hundred countries.

Most works offered on peer-to-peer sites are under $1,000. Besides the desire to see the work, a constraining factor on price is that at the highest levels, contemporary art auctions and über dealers produce astonishing prices through a mix of art, brand, event, celebrity, theatre **153**

and backstory. For Saatchi and other online sellers, the value is just the artwork.

Saatchi offers the ability to browse by style, subject, medium, artist or country—which makes the site popular with interior designers. Saatchi also offers curated collections. In October 2015 the site showed a selection of sixteen photographs selected by actor Jamie Lee Curtis.

Saatchi aids a vast number of artists in making at least a modest living. Every artist I know who shows on the site reports some regular sales. An artist who would like to gross $70,000 a year can do so with a few more than fifty sales at $2,000 each (taking commission and other costs into consideration). This is one a week, with the work exposed to a worldwide audience. If the artist had a mainstream dealer, she would need thirty-five to forty sales at $4,000, made to a local collector base. Most dealers could not manage that.

Consider the modest but probably typical case history of HyunRyoung Kim, an artist of Korean heritage who lives in suburban Toronto. In 2010 she began selling on Saatchi Online. At the time of writing she had sold fourteen works on the site at prices between $1,300 and $5,400. An example is her *Untitled 15* (2013), a 4 × 3-foot (122 × 91 cm) acrylic on canvas (see photo insert after page 96), which in November 2016 had 4,549 views and 129 "favourites" on the site. Each year she takes part in a number of juried shows around Toronto, and some one-time gallery exhibitions. Her Saatchi income is a good supplement to these other channels.

Saatchi Art illustrates the difficulty in making money in the online art market. The site charges a high 30 percent of the selling price as a commission. When the company was sold to Demand Media in August 2014, it was revealed that Saatchi Online had lost $5.7 million in 2013 and $4.2 million in the first six months of 2014.

Amazon's online art sales model is similar to that of Saatchi, except that most of the works come from dealers. The site was introduced as an experiment to see if clients would buy paintings and prints online the way they bought books or small kitchen appliances. Amazon solicited galleries in the United States and six other countries with the proposition, "List work on our site and for a modest commission, 20 percent for works up to $100 declining to 5 percent for works over $5,000, we will give you exposure to 240 million customers worldwide." A few artists have registered a "gallery" on Amazon and sold their own work through the listing.

As of mid-2015, Amazon showed work from 210 galleries: fifty-five thousand paintings and prints from five thousand artists. Amazon does not guarantee authenticity; it does allow customers to return merchandise for thirty days for any reason (although that may involve reshipping a painting to China). Typical expensive works offered were the Warhol screen print *Shoes* (1980) and the Banksy screen print *Girl with Balloon* (2004), both at $135,000, both including a "Make an Offer" option. About 40 percent of the works offered were under $1,000. The first hundred galleries I checked were ones I had not previously heard of.

Artists who market their own work online are unlikely to have representation by mainstream dealers, but this norm may change. There is a cute exception to this; I know several artists who are represented by a mainstream gallery and also sell their work under an "artistic stage name" on Saatchi Art or eBay. (Kim is not one of them.)

Artists who market their own work are also unlikely to see that work appear at an art fair. It would seem reasonable that artists creating good work but without gallery representation—or artists with an established reputation who no longer wanted representation—could show their work at a half-dozen fairs a year and earn a good living. It does not happen. Any fair that suggested admitting artists showing their own work would face opposition from indignant dealers threatening retribution.

Online sales hold one disadvantage: artists no longer receive feedback and advice from dealers. Artists get direct feedback from online customers, and will learn from buyers what versions of art are well received and which are not. The artists can have their work rated online, by purchasers and non-purchasers alike.

Saatchi Art and similar sites are highly disruptive for mainstream dealers. Some of their online sales substitute for gallery sales. Some observers argue that the disruption is self-limiting. But even if the realistic price ceiling for online sales is $25,000, that still covers half or more of the sales made by mainstream galleries. At $100,000 it overlaps 95 percent of those sales. As dealers lose revenue they risk losing their more prominent gallery artists to dealers higher on the pecking order. Each year, more mainstream dealers fall below the tipping point of survival. Each failed dealer leaves twenty to thirty artists without gallery representation. Many of these resort to selling their work online.

There are hundreds of other sites that offer peer-to-peer art sales. **155**

156 Artspace, 1stDibs and Auctionata are examples. Some sites continue, others disappear quickly and quietly. The attrition comes because to open a peer-to-peer site you need art to list, a domain name, good photography and click-to-buy software. To actually sell from the site you need to find a way to promote it, which usually means using Google, Twitter or YouTube to inform potential collectors.

Many dealers list art on their own websites. There is always a suspicion that those are works that have gone unsold in the gallery, that dealers would never post their best pieces. In particular they would certainly never offer work by an artist with a gallery waiting list.

There are three online selling models that seem to offer the greatest potential for disrupting the high end of the market: ArtRank, ArtViac and Artsy.

ArtRank (www.artrank.com), first mentioned in Chapter 1, offers "Buy," "Sell now" or "Liquidate" judgments on contemporary artists, using an algorithm-based forecast of near-term prices, analogous to the way that investment bankers rate stocks. Carlos Rivera, co-founder of ArtRank, says the algorithm uses trend data on "presence," "auction results," "market saturation," "market support," "representation" and "social mapping." The site also has input from twenty-five art-world professionals—collectors, advisers and dealers—who provide data on things like studio output.

The most important rating factors seem to be auction results, the identity of the dealer, appearances at art fairs or auction houses, and likes and hashtags on Instagram and Twitter. If an artist's selling prices drop at two successive auctions, or the artist is dropped by a dealer, bad rankings result. If prices go back up or the artist is taken on by a higher-ranked dealer, the artist is back in favour.

At the time I was writing this, artists Walead Beshty and Mark Flood were rated "Sell now" because their market had lost momentum. Artists Jacob Kassay, Sterling Ruby and Parker Ito were rated "Liquidate," which means sell as fast as possible for whatever you can get. If ArtRank were widely followed, this would mean that the market value of a work by Kassay, Ruby or Ito would drop almost immediately to a level where their work could be acquired with no speculative price component.

"If you sold Oscar Murillo at the beginning of 2015 when he was rated liquidate, you might have got $300,000 to $400,000," Rivera said, explaining changing rankings. "By mid-2015, when he was rated as early

blue-chip, that price had dropped by 60 percent ... At $200,000 he is an artist who is worthy of investment."

Rivera says he is not encouraging speculation, but rather offering a twenty-first-century art advisory service. "People don't know about emerging-market artists without a great adviser, and you don't get a great adviser unless you've got millions of dollars to spend. I'm not asking for $50,000 upfront like a top art adviser."[83]

Rivera adds that as Kayak.com allows travel amateurs to act like professional travel agents, so ArtRank.com allows art amateurs to act like art professionals. It is clear that the service is of greater interest to those flipping art than to those building a long-term collection. Perhaps not surprisingly, Rivera and ArtRank are consulted and respected by investors but not beloved by artists.

The second disruptive site is Monaco-based ArtViatic (www.artviatic .com). ArtViatic promotes itself as a platform for the private sale and purchase of exceptional works of art. The site accepts paintings, sculptures and works on paper listing at €150,000 ($164,000) and above. It avoids providing (or guaranteeing) authentication by requiring that a work either be included in a catalogue raisonné or have a certificate of authenticity.

ArtViatic connects sellers with buyers; the parties negotiate privately. If a sale occurs, each party pays a 3-percent commission to the company on an honour system. Sellers and buyers get a free trial period on ArtViatic, after which there is a subscription fee. The company offers confidentiality for sellers and buyers, making it less likely that artists will learn that their work has been flipped. There is still a problem if the certificate of authenticity that accompanied the original art is offered with the fake. Many buyers take the easy path of checking the certificate rather than authenticating the work. If the work is fake, ArtViatic has no responsibility.

ArtViatic would be my choice for a disrupter of the high end of the art market because it handles the problems of authenticity and confidentiality reasonably well. However, there is a limiting factor: there are many dealers, auction house specialists and art advisers who for an 8- to 10-percent commission, will negotiate private placements at $1 million or over. They provide better authenticity checks, better confidentiality and better access to potential buyers. That would seem to box ArtViatic into a narrow price range, above peer-to-peer sellers and below private **157**

placements. The middle ground narrows even more when agents doing private placements accept less valuable works as part of disposing of a whole collection.

The third disruptive site is Artsy (www.artsy.net), a technology start-up that has raised $50 million in funding from art-world backers, including dealer Larry Gagosian and Russian art patron Dasha Zhukova. (Full disclosure: I have been involved with Artsy's online video series and online editorial series.)

Artsy launched its online platform in 2012. As of late 2016, over 4,000 galleries had displayed art for sale on the site. These were mid-level or below; no über galleries. Each pays a subscription fee ranging from $375 to $1,400 a month for software and other services. At the end of 2016, the Artsy app has been downloaded more than 650,000 times by collectors worldwide.

Over seven hundred museums and foundations and sixty art fairs, including EXPO Chicago, the Armory Show and Art Cologne, display on the site. Museums, foundations and art fairs upload for free. The art-fair postings have a huge following.

Based on a user's browsing activity, Artsy uses an affinity test to predict what art attributes the collector might like. Recommendations come from its Art Genome Project algorithm, a version of that used by the internet music website Pandora. The algorithm includes eight hundred preference indicators from each artwork—"political," "minimalist" and so on. If a collector likes the work of Cindy Sherman, the algorithm will produce a list of related artists—Francis Bacon and Barbara Kruger—and show works by each. The algorithm has glitches, which make it fun. The *Economist* magazine cited the example of Gustave Courbet's *The Origin of the World* (1886), where the labels included "Breast" and "Close-up." Admirers of *Origin* were shown Tom Wesselmann's *Study for Bedroom Painting with Tit & Lemon* (1968), which the algorithm also related to "Breast."

The most important online influence may be Instagram, a 320-million-member online photo-sharing and social-networking service, and probably the major social-media platform in the art world. In April 2015, Artsy published survey results that showed 51 percent of collectors on Instagram had purchased works from artists they discovered on the site, and had on average purchased five works from the site. All such self-reported purchasing behaviour is highly suspect. But even if the Artsy survey overstates reality by a factor of three, the results are impressive.

Interest in Art on Instagram was boosted by a 2015 story concerning Hollywood star and avid art collector Leonardo DiCaprio. In March of that year, DiCaprio saw an Instagram image posted by Copenhagen's Gallery Poulsen, of artist Jean-Pierre Roy's work *Nachlass* (2015) in a shot of the gallery's PULSE Art Fair booth in New York (see *Entopticon 1*, from same Roy series, in photo insert after page 96). The actor purchased the work on the phone before the fair opened. The asking price was reported as $30,000.

Instagram's success comes in part from triggering a sequence of emotional points in viewers. Collectors see an artwork, click on other works by the artist, then see a personal profile, then a website address. They can view an artwork in different stages of completion and create their own backstories to art they buy. Pricing and purchase information have to be searched, but that is not difficult once you have a website. Art on Instagram produces instant feedback in the form of "likes" and comments. If there are a lot of likes, an artist can attract hundreds of new followers every day.

The little-known aspect to Instagram is that many sites involve product placement; site owners are compensated by the brands shown. They feature professional photography, sometimes professional models, and clothing brand identification tags. For a fee of $200 and up (and a requested $50,000 for a celebrity endorser with over a million followers), such sites include artwork as background, with artist credits listed. The art can be digitally inserted; no shipping is required. Some artists claim this is a profitable form of promotion. That may change once more Instagram followers understand that what they are viewing is a paid placement.

Art speculator Stefan Simchowitz has found another way to profit as an intermediary in the art market. He identifies young artists such as Parker Ito and Petra Cortright before they are taken on by galleries, and buys all their work he is able to get—much as Charles Saatchi used to do. Simchowitz publicizes the artists and their work on Instagram, or by sending JPEG images to his collector base, most of whom he has never met. He moves hundreds of artworks each year and popularizes artists, almost all accomplished online.

What is common to the examples above is that initial competition to the dealer and auction house system came from disruptive innovation **159**

from outside the art market, not within. That is true in other industries: the speed of innovation in terms of development and diffusion is accelerating, but existing organizations in those industries do not notice, or find it hard to restructure. Uber came from outside the taxi industry, Tesla from outside the auto industry, and Apple health care and finance from outside those industries. Disruption can happen whenever technology can be applied.

It is also not surprising that innovation comes from outside. Every MBA student learns that the vulnerability of a market to outside market innovators is greatest if that market has high information asymmetries between suppliers and customers, high search costs or substantial fees charged by intermediaries. The art market rates high on all three.

New York dealer Edward Winkleman thinks online art selling may have what economists call network effects, that online art sales may be a "winner take almost all" game. I agree. In the digital world it is common for one company to evolve to dominate completion, to become quasi-monopolies. Think of Google in online search, Facebook in social networking, Airbnb in apartment rentals, Spotify in music streaming and of course Amazon in online retail. Competitors come and go. Some continue to exist, but struggle.

Once network effects take hold, there is a huge barrier to entry to potential rivals. The more familiar and comfortable you are with one firm, the harder it is for a competitor to offer you enough to induce you to switch—again, think of Google or eBay. The more customers are on one internet art site, the more likely you are to offer your art there. The more art on a site, the more collectors will search only there.

However much internet sales expand, and however few online competitors survive, there will still be one gap in Stefan Simchowitz's analogy to Lutheranism at the beginning of this chapter. Collectors will still need to have a long relationship with a dealer to get access to work of the most sought-after artists. First option will always go to institutions, second to branded collectors with public collections, third to long-term customers of the gallery. To make it to the third rung of the ladder, a collector may still have to tithe by purchasing lesser works from the dealer.

THE NEW WORLD OF MUSEUMS

"I can never pass by the Metropolitan Museum in New York without thinking of it not as a gallery of living portraits but as a cemetery of tax-deductible wealth."

—Lewis H. Lapham, American writer and editor

"[What we do is] the conscientious, continuous, resolute distinction of quality from mediocrity."

—Alfred Barr, former director of the Museum of Modern Art

NOT YOUR FATHER'S MUSEUM

FOR NON-COLLECTORS, THE MAIN INTERACTION WITH MODERN ART IS through museums rather than dealers or salesrooms. Museums are about much more than displaying art; they are linked to the economics of the art market in ways that are important but not always obvious. In particular they are about fundraising. They compete with other museums, cultural activities and charities for publicity, prestige, donations and wealthy trustees.

For museums, the most important customers are not potential museum-goers. Rather they are donors, in the same way that the important customers for newspapers are not readers but advertisers. As every MBA student learns, to find out what business an organization is in, you ask, "What is the revenue model? Where does the money come from?" The revenue provider is the customer. That is one reason why so many museum directors come from non-curatorial backgrounds, and

sometimes from earlier careers as dealers. They are appointed in large part for their negotiating and diplomatic skills. It is also why, in many cases, the public image of a museum is so closely tied to that of its leader.

If North American art museums had to rely on admission fees they would be in trouble. The Association of Art Museum Directors confirmed this in the report *Art Museums by the Numbers 2014*, which summarized responses from 204 museums in the United States and sixteen in Canada and Mexico. Only 27 percent of museum revenue came from admissions, parking, refreshments, gift-shop merchandise and space rentals. The remaining 73 percent came from private donations, government funding and interest on endowments. The average visitor to a North American art museum paid $3.70 at the admission desk and an additional $4.23 in the café and gift shop, a total of $7.93 per visit. The average is skewed by the fact that admission is free in a growing number of museums.

Dividing the total cost of running museums in the sample by the number of visitors gives an average per-visitor cost of $53.17. That figure is also misleading. Many of the costs are fixed—administration, storage of the collection, conservation and research—rather than variable costs related to the number of visitors. The averages are higher for the few large institutions with budgets in the tens or hundreds of millions of dollars. It's comparable to what 1-percenters do to statistics on average earnings and household wealth.

Donors provide operating funds and, more significantly, gifts of art. The bequests often come with conditions. In 2014 the Art Institute of Chicago outbid the Museum of Modern Art, among others, for the collection of retired plastics manufacturer Stefan Edlis and his wife, Gael Neeson. The bequest involved forty-two artworks, including Warhol and Koons, and was valued at $500 million. The institute agreed to keep all the works on continuous display for fifty years in a new museum wing designed by Renzo Piano. With the gift to the Art Institute, Edlis became both donor and partial curator of what would be shown. MOMA says it lost out because the museum never agrees to an "always on display" condition.

Even the best-known museums do sometimes agree. In 1969 the Metropolitan Museum of Art accepted a bequest of 2,600 works of Western European art from Robert Lehman. The gift came with the condition that the works always be shown together. Today they occupy a dedicated wing of the museum.

The question of what motivates donors is both simple and complex. The simple part is that what motivates the wealthy to donate to a museum is very much what motivates anyone to take a charitable action—some combination of personal satisfaction, public recognition and social duty. The more complex part of the charitable motivation of the wealthy can be the desire to structure their gifts to shape rather than just support an artistic activity.

We know that many wealthy donors prefer to associate with high-prestige institutions, museums high on the public recognition list. Where ten museums in a region compete for donations, it is thought that number one in public perception will get 25 percent of gifts, number two 15 percent, number three 10 percent, and the other seven will share 50 percent. The same percentages are thought to hold true with universities and professional schools in medicine, business and law. Those percentage donation differences are huge when translated to dollars. In December 2015 there were fifteen arts institutions in Manhattan running fundraising campaigns totalling $3.4 billion, most for earmarked capital projects. Of this, $400 million was for MOMA and $600 million was for the Met's proposed new modern and contemporary arts wing designed by David Chipperfield.

Some museum expansion is not to accommodate increased attendance, but rather to provide room for new collections. When Univision CEO Jerry Perenchio proposed donating art with a valuation of $500 million to the Los Angeles County Museum of Art (LACMA), the offer was conditioned on the museum financing and completing an expansion to provide room to show the works.

Each expansion involves a risk. Each produces an increase in operating costs, and requires an increase in attendance or in endowment for the museum to break even, given the new costs. The *New York Times* estimated the Whitney's 2015 move to its new larger location in Chelsea would see its operating budget go from $33 million to $49 million. In 2016 the Met, MOMA and the Brooklyn Museum each within a four-month period announced deficits and staff reductions, with the Met and Brooklyn attributing part of their losses to too-rapid expansion and the resulting need for additional staff and security.

Consider the competition in New York among four institutions: the Met, the Whitney, MOMA and the Guggenheim. There are many more **165**

museums in the New York area; these four compete at the high end. All have undertaken massive expansion and renovation. There is a battle for public recognition, and to find and attract high-profile board members whose personal contributions are an important source of funds. Board-member fundraising obligations are privately described as "give, get or get off." New board members are routinely asked for large annual contributions to operating funds, plus long-term contributions of art or capital.

Until the end of the 1990s the four high-end institutions each had distinct collections and missions. The Met spanned several thousand years of art history. MOMA was modernism. The Whitney was American art. The Guggenheim was about showing off its architecturally superb building and about attaining the economics of scale by franchising more Guggenheims around the world.

The Met gained the "number one in perception" position in 2014 after receiving the fabulous Leonard Lauder collection of Cubist art. This included eighty-one paintings, drawings and sculptures by such artists as Pablo Picasso, Georges Braque and Juan Gris. In quality these rivalled comparable works in MOMA, the Centre Pompidou in Paris or the Hermitage in St. Petersburg. The Met valued the bequest conservatively at $1 billion. Were the collection to have gone to auction, some estimates went as high as $3 billion.

The Met had finalized its expansion into the Met Breuer, the former Whitney Museum space that now shows twentieth-century art. Met director Thomas Campbell described the Met's expansion in alpha-dog terms, his comments directed to donors as much as the art community. "It's ... the most high-profile cultural building project in New York in the next 10 years."[84] Campbell talked about the show that opened the Met Breuer, *Unfinished: Thoughts Left Visible*, which posed the question "When is a work of art finished?" Campbell said: "What the Met can do is show contemporary art through the lens of history."[85] We have "five thousand years of aesthetic traditions, which modernism is either engaging with or rejecting."[86] Unstated was "and others can't." However, when *Unfinished* opened in March 2016, it turned out that only a third of the works displayed came from the Met's collection; two-thirds came on loan.

In losing its "modern art" exclusivity, MOMA lost some media coverage and dropped in public perception. MOMA did its best to ignore the Met's Lauder windfall, which many observers thought should logically

have gone to MOMA. In May 2016, MOMA got its own windfall: music and film producer David Geffen donated $100 million to the MOMA expansion. Three floors of new galleries in MOMA's new building plus the fourth-floor galleries in the existing building were to be named the David Geffen Galleries.

The Whitney Museum is probably third in public perception in New York, behind the Met and MOMA. The Whitney was founded in 1930 to compete with the Met. In that year the Met rejected Gertrude Vanderbilt Whitney's offer of five hundred works from her collection, which was to be accompanied by an endowment. Instead the funds went to the expansion of the Whitney Studio Club in Greenwich Village, a museum to show what the Met rejected. The end result was the 30,000-square-foot Whitney building on Madison Avenue, completed in 1966. There were several attempts in the 1980s to expand the museum with Renzo Piano and Rem Koolhaas designs; all efforts were beaten down by the museum's well-connected neighbours.

The Whitney ended 2014 with its most attended exhibition ever—the Jeff Koons retrospective discussed earlier (see Chapter 5). The Whitney then closed to prepare for the move to Chelsea. During the closing it still needed to attract attention and remain in the top three in public perception during transition to the new site.

Many museums adopt a bland interior architecture called white cube, to focus all attention on the art. The new Whitney's architecture is dramatic, an attempt to attract visitors and impress donors with a building that is itself a destination. For every story about the Whitney's opening show there were ten about the architecture and interior design. After opening, the Whitney ran with its "Bilbao effect," the term coming from the Frank Gehry–designed Guggenheim in Spain, where more people visit to see the building than the art.

Leonard Lauder (separately from his art-collection gift to the Met) contributed $131 million toward the Whitney's new downtown location. One condition that came with the offer was that the Whitney not sell the old building but rather lease it. Lauder has given many works of art to the Whitney in the past. In 2016 the museum announced that Lauder's name would grace the new building.

The Guggenheim is not directly involved in the New York competition, except for blockbuster shows like Christopher Wool in 2014. **167**

168 The Guggenheim seeks recognition and financial support through its ongoing role with the new Guggenheim Abu Dhabi and the planned Guggenheim Helsinki.

On what basis then can an institution like the Brooklyn Museum compete? Arnold Lehman became director of the BM in 1997. At that time the museum held a minor place in the New York museum world, well below the top four. The BM was known best—and, for many, known only—for its Egyptian art collection.

The first problem Lehman faced was how to get publicity and improve attendance by reaching a broader audience. He could then focus on attracting donors. One answer was inclusiveness, at that time the mantra for many museums. That meant challenging the W's of major museums: white, Western and (for artists shown) womanless.

Lehman said that when he started at the BM, minorities made up a third of the US population and 40 percent of Brooklyn, but that only 17 to 20 percent of his museum audience was composed of people of colour. The median age of Brooklyn Museum attendees then was in the upper fifties. In 2015, patrons of colour represented about 45 percent of attendees (in Greater New York, 65 percent identify as non-white), and the median age of visitors dropped to thirty-five. Lehman thought that the BM at that point had achieved the most diverse museum audience in the country.

An early step in rebranding was to make the building more welcoming. The old BM had five giant bronze doors. Guests had to tackle a long set of steps to enter off the third-floor level. The concept, Lehman said, was that you ascended to art. Lehman's wife said it reminded her of a government building on Moscow's ring road.[87]

The BM's doors and steps were replaced and the front facade of the building had lots of glass added. A fence around the entrance plaza was taken out so visitors could picnic on the grass. The changes were expensive, and represented money invested in rebranding rather than in art. The BM then introduced a version of free admission on the first Saturday of each month. Each "First Saturday" draws ten thousand to twelve thousand people and culminates in a two-hour dance party.

That was the long-term repositioning. In the short term the museum got press coverage with controversial exhibits – sufficiently controversial to elicit threats from patrons to boycott and from government officials

to cut off grants. One in 1999–2000 was Charles Saatchi's *Sensation*. Displayed the previous year at the Royal Academy in London, it featured Marcus Harvey's *Myra* (1995), an image of the murderer Myra Hindley. The museum also showed Chris Ofili's *The Holy Virgin Mary* (1996) depicting a black Virgin. Another show included David Wojnarowicz's film *A Fire in My Belly* (1986–87), with a scene showing a crucifix covered in ants.

Lehman could not afford the cost of participating in blockbuster art shows with other museums; *Sensation* was subsidized by Saatchi. Instead, the BM held exhibitions of popular culture: *Hip-Hop Nation, Star Wars: The Magic of Myth* and *Killer Heels*. "It's part of how we reinforce the museum's brand," Lehman said, "and how we hopefully continue to grow our audience and grow loyalty to the museum among our members, our donors."[88]

Lehman was seen as following the vision of former LAMOCA museum director Jeffrey Deitch, who had stated: "Museums needed young audiences and ... what young audiences wanted to see is events, whether the events are fashion shows, rock concerts or exhibition openings."[89]

Lehman diversified the museum audience but could not do the same for his board. He was quoted as saying: "There is a greater degree of difficulty in diversifying the board, because the reason you serve as a board member is not only because you love the institution, but because [you have] both a leadership and a fiduciary responsibility."[90] He continued that diversity is not consistent with "give or get," the ability to bring in hundreds of thousands of dollars a year at a minimum. Board membership in New York is in most cases a rich person's activity. The same problem exists through the museum world. In New York the Met, MOMA, the Guggenheim and the Whitney have never had a non-white chairperson or president, or as many as a quarter of its board non-white.

The changes have not elevated the Brooklyn Museum to New York's top four, but it is closer. The museum has increased its rank in the publicity and pecking order, and increased its donations by a factor of six—although in 2016, staff expansion and related costs produced a deficit of $3 million against an operating budget of $39 million, and the museum asked staff to accept voluntary buyouts.

For museums not named MOMA or Metropolitan, would simply not charging admission pay off in visibility, in visitors and in attracting donors? Digital providers such as Google, Facebook and Instagram **169**

170 understand the value of giving their product away. This yields data about customer preferences and habits. Companies sell that information to advertisers and others. Would it be a good strategy for an art museum to do the same?

Free admission is uncommon among Western art museums, one exception being that it is mandated by government in the UK. Ninety percent of US museums charge entry fees, most between $7 and $15. MOMA and the Metropolitan Museum charge a $25 fee, although in the latter case, in very small print beneath the price list is the word "Recommended." The Met will accept $1 if that is what you offer. (That one tip covers the cost of this book!) The MOMA and Met logic is that their institutions offer value, that visitors should be willing to pay more of the total cost rather than have others subsidize their experience.

In 2012, Maxwell Anderson, director of the Dallas Museum of Art, decided to test the "free" model to learn whether understanding behaviour produced more revenue than charging admission. Anderson convinced the DMA's board of directors to offer free admission to any visitor willing to enter personal information on an iPad at the museum entrance. It was thought that visitors would later provide information on what galleries they visited, what they liked and what they hoped to see during their next visit. Special exhibitions still required a paid ticket.

The risk for the DMA was actually quite minimal. Prior to the change, admissions and basic memberships together represented 5 percent of the DMA's annual budget, $1.2 million of $24 million. The rest of the budget came from donors, foundations and governments. Anderson hoped that having more specific information on users, and on what the museum was achieving with each group, would persuade those contributors to step up.

Beside each artwork was a code. Visitors who texted that code or entered it at one of the iPhone kiosks were credited with viewing that artwork, and could accumulate points to be redeemed for free parking, gift-shop discounts or free entry to ticketed exhibitions.

DMA visitors could further indicate which art they liked by choosing between paired choices, usually between a painting and a sculpture. One pairing was *The Icebergs* (1861) by Frederic Edwin Church against *Semiramis* (1872) by William Wetmore Story. The pairings offered sharp contrasts. Voting determined the DMA's eight most popular works, then four, then two, then the winner. Popular art remained on exhibit; early

losers spent more time in storage. The DMA now knew which galleries and pictures were the most popular and which events attracted visitors from low-income neighbourhoods.

The program produced three million records of how visitors use the museum. Anderson was able to show donors that they were subsidizing attendance from low-income areas. That appeal secured a $4-million anonymous donation. Admission then became free for everyone, whether or not they offered personal information.

Anderson could map attendance by postal code, so he could identify neighbourhoods that were still under-represented, and plan on how to reach what he called "art deserts." The DMA used its data to raise an additional $5 million a year, four times the previous revenue from paid admission and memberships. Donors were willing to support organizations that could provide metrics on the benefits being achieved.

Exhibits featuring contemporary artists turned out to be so popular, and historical art sufficiently ignored, that the DMA considered showing contemporary art in more galleries and having "special exhibits" of historical art—rather than the opposite.

On several occasions when I have discussed the DMA model with museum CEOs, their conclusion has been, "This is probably not for us." I think one reason is that free admission and reliance on donations makes the CEO even more a fundraiser, less a curator. Watching visitors pay to pass through turnstiles is replaced by knocking on donor doors and mounting exhibits based on visitor voting. For Maxwell Anderson, this was acceptable. The role is not for everyone.

"A painting in a museum hears more ridiculous opinions than anything else in the world."

—Edmond de Goncourt, French art critic

MUSEUM EXHIBITIONS

ALMOST A THIRD OF THE MAJOR SOLO EXHIBITIONS OR THEMED RETRO-spectives held in US museums between 2007 and 2013 featured artists represented by just five über galleries. These are Gagosian, Pace, David Zwirner, Marian Goodman and Hauser & Wirth. The figures come from a 2015 study published in *The Art Newspaper*, which analyzed nearly six hundred solo exhibitions held by sixty-eight museums. The five galleries are large by any measure. Between them they have thirty locations in ten major cities, estimated annual sales of $2.25 billion and account for roughly 7 percent of the world contemporary art market.

The five-gallery domination is not surprising: über galleries are thought to be both wealthy and willing to contribute to shows when gallery artists are featured. Über galleries commonly pay shipping costs, finance the catalogue and may pay for the opening reception for their artists. Dealers sometimes finance an entire show. In a well-publicized

example, Gagosian, Emmanuel Perrotin and Blum & Poe each contributed a six-figure sum to a Takashi Murakami solo show at the Museum of Contemporary Art, Lost Angeles (LAMOCA) in 2007. They also offer logistical support for assembling artworks. The galleries know who owns work and can assist in securing loans.

The figures are more dramatic for the best-known museums. Eleven of twelve solo exhibitions between 2007 and 2013 at New York's Guggenheim featured artists represented by one of the five galleries. The figure for the same period was 45 percent for single-artist shows at the Museum of Modern Art and 40 percent for LAMOCA. Typical of the low end of the percentage spectrum is Houston's Contemporary Arts Museum, where only 15 percent of the shows featured artists from the five. The percentage declines as the importance, size and audience of the museums gets smaller.

Helen Molesworth, chief curator at LAMOCA, was quoted in the *Art Newspaper* article as saying that the concentration of artists is "a symptom of how culture works in general, which is towards consolidation. ... What are you going to do? They have amazing groups of artists. You can't be wilful and say, 'I'm not going to show this person.'"[91] There is also pressure to produce a profit, or at least have a large attendance for each exhibition, which makes curators less willing to risk shows with less-recognized artists. Risk is associated with choosing artists represented by less-recognized galleries.

One interesting aside from analysis of the six hundred solo shows is that almost 75 percent featured male artists. *The Art Newspaper* calculated that male painters represented by the five galleries were 7.3 times as likely to be given solo shows as female painters represented by the same galleries.

What is less well known is the degree to which über dealers finance their artists' appearance at the Venice Biennale and other cultural events. Michael Plummer, co-founder of Artvest Partners, says, "Venice very much affirms a dealer's taste and judgement, which is why dealers make such a significant investment of time and money ... There is a great deal at stake for the dealer's brand."[92] *The Art Newspaper* cited a spokeswoman for the British Council as saying that the council's budget for the British pavilion at Venice is £250,000 ($375,000) and that dealers pay the "entire cost of the production of new work made for the exhibition" plus the cost

of the opening reception.[93] It's not just Venice; with so many biennales around the world, a gallery needs deep pockets to be able to participate. That restricts the game to über galleries.

Dealer support is not entirely altruistic. While Venice, like other biennales, is assumed to be a non-selling exhibition, in reality it is an important marketplace. No savvy visitor would ask, "How much is this work?" Rather, he or she offers a business card and says, "I would very much like to talk to you about this piece after the Biennale closes" (which may mean that evening).

The concentration on five galleries and around three hundred international artists and estates raises concerns about the extent of dealer influence on museum curation. Robert Storr, then dean of the Yale University School of Art, said about the *Art Newspaper* findings: "Curators are abdicating and delegating their responsibilities ... to more adventurous gallerists who, aside from the profit motive and in some respects because of it, seem in many cases to be bolder and more curious than their institutional counterparts."[94] New York artist William Powhida puts it more directly: "The curatorial message today might read: 'The best art is the most familiar art because the market is so smart. We are redundant!'"[95]

There is another anomaly in what museums show, a version of the economist's idea of sunk costs. A donor will gift a museum a work that the museum (or donor) publicizes as having high monetary value. Sometimes the work has been purchased at auction for the purpose of donation. The museum now is under pressure to hang the art for a long period of time—even if it is not of exceptional quality—because visitors have read about its value. This has been compared to a National Football League team having a first–draft choice player who receives a huge signing bonus but soon proves to be a marginal contributor. The team is under pressure to play him no matter how well he is doing, because the general manager feels pressured to justify his investment. Everyone seems to know at least one lawyer who claims he or she would like to leave law practice but anguishes about their own sunk cost—the years and tuition of law school, and the long hours put in before achieving partner status.

Sometimes a museum exhibit is motivated in part by the hope of future donations. In 2010, the New Museum in New York had an exhibition titled *Skin Fruit*, which showed work from the collection of Greek **175**

collector (and museum trustee) Dakis Joannou. He recommended that his friend Jeff Koons act as curator for the show. The *New York Times* referred to this arrangement as "museums renting out their reputations."[96] Museum director Lisa Phillips defended the show as a "public-private partnership."[97] It was considered a good show, although art critic Jerry Saltz wrote that Koons' curating "tells us more about Koons than it does about contemporary art, and he says it better in his own work."[98]

Another change comes when museum curators switch roles after leaving their museum positions. Über galleries hire former curators to mount exhibitions—sometimes of an artist the curator has shown at his or her previous institution. One curator was said to have been offered $350,000 plus a percentage of sales at the show, likely more money for several months of work than he had received in his last two years of museum employment. Involvement of a well-known curator reinforces perception of the gallery as museum-like in stature. The show nudges new artists and estates to sign up, and positions the gallery as the place to acquire or sell work from these artists and their peers.

A well-publicized example is that of John Elderfield, former chief curator of painting and sculpture at MOMA. Elderfield has organized two shows at Gagosian—one of Helen Frankenthaler, one of Willem de Kooning. He borrowed works from private collectors, museums, foundations, estates and other galleries. Institutions and private collectors are likely to look favourably on a request from a curator of Elderfield's stature. Others who have organized shows for Gagosian include Peter Galassi, formerly chief photography curator at MOMA; Robert Storr, formerly senior curator at MOMA and the Met; and Anya Hindmarch, an English designer of handbags and fashion accessories, and a trustee of the Royal Academy of Arts.

Several well-known museum people have moved to the commercial side. Paul Schimmel, former chief curator at LAMOCA, joined Los Angeles gallery Hauser & Wirth in 2013 to form Hauser Wirth & Schimmel. He said he would "focus on museum-type shows." Eric Shiner went from director of the Andy Warhol Museum in Pittsburgh to selling Warhols as a vice-president at Sotheby's. Arnold Lehman, retired director of the Brooklyn Art Museum, became a senior adviser at Phillips. The blurring of boundaries includes museum directors curating sections of art fairs, and collectors hiring curators to help design private museums.

There is a powerful economic explanation for why museum curators are reluctant to show unknown but promising artists, and for why many will be surprised to read about the audacious museum experiments undertaken by Arnold Lehman at the Brooklyn Museum and Maxwell Anderson at the Dallas Museum of Art. Museum curators and directors, like everyone else, make decisions based on loss aversion. This is one of the most important emotions in economic life; we all dislike and fear a loss more than we feel the pleasure of a gain of equal size. Offered a coin toss where a head earns $100 and a tail results in a loss of $75, most people would refuse to play. The pain of possible loss exceeds the pleasure of an equal probability of larger gain. Or perhaps in 2000 on a hunch you invested in Yahoo shares when they were over $100 and the share value was $128 billion. The value plummeted after your purchase. Logic told you to sell in 2008 when Microsoft offered $48 billion to acquire Yahoo, but your shares were still underwater. Selling in the interim would have meant admitting your mistake and accepting the psychic blow of a loss—which might have hurt more than the monetary one. In 2016, most of Yahoo's assets were sold for $4.8 billion.

In a museum setting, this is exacerbated by the perceived (and probably real) system of individual reward and punishment. Championing an initiative that produces a large gain will lead to modest recognition. If an action leads to a loss of equal size, the curator may get fired or at least suffer a blow to his or her personal brand and museum-world reputation.

In economics this is known as a principal-agent problem. Assume that an innovative but expensive art exhibit offers a 50-percent chance of $2 million in profit and publicity for the museum, and a 50-percent chance of a $1-million loss. The expected payoff of doing the exhibition is $500,000 (0.5 × $2 million + 0.5 × minus $1 million). This is a great gamble for the museum; if every exhibition had this payoff, there would be a high probability of profit for the institution at the end of a year. It would also offer the public a chance to see new and innovative art. But it is not a great gamble for the curator or museum director, for whom incurring a large loss, even after a long run of modest profits, has a large potential downside.

"You ... hear about billionaires [opening museums] who've otherwise been discreet during their decades of wealth accumulation."

—Nick Paumgarten, art journalist[99]

"What is the difference between a theme park, a museum and a tourist attraction, especially when the design of new museums has become increasingly sensationalistic?"

—Jonathan Glancey, architectural critic

PRIVATE MUSEUMS

MORE EVIDENCE OF THE ROLE OF WEALTHY COLLECTORS IN THE CONTEM-
porary art environment comes with the proliferation of private art museums.
A highly publicized recent example is The Broad, a 120,000-square-foot
Los Angeles museum that opened in September 2015. Dedicated to the
1960s-and-onward collection of Eli and Edythe Broad, the spectacular
$140-million building across from Museum of Contemporary Art, Los
Angeles (LAMOCA) is a step in what Eli Broad says is his mission to turn
Los Angeles into a hub of the contemporary art world.

An interesting commentary on the publicity contemporary art re-
ceives is that Eli and Edythe Broad are better known in their role as art
patrons than for their donation over twenty-five years of $800 million to
Los Angeles charities, or their 2003 founding of the Broad Institute at
Harvard and the Massachusetts Institute of Technology. Gene-therapy
technology arising from this grant offers the promise of cures for diseases

as diverse as diabetes, autism, Alzheimer's and cancer. The art component of their philanthropy gets far more media coverage. A cover story in *Los Angeles Magazine* described Eli Broad's primary significance as having "more art than the Getty" museum (which is factually incorrect).

Eli Broad originally intended to donate his collection to LAMOCA, where he had both funded a building that carries his name and rescued the museum from a financial crisis. A dispute with the then director of the museum over how many of his works would be displayed at any one time caused him to drop the idea of a donation in favour of constructing his own museum.

The Broad opened with two thousand works, among them thirty-four by Jeff Koons, thirty-nine by Roy Lichtenstein and a Takashi Murakami painting that is 82 feet (25 metres) long. The Broads also provided a $200-million endowment plus funding for new acquisitions. That is a larger endowment than any museum in Los Angeles other than the J. Paul Getty Museum.

The major media criticism of The Broad has been that the collection features the same artists and art schools that commercial galleries are showing. That is true. The collection is primarily work first shown in New York in the 1970s, '80s and '90s. Most artists represented are white, male and from New York or Los Angeles. The works are painting and sculpture rather than film or performance art. The collection is not European or Asian, not Black or Latino. But the "narrowness" criticism is unfair. The Broad, like other private museums, reflects what the donors collected and wanted to have shown.

The concept of private museums is not new. In the nineteenth and early twentieth century, collectors Andrew Carnegie, John Pierpont Morgan, Henry Clay Frick and Huntington Hartford created world-class art collections intended to be shared with the public. In the twentieth century, personal collections were the basis of the Barnes Foundation in Philadelphia, the Whitney and Frick collections in New York, the Phillips Collection in Washington, DC, and the Isabella Stewart Gardner Museum in Boston. After the death of J. Paul Getty, his home near Malibu and his collection became the Getty museum.

The Getty is an extreme example of what a private museum can become. The philanthropist left the museum four million shares of Getty oil stock, worth $1.2 billion at the time the legacy was disbursed. Getty

put few restrictions on the institution he was funding; its purpose was simply "the diffusion of artistic and general knowledge."[100]

More recently, a number of art foundations have been established with galleries open to the public—the Italian Fondazione Sandretto Re Rebaudengo in Turin in 1995; Ron Lauder's Neue Galerie of German and Austrian Art in Manhattan in 2001; Guy and Myriam Ullens' Center for Contemporary Art in Beijing in 2007; Alice Walton's Crystal Bridges Museum of American Art in Bentonville, AR, in 2011; and Bernard Arnault's Fondation Louis Vuitton museum in a spectacular Frank Gehry building in Paris in 2014 (see photo insert after page 96). There is also Liu Yiqian and Wang Wei's Long Museum in Shanghai; Dasha Zhukova's Garage Museum of Contemporary Art in Gorky Park, Moscow (2015); and Tony and Elham Salamé's Aïshti Foundation (Aïshti being a contraction of "I love you" in Japanese) in Beirut (2015).

The Broad, Getty, Walton and Louis Vuitton spaces are custom-built. Some of the others, like the Fondazione in Turin, are in converted factories. Garage is in a prefabricated restaurant pavilion that dates to 1968. Aïshti is in a shopping mall. At one extreme, there are fabulous collections being shown. At the other, there are small local vanity projects that reflect the founders' wealth while providing tax shelters.

Several artists have also opened private museums to show collections of other artists' work. The best known is probably Damien Hirst's Newport Street Gallery in London, which has shown work by Jeff Koons, including one of the *Play-Doh* series.

The most common criticism of private museums is their tax status. This has come under particular scrutiny in the US with concerns about income inequality and policies that favour the rich. Donors can deduct the fair market value of art to reduce taxable income by as much as 50 percent each year.

In May 2016, US Senate finance chairman Orrin Hatch reported on what might be the first stage of future rule changes for these not-for-profit institutions. He wrote to eleven museums asking for information on opening hours, attendance and grant activities. One private museum that was mentioned as benefiting from tax treatment lies only 24 kilometres from Hatch's office in Washington, DC; Glenstone, in Potomac, MD.

It is the creation of industrialist Mitchell P. Rales and his wife, Emily Wei Rales. She is a former curator and dealer. Glenstone is a **181**

contemporary art museum showing works by Alberto Giacometti, Willem de Kooning and Jackson Pollock. It is set in a 200-acre estate with sculptures by Ellsworth Kelly, Richard Serra and Jeff Koons. The museum name derives from the location—Glen Road, with stone quarries nearby. When Glenstone completes an expansion in 2018 it will have 60,000 square feet of display space, more than the Whitney Museum of American Art in New York.

Glenstone has always required reservations, because the Rales are concerned about overcrowding. They commissioned studies on the amount of room needed to display art comfortably. The answer was 30 square feet per visitor: a third for personal space, a third for the art-work and a third for the viewing area. No public museum has restricted admission to this extent. A popular exhibition at a museum like the MOMA may leave each visitor with less than half that viewing area.

The Rubell Family Collection in Miami's art district opened in 1996. It is well known to visitors to the Basel Miami art fair each December. Another private museum is The Brant Foundation Art Study Center, located in a converted 1902 stone barn in Greenwich, CT, near the estate of founders Peter Brant and his wife, Stephanie Seymour.

Glenstone and the Rubell and Brant museums are nonprofit, tax-exempt charitable foundations. Their founders (and other donors) can deduct the market value of art, cash and stocks they donate. The tax status of the foundations has created debate on what form public benefit should take in order to qualify for a tax exemption. US tax guidelines are unclear. Benefits can be public access, educational outreach or loaning works. Brant's foundation organizes travelling exhibitions and sponsors children's workshops.

Then there are the mini-museums, which are open only occasionally to friends of the founders and for charity events, and generally (but not always) are without tax-exempt status. Steve Tisch, owner of the New York Giants Football Club and a movie producer, has a backyard mu-seum behind his Benedict Canyon home in Los Angeles. The collection includes works by Gerhard Richter and Ed Ruscha.

A strong motive for establishing a private museum is that public museums are selective about what they accept. The issue is not just quality or authenticity, but whether the work fills a gap in the museum's collection. Many art museums won't accept cutting-edge contemporary

art; several have rejected significant works by Jean-Michel Basquiat. An advantage of a private museum is that the donor retains control of the collection and can show it all at one time. The donor gets to curate how the art is exhibited, and what to add or deaccession.

This idea of wealthy founders of private museums using tax-deductible money to improve the relative importance of artists they favour in art history produces criticism. A frequently cited example is the new fame of Gustav Klimt, seen as one among many Austrian symbolist artists until Ron Lauder paid a then-record $135 million in 2006 to acquire *Adele Bloch Bauer I* (1907) as "Our Mona Lisa" for his Neue Galerie in New York.

The concern about influencing taste is puzzling. Private museums are a minuscule part of a much larger phenomenon, the size and power of American social and charitable foundations. These have a combined endowment of about $740 billion and dispense $70 billion a year. The foundations are conduits for the rich to spend tax-free money to attempt to convert societies in the us and abroad to what donors think they should be. The Gates Foundation has an endowment of $40 billion. Over an eight-year period it spent $1 billion in twelve states to fund charter schools to replace public ones. Over the same period it spent $2 billion in forty-five us states to subsidize replacement of large public high schools with small ones. Both initiatives were aimed at improving accountability for teaching and learning. Diane Ravitch, a former us assistant secretary of education, said the foundation had self-declared itself America's national school superintendent. Almost no one paid much attention to the criticism, perhaps because many Americans saw any change in ossified school structures as desirable. More Americans seem to care about the display of private art collections that have not been professionally curated.

There is one great private museum in the world that is virtually unknown. It has what is almost certainly the best collection of twentieth-century Western art outside the United States and Europe. There are fifteen hundred works, including Picasso, Monet, Van Gogh, Rothko, Frank Stella, Wassily Kandinsky and Motherwell. There are twelve Jasper Johns and fifteen Warhols, alongside what some consider the best work produced by Jackson Pollock, *Mural on Indian Red Ground* (1950). This museum has no issues of tax avoidance, or founder meddling, or acquisition

183

policy. There are no plans for a stunning new building. It also offers no reference to the benefactors who assembled the collection.

The collection is in an unimposing building in central Tehran. The building title in Farsi translates as "Tehran Museum of Contemporary Art"—although few of the works would today be considered contemporary. It was assembled in the early and mid-1970s by Empress Farah Diba Pahlavi, the third wife of Shah Mohammed Reza Pahlavi; her cousin, the museum's architect and director Kamran Diba; and curators Fereshteh Daftari and Donna Stein.

Andrew Scott Cooper, who authored a biography of the shah, described Farah Diba as "the most accomplished female sovereign of the 20th century." She spent a decade turning Tehran into a centre of artistic and cultural life. The cost of the art collection to the empress and the state treasury at the time is hard to estimate because many works were acquired through private American and French dealers, and by purchasing entire collections. It was certainly in excess of $100 million, the equivalent of more than $2 billion today.

The collection opened to the public—at least to foreign residents of Tehran—in 1978. Empress Farah fled to the United States at the beginning of the 1979 revolution, which created the new Islamic Republic. The art remained in the current building, unseen for twenty years except for brief showings as part of political events. Empress Farah is now in her late seventies and lives in Paris and Washington, DC.

The museum reopened in 1999, displaying pop and Impressionist art but no nudes or art suggestive of homosexuality. Notably, Francis Bacon's great triptych *Two Figures Lying on a Bed With Attendants* (1968) is not displayed. It is in storage but available for viewing by non-Muslim foreigners who go through an informal request process. Admission to the museum itself costs the equivalent of less than one American dollar. A portion of the collection, but not *Two Figures*, was scheduled to travel to Berlin's Gemäldegalerie and to Rome's MAXXI Museum in 2017.

There is a great backstory to the stored collection. As might be imagined, during the twenty years the museum was closed and the work stored, government officials received many offers to purchase its masterpieces. Only one work was ever deaccessioned. The Iranian government wanted to repatriate the *Shahnama* ("Book of Kings") of Shah Tahmasp, a set of four-hundred-year-old miniatures owned by the Houghton family,

founders of Corning Glass in New York. After long and secretive negotiations, the miniatures were traded for *Woman III* (1952–53), an unwanted Willem de Kooning nude mentioned earlier in the book (Chapter 10). Zurich dealer Doris Ammann negotiated the exchange, which took place on the runway of the Vienna airport. Houghton sold the de Kooning to David Geffen. In 2006, Geffen sold it to Steven Cohen for $137.5 million. At the time of the Vienna airport exchange the *Shahnama* was valued at $6 million.

"In 40 or 50 years' time ... will Doha be as important in global art and culture as London, New York and Paris? It's possible. Why not? Let's talk again in ten years."

—Sheikha al-Mayassa al-Thani of Qatar in an interview with the London *Evening Standard*[101]

"I am highly moved by [Sheikha al-Mayassa's] vision and strong passion for art."

—Takashi Murakami, artist[102]

THE MOST INFLUENTIAL BUYER

IN MAY 2015, I ATTENDED IN A DINNER IN TURIN, ITALY, HELD TO HONOUR Her Excellency Sheikha al-Mayassa bint Hamad bin Khalifa al-Thani of Qatar. It was sponsored by art patron Patrizia Sandretto Re Rebaudengo, whose foundation awarded the Sheikha the StellaRe Prize. The award is an ornate ring designed by Italian artist Maurizio Cattelan. It celebrates women who "through their work, dedication, and innovative vision, have opened up new perspectives across a diversity of fields."[103]

Sheikha al-Mayassa is the chairperson of the Qatar Museums Authority (QM). Born in 1983, she is the sister of the Emir of Qatar. Her father is the former emir. In 2015, and almost certainly in years prior, she managed the largest art acquisition budget in the world. Many consider that she—rather than an artist, dealer, auction house executive or museum director—is the most important person in the world of contemporary art. She has been called a desert Catherine

de Medici. She is certainly the most influential buyer; she reflects the internationalization of Western art better than any other individual I can think of.

Others agree with her importance. In 2013, the magazine *ArtReview* rated the Sheikha the most influential person in art. In 2014, *Time* magazine named her one of the one hundred most influential people in the world. Also in 2014, the *Economist* called her "the art world's most powerful woman." *Forbes* named her one of the world's one hundred most powerful women.

To put the rankings in context, the next three people in the *ArtReview* power list were American dealers David Zwirner, Iwan Wirth and Larry Gagosian. They were followed by curators Hans Ulrich Obrist and Julia Peyton-Jones of the Serpentine gallery in London, and Nicholas Serota, director of the Tate Modern in London.

Qatar is 300 kilometres across the Persian Gulf from Abu Dhabi. A little larger than Connecticut, the country is best known as the home of TV network al-Jazeera, and for winning the competition to stage the 2022 football World Cup. The emirate has 1.8 million residents, of whom only 280,000 are citizens. Until the 1980s, Qatar exported little except pearls, and that industry was in decline. The discovery of oil and, later, the third-largest gas reserves in the world means Qatari citizens now have the world's highest per-capital incomes.

The long-term goal is to transform the country from a hydrocarbon economy to one that is knowledge- and culture-based. The Sheikha oversees institutions that include Mathaf: Arab Museum of Modern Art, the first museum in the region to focus on contemporary and modern Arab art; the Museum of Islamic Art, designed by I.M. Pei; and the Jean Nouvel–designed National Museum of Qatar. The latter is the showpiece—it covers 1.4 million square feet.

The extensive collection of Western art being acquired will be shown in a new contemporary museum, probably situated in the Art Mill, a converted flour mill and grain silo on Doha Bay. When completed, the Art Mill is intended to have 995,000 square feet of exhibition space. By comparison, the Tate Modern's most recent expansion resulted in that museum having 590,000 square feet.

The Sheikha has funded exhibitions to introduce Qataris to foreign art. She invited Chinese artist Cai Guo-Qiang, known for fireworks

art, to exhibit. At the Sheikha's insistence, Cai showed Arab-themed sculpture, with a taxidermal camel suspended in mid-air.

She has also exhibited Richard Serra, Takashi Murakami and Damien Hirst. She sponsored Murakami's 2010 show at the Palace of Versailles and Hirst's 2013 show at the Tate Modern, then transported each to Doha. Moving the Hirst exhibit from London to Doha was a logistical feat. The sculptures, vitrines and formaldehyde required for three Hirst shark pieces were flown from London to Doha in Qatar's Emiri Air Force transport aircraft.

Jean-Paul Engelen, former director of public art programs at the QM, recounts a great cultural anecdote from the Hirst show in Doha: "A group from a religious boys school saw Hirst's diamond-encrusted skull, 'For the Love of God,' and shouted 'Allahu Akbar' [God is great]. ... They totally understood the message that we are all mortal."[104]

Western museums acquire 90 to 95 percent of their art through gifts and bequests from collectors. All art for the new Qatari museums must be purchased. This is more challenging than it may seem. The Sheikha has spent record amounts on Andy Warhol and Damien Hirst. Justifying the acquisition of Islamic and Orientalist art would have been much easier.

Several sources, including *Bloomberg*, have reported the QM art acquisition budget at $1 billion a year. To put that in perspective, the Museum of Modern Art in New York has an annual acquisition budget of about $35 million—one-thirtieth that of the QM. The Metropolitan Museum has $40 million. The Centre Pompidou in Paris has $4 million. The only budget comparable to that of the QM would be that of the new Abu Dhabi Louvre and Guggenheim museums, although it is doubtful they have spent anywhere close to $1 billion in one year. The closest Western museum would be the Getty, but its (highly confidential) expenditure has probably only in a few years exceeded $100 million.

The impact of the Sheikha's purchases on art prices—and on our perception of the value of modern art—is substantial. Paul Gauguin's *Nafea Faa Ipoipo* (*When Will You Marry?*) (1892), a painting of two Tahitian girls, was purchased in 2014 in a private transaction for $300 million. This is thought to be the highest price ever paid for a work of art, and four times the highest previous price for any Gauguin. *Nafea* is an important work, but not considered among the top ten Gauguin paintings.

Until the QM's 2007 purchase of Mark Rothko's *White Center* (*Yellow,* **189**

190 *Pink and Lavender on Rose*) (1950) for $72.8 million at Sotheby's New York, the highest auction price for the artist was his *Homage to Matisse* in 2005 for $22 million—less than one-third the *White Center* price. In 2011, the QM spent $250 million for Paul Cézanne's The *Card Players* (1893). That was four times the highest public price ever paid for a work by that artist.

The Sheikha purchased Damien Hirst's *The Golden Calf* (2008) (see photo insert after page 96), a bull preserved in formaldehyde. It has eighteen-carat gold hooves and horns, a gold Egyptian solar disc on its head and outsized reproductive organs. The acquisition came for £10.3 million ($18.7 million) at Hirst's single-artist sale at Sotheby's London in 2008. The Sheikha and the QM have also acquired works by Bacon, Warhol and Lichtenstein.

There are fascinating backstories to some of the Sheikha and QM acquisitions; they illustrate the huge clout and determination of foreign collectors in the world contemporary art market.

The seller of the record-price Gauguin was Rudolf Staechelin, sixty-two, a retired Sotheby's executive living in Basel, Switzerland. Through a family trust, Staechelin controlled an important collection of Impressionist and post-Impressionist works. The art was acquired after the First World War by his grandfather, a Swiss merchant also named Rudolf Staechelin. Nineteen works—the Gauguin plus works by Van Gogh, Picasso, Camille Pissarro and others—had been on loan to the Kunstmuseum Basel for fifty years. Staechelin told the newspaper *Basler Zeitung* that he was unhappy that the Kunstmuseum director would not commit to hanging the works in prime locations in the museum, or to displaying all the art all the time. Staechelin withdrew the works from the Kunstmuseum.

A Swiss dealer with knowledge of the dispute approached Qatar authorities and said that a "blockbuster offer" might induce Staechelin to sell the Gauguin or other paintings, and without any need to seek a competitive offer—notably not from the Abu Dhabi museums. The record-breaking figure resulted. Whether other works withdrawn from the Kunstmuseum were also offered to Qatar is not known. Staechelin was said to be negotiating with other museums to accept the remaining paintings on his terms. In the interim, sixteen of the works were offered on loan to the Phillips Collection in Washington.

In 2011 the art amassed by deceased Greek collector George

Embiricos was offered for sale by his estate. The most notable work was Cézanne's *The Card Players*. Four of Cézanne's five card-player paintings are in the Met in New York, the Musée d'Orsay in Paris, the Courtauld Gallery in London and the Barnes Foundation in Philadelphia. In 2011, *ArtNews* magazine listed the Embiricos version of *Card Players* as one of the world's top artworks still in private hands.

When it was known that *Card Players* might be available, art-world rumour had two dealers—Larry Gagosian and William Acquavella—each making unsolicited offers to the estate of between $220 and $230 million. The Qatar Museums Authority then offered $250 million, also with the condition that there would be no negotiating or seeking a counter-offer. Take it or leave it. The estate took it. The Cézanne may be the QM's star acquisition to date. It is a major image, reproduced in every "Introduction to Art 101" text.

Qatar was also thought to be the new home of the Merkin Rothkos, following a $310-million, court-ordered sale in New York. J. Ezra Merkin had assembled what was considered the best private collection of Mark Rothko paintings in the world. Merkin was sued over his role as a provider of financing in the Bernie Madoff fraud saga, and needed to liquidate some of his collection. The story is that Russian collector Roman Abramovich opened bidding for the Rothkos with an offer in the high $200 millions (he later denied it). Qatar countered with $310 million, said by one dealer to be valid for a short time, perhaps only forty-eight hours. The Rothkos rank a strong second to the Cézanne in star power. The acquisition of the Merkin collection was one of the most impressive art-buying coups of the decade.

Several dealers told me that QM purchases included Andy Warhol's *Men in Her Life* (1962), a 6½-foot-tall (2-metre) silkscreen highlighted with pencil, of photos from a *Life* magazine feature on actress Elizabeth Taylor. The canvas has thirty-eight blurred images in seven rows. There is Taylor at the Epsom Derby with Mike Todd, her third husband, to her left, and Eddie Fisher, soon to be husband number four, on her right. Beside Fisher is his then wife, actress Debbie Reynolds. The silkscreen has little visual impact; it's hard to make out the images from more than three feet away.

Men in Her Life was hammered down at Phillips New York in November 2010 for $63.4 million, at that time the second most expensive Warhol ever at auction. The backstory of Taylor, Fisher, Reynolds and **191**

Warhol attracted a lot of attention from Western media. It is doubtful whether many Qataris would understand or appreciate it. In retrospect this may be the least impressive of the QM's contemporary acquisitions.

There are other examples of Qatari art-buying. In 2009, the QM purchased William Hoare's 1733 *Portrait of Ayuba Suleiman Diallo* (also known as *Job ben Solomon*) for £540,000 ($890,000) at Christie's London. *Ayuba* is the first known English portrait of a freed Black African Muslim slave. The UK government turned down an application from Qatar for an export licence. The expectation was then that the National Portrait Gallery would try to raise matching funds to retain the portrait.

Normally when an export licence is declined the art buyer defers to the licence authority and allows a British museum to purchase the work. In this case the QM withdrew its application. That meant there was a compulsory year-long waiting period before a reapplication could be considered. The QM agreed that the portrait would go on an extended UK museum tour, then for a five-year loan to the National Portrait Gallery. It was assumed this was done in return for the portrait gallery's agreement not to oppose the QM when it filed a future export application.

Commentators express dismay that these and other acquisitions result in ownership of cultural treasures determined by the vagaries of international wealth distribution. That may be true, but that is how the art world functions. Power at the national or international level is simply the ability and willingness to bid until all others drop out.

Sheikha al-Mayassa is the fourteenth child in her royal family. She holds a 2005 BA in political science and literature from Duke University. During her junior year she did an overseas semester at the Sorbonne. Both she and her husband, Sheikh Jassim bin Abdul Aziz al-Thani, did postgraduate work at Columbia University before returning to Qatar. She has no formal training in art or art history, but those who know her describe her as self-educated and very knowledgeable.

In a 2012 interview with the *New York Times*, the Sheikha said she hopes that Qatar's new art institutions will help change both Western conceptions about Muslim societies and Islam's perception of the West. She said she hopes to "nudge" (her term) the more conservative elements of Qatari society toward the modern artistic world. "It is a good thing to celebrate Western art in this region. You have to accept, appreciate and yes, learn from different cultures."[105]

The artistic limits of what the QM will show are not always what a Westerner might expect. In 2013 the Sheikha mounted an exhibit outside a new medical facility in Doha. Titled *The Miraculous Journey*, it consisted of fourteen Damien Hirst bronze sculptures of the gestation of a human fetus, beginning with a sperm fertilizing an egg and progressing to a 46-foot-tall (14-metre) anatomically correct baby boy.

One artistic red line would be expected to be female nudity, almost never seen in exhibits in the Middle East. The Sheikha has said that there would be no restrictions on works displayed in Doha, even on nudes. She has had to backtrack at least once. Statues of nudes from Greek antiquity that were to be shown in the city were returned to Athens after QM officials refused to display them. Jean-Paul Engelen says he dislikes this story. "This is a different, family-oriented culture; to put a message across, it's better to include people than to exclude them."[106]

Two of the Sheikha's competitors for art acquisitions are the proposed new museums on Saadiyat Island in Abu Dhabi. These are a Guggenheim Abu Dhabi, designed by Frank Gehry, and a Louvre Abu Dhabi, designed by [Norman] Foster + Partners. As of 2016, construction of the Guggenheim had been suspended for three years but was expected to restart. These museums challenge Qatar for art acquisitions because each emirate believes there is room for only one branded "destination museum" in that part of the world.

The Abu Dhabi acquisition process has become what the government refers to as "measured," which means slow. Earlier in the acquisition process, a museum official made a purchase decision that the Sheikh challenged as overpriced and irresponsible. There is now a vetting stage by an acquisitions committee comprised of foreign curators and representatives of the Abu Dhabi government. This is a sufficiently long process that several dealers say they have sold work elsewhere rather than wait months for a committee decision.

The Qatar decision process can be very fast. Qatar has acquired works that were only to be offered to Abu Dhabi if Qatar rejected them—and in at least one case were first requested by Abu Dhabi, with the purchase decision stalling. Abu Dhabi is instead acquiring art through loan, most recently in 2015 by renting five hundred objects from the British Museum for a five-year period, in return for an undisclosed fee. What the Sheikha is attempting is uncommon in another way. New museums are

193

194 built on the foundation of a community of artists, collectors, curators and commercial galleries. Qatar is building in reverse. There are few artists, experienced curators, contemporary dealers or collectors. The museums are coming first, and will take longer to achieve full acceptance. In 2014, Qatar's Mathaf averaged 1,450 visitors a month, less than 100 a day. Half those visitors were foreigners.

The long-term impact of the Sheikha's collecting on contemporary art prices also creates concern. When Qatar and its cousin museums in Abu Dhabi complete their purchasing programs, many works that come up for auction with high reserve prices may go unsold. Or the Sheikha's collecting tastes may change, or she might have a successor who decides to pursue only Middle Eastern art. Would any of these be sufficient to seriously deflate the art price bubble?

Early 2015 brought elevated speed bumps on this bridge between East and West. There were renewed allegations about the way that Qatar won the right to hold the 2022 World Cup football competition. More painful were allegations that the country's football stadiums were being built by third-world migrant workers.

The issue was the events, but more importantly how the Western press would cover them. The opinion of most art-world officials seemed to be that international criticism ignored the subtleties of power in the region and the cause of moderate Islam. The argument continued that conservatives and others who opposed globalization gained ground each time international organizations and news media put pressure on the government.

If highly critical media stories continue, it is unclear how many Western tourists might in the near future want to visit the emirate to see the new museums, even with the lure of Cézanne, Rothko, Hirst and Warhol.

THE
BUBBLE

"The price of a work of art is an index of pure, irrational desire."

—Robert Hughes, art critic[107]

"I'm really not optimistic [that individuals can debias themselves]."

—Daniel Kahneman, behavioural economist and Nobel laureate[108]

GAMING THE ART BUBBLE

BALLOON DOG (ORANGE), *APOCALYPSE NOW*, POPEYE, THE EXPANSION OF freeports—these and other indicators all point to the contemporary art market as a looming price bubble. That outcome is, in my view, a certainty. The main explanation for the huge sums of money changing hands is wishful speculation, both for iconic works of art and for work by emerging artists. Economics students learn that all things are cyclical and that speculation-driven cycles are wilder. No luxury good (or commodity) can increase in value at many times the annual rate of growth in GNP—or grow as a percentage of disposable income—for very long. A quote attributed to Herb Stein, chair of the US Council of Economic Advisers under president Richard Nixon, fits well: "If something can't go on forever, it won't." Some art price bubbles deflate slowly; sometimes the bubble bursts. Whatever the rate of deflation, the likelihood is that it will happen sooner rather than later.

Sometimes bubbles deflate with dramatic impact. The most recent art bubble appeared in the second quarter of 2008. The final three months of 2007 saw the beginning of an economic recession, and art prices followed stock market and housing prices downward. There was a five- to seven-month lag in the drop in auction prices; prices for art at auction were propped up by auction house guarantees offered months earlier. Price levels in contemporary art auctions in Hong Kong, Beijing, Dubai and Moscow all cratered in the second half of 2008.

Many 1-percenters continued to buy art, but offered lowball bids at auction or demanded high discounts from dealers and private sellers. Few works were offered at auction with estimates over $1 million. Auction specialists told potential bidders that estimates could be ignored. That meant that reserve prices (below which the auction house will not sell) had been lowered by concerned consignors. This was happening when (as is still true) interest rates were close to zero.

By mid-2009, prices for museum-quality contemporary art had stabilized, down between 10 and 15 percent from early 2007 levels. The number of $1-million-plus contemporary sales at auction dropped almost 80 percent from 2007 to 2009. Prices in the middle third of the contemporary market were down 40 percent; in the bottom third, down 50 to 60 percent.

About 15 percent of New York and London galleries closed their doors in the eighteen months beginning in February 2008. Every gallery that closed left twenty-five to thirty artists orphaned, without dealer representation. Other dealers relocated to less expensive quarters, or sold from apartments. From 2007 to 2009 the number of significant art fairs around the world shrank from 425 to about 225. Fairs that survived offered more conservative and moderately priced art to attract older buyers and older money.

The market began its upswing in early 2010. By mid-2011, prices at the top of the market had returned to 2007 levels. The middle and lower segments did not fully recover until 2012.

There are bubbles that are artist-, sector- or country-specific. Individual artist bubbles are common. These inflate and burst all the time, sometimes from speculation and changes in taste and fashion, sometimes from the exit of key buyers. German artist Matthias Weischer, represented by Galerie EIGEN + ART, had his large paintings go from a gallery price of €25,000 ($30,000) in 2004 to an auction price of £210,000

($305,000) at Christie's in 2005. His 2003 painting *Wand* (Wall) sold at £105,000 ($125,000) at Sotheby's London in 2006, went unsold with a €160,000 ($200,000) estimate at Berlin's Villa Grisebach Auktionen GmbH in 2008, then brought €48,000 ($58,000) at the same auction house in 2011.

There is tremendous speculation for the work of a few emerging artists, another signal of a bubble. Collectors chase these works with the hope of flipping them for a quick profit. The focus on emerging artists is partly from lower investment costs, partly because it is easier to establish (or pretend there already are) waiting lists and pent-up demand. Lucien Smith's 10-foot-tall (3-metre) painting of a "Winnie the Pooh" landscape, made by spraying paint from a fire extinguisher, sold at Phillips New York in 2014 for $389,000. Two years earlier, while Smith was still an art student at New York's Cooper Union, the same work sold for $10,000. In the interval, much of his output was purchased by speculators. Private dealer Alberto Mugrabi has said he owned at least twenty-five Smith works.

For five years starting in late 2009, the hope was that the Chinese or Russian markets would purchase Western art and prop up prices. This was a reasonable expectation. About a third of China's wealth and 25 percent of Russia's is in the hands of 1 percent of families in each country. China has more dollar billionaires than either the US or Western Europe. The formation of a super-rich oligarchy, first in Russia and then in with the *fuerdai* (second-generation children of the ultra-rich) in China, meant that there were many people without much experience in how the upper class spend, invest or protect their wealth. And there were many art advisers trying to help them spend.

This is a new version of an old idea. Thorstein Veblen in his 1899 book *The Theory of the Leisure Class* argued that wealth would produce conspicuous consumption. And this would, dealers hoped, result in the new Chinese and Russian leisure classes requiring ever-increasing amounts of Western art.

As it turned out, this had limits. After Chinese leader Xi Jinping implemented his anti-corruption drive with a crackdown on conspicuous spending and on "gifting," China's booming high-end art market shrank by a third in 2014 and a further third in 2015. (It rose a bit in 2016.) Russian demand for Western art dropped by half after President Vladimir Putin's "invest here" edict and later with the drop in the value of the ruble. **199**

Billionaires in both countries, along with newly rich from the Arab states, India and Africa, came to prefer investing and parking their families in high-end Western real estate owned through offshore entities.

The real question is why there is so little acceptance that there will be an inevitable price correction for high-end contemporary art. A partial answer comes in the findings of behavioural economists, who argue that our brains are hard-wired to make bad decisions about the near future. The most significant behavioural quirk is that we all expect that the future will resemble the recent past, that change will occur only gradually. It is too hard to analyze the implications of the extreme economic and political events we read about, so we generally ignore them. Consider the slump in oil prices that began in 2014, the commodities glut, the collapse of the Russian ruble, the slowing of the Chinese and Brazilian economies and art markets, the six-sided war in the Middle East, terrorist attacks in France, Belgium and the US, or currency volatility as countries sought competitive devaluation. Most auction specialists and dealers ignore these and offer a single forecast for future art markets. This single forecast is their response to wanting to believe that the future will be like the recent past. If change comes, it will be gradual and there will be time to react.

For art and other investments this often means that we buy when the market is rising, and we rush to sell when it is falling (when we should be buying). Research shows that investors are four times more likely to sell a stock that has risen 60 percent than one that has been flat. I have no doubt this is true of art held for investment purposes.

Some art insiders seem to view demand for art with the implicit assumption that business cycles no longer matter. The godfather of that dogma is Tobias Meyer, when he was chief auctioneer at Sotheby's. Meyer argued in 2006 that for the first time since 1914, art was in a noncyclical market.[109] His logic was that any downturn in US demand would be offset by new collectors from Russia, Asia, Latin America and the Middle East.

Meyer made an avoidable error: he equated the top 5 percent of the market, which had been globally integrated, with the remainder of the market, which was still predominantly national—Brazilians buying Brazilian art, Germans buying German art. A broad, no-longer-cyclical statement should itself have created concern that a speculative bubble loomed.

The bubble was there. Price levels in contemporary art auctions in

the US and UK, and in Hong Kong, Beijing and Moscow all cratered in the second half of 2008. Billionaires were, as Meyer also surmised, largely insulated from the recession. Those who continued to buy sought and received high discounts.

Christie's then chairman Brett Gorvy then offered another version of the Tobias Meyer outcome. "They are making billionaires faster than they are producing iconic works of art." But his underlying assumption of unending lust for Western contemporary art by new billionaires, wherever situated, may also be fallacious. It implies that future demand by the wealthy will be fundamentally different from that of the more cyclical past. It does not require much of a change in confidence or tastes to produce a dramatic shrinkage in Christie's estimate that there were about 150 people in the world who might bid for expensive art.

The irrational exuberance of the stock market before the crash of 1987, of the real estate market before 2008 and of the high end of the contemporary art market in 2016 reflects another behavioural economics phenomenon—call it the momentum effect. Groups of people, at an auction house luncheon, an art dealer reception or a private club dinner, inhale the preaching of unlimited promise of the art market (or of an individual artist) offered by the most opinionated person in the room. Group members nod agreement. To remain out of the market when everyone else is doing so well seems dumb, so you buy. Your subsequent recounting of short-term profits encourages others to follow.

Irrational exuberance in a rising art market is fed by auction house efforts—like those of Tobias Meyer—aimed at maintaining the impression of a boom. Prior to an auction, reserves are firmed up by guarantees or irrevocable bids. Artists like Jeff Koons are featured in auction publicity and in post-auction announcements. There are low opening bids, chandelier bids to build excitement, and an auctioneer creating tension among the last few bidders. Recall the *Balloon Dog (Orange)* auctioneer's comment "Don't let him have it." My favourite not-very-subtle auction bidding nudge was something that Amy Cappellazzo mentioned while relating her phone conversations with clients during an auction when she was still at Christie's. She said she tried to squeeze them. "I say, 'Listen, it's like you saw the most beautiful woman in the world at a bar, and you didn't ask her for a drink. What a loser!'"[110] That would certainly nudge me to bid again.

The phenomenon called anchoring also acts to maintain art prices during flat periods. Anchoring is one of the most powerful biases in economics. A consignor attributes a minimum value to an artwork based on what she paid for it. The collector, call her Sarah, refuses to part with her Damien Hirst butterfly-wing collage for $2 million because she paid $3 million—so that is what it is "worth," that is her anchor price. She holds to this concept even in the face of evidence that no one seems interested in purchasing at this price.

Sarah offers her Hirst to an auction house. The auction specialist is reluctant to accept it with a $3-million reserve, but even more reluctant to see it go to a competitor. The specialist tries to convince Sarah to agree to a $1.5-million reserve and a $1.5-million estimate. This is a lowball approach to consignor estimates, intended to attract bidders. It is the auction house's preferred strategy. The logic is that during the bidding process, those seduced by the low estimate become caught up in the endowment effect, and commit to progressively higher bids than they intended when bidding began. For the auction house, low reserves and estimates produce a high sell-through rate, and a high sold-over-estimate figure.

Sarah holds firm, insisting on her $3-million reserve, thus a $3-million to $4-million estimate. The high estimate range is not what the auction specialist wants, but it has an underlying logic. A risk-adverse bidder with no basis to judge the estimate may choose to bid to the low estimate or to the halfway point between low and high.

Having "no basis to judge" is another form of information asymmetry. Most potential bidders have no way of acquiring the same information the auction house specialist has about the work and its history. Failure to understand information asymmetry causes bidders to think that an auction is inherently self-regulating, that the amount other bidders offer is a reliable signal as to value. Bidders also assume that an auction house would never intentionally over-estimate value for fear of reputational damage. (That fear of reputational risk is what Volkswagen owners assumed about that company before the 2015 exhaust-rigging scandal. In a 2016 agreement to settle a class-action suit, Volkswagen agreed to pay each US owner of its problematic diesels $20,000 for loss of value and to compensate for angst caused by the company's misleading claims, and $2.1 billion to 105,000 Canadian owners.)

The auction house takes the consignment and tries to compensate

for Sarah's anchoring bias in two ways. One is to emphasize in auction promotion the past prices that Hirst works have achieved. Past prices are relevant because they imply to a hesitant bidder that there is some component of artist value that is known to others.

It is not only small-scale collectors for whom anchoring becomes significant. Consider New Yorker Jose Mugrabi, who with his sons Alberto and David have the biggest Warhol collection in the world outside the Andy Warhol Museum in Pittsburgh. The family has said there are at least eight hundred works, with some outside estimates higher. Beyond Warhol, the Mugrabis own three thousand works, including one hundred or more by each of Hirst, Jean-Michel Basquiat, George Condo and Tom Wesselmann. The family members collect, but are also private dealers on a massive scale, buying and selling works through dealers and in auctions.

Mugrabi purchases and sales are carefully tracked by other art investors. The market anticipates that the Mugrabis will hold rather than sell if there is temporary market weakness. They will accept earlier "valuation" as an anchor. But what happens if the Mugrabis, for whatever reason, decide to sell off Warhol, or Hirst or one of their other artists-held-in-bulk? The anchor they were expected to observe now disappears. Trade papers would all have a version of the same headline: "The Mugrabis Are Selling, the Mugrabis Are Selling." When insiders are seen to be dumping art, particularly when there is concern about a looming bubble, regular investors get nervous. The easy prediction is that other collectors-in-bulk—Peter Brant or S.I. Newhouse Jr.—would immediately decide to sell, as happens in financial markets when there is a disruption.

In the art market this can be even more disastrous than in financial markets. When the market for an artist's work is seen as illiquid, it is hard to sell at any price. No collector wants to be last out the door, or the first to get rejected for inclusion in the next auction catalogue.

How do you take all this into account and still game the art market and its looming bubble? First, have this tattooed on your arm: "The past is not a guide to the future." Then write down a range of possible future outcomes for the art market, and beside each, the sequence of events that would be required for each outcome to occur. Consider major economic events. How likely are we to repeat the stock-market crash of October 1987, the Asian collapse of the late 1990s, the crashes of the real estate **203**

and art market in 1990 and 2008, and the worldwide but short-term stock-market slump of 2015?

You might think that these were low-probability events, that they can be ignored. But ignoring such events is another cognitive bias that affects investing, an understandable confusion of the concepts of probability and risk. These are different things. Risk is the probability of an event times its magnitude. What is seen as a low-probability event—the mortgage crash of '08—was disastrous because its magnitude was huge. Do you want to totally ignore the probability of a 30-percent slump in the North American real estate and stock market? Think of other examples where an investor has been blindsided by a very low-probability event.

The bias toward optimistic outcomes is seen in many other facets of life. Various surveys show that between 5 and 10 percent of heavy smokers think they might develop cancer; 90 percent or more are confident they will not. Fifty-eight percent will develop cancer.

We may accept that a negative event might occur, but prefer to assume it will take place a few years in the future—certainly not next week. In 2006 and 2007, every US real estate economist knew there was going to be a peak in resets on adjustable-rate mortgages in 2008 and 2009. They knew that because 2005–06 was the peak time for sales of homes with three-year, low introductory-rate mortgages that would reset after that period. It was hard to avoid the conclusion that there would be a mortgage crisis and resulting housing price slump that would impact the whole economy, likely beginning in 2008. Many observers did avoid it with the hope that something good would happen to minimize the impact, or that others would not notice what was happening. Investors kept investing in real estate and stocks (and art) through 2008.

After the "future outcomes" exercise, here is a second. Assume you have spotted a desirable work of art that is available for $10 million. Should you buy it as an investment? Say you want to achieve a 15-percent return on that investment, over and above costs. Work backwards from your target. What conditions are needed to achieve this 15-percent figure over a five-year period? You would have to net $20.1 million, so you have to gross about $24 million on resale after five years, to cover commissions, insurance, the cost of capital, and still earn 15 percent.

What do you believe, not only about the future state of the economy but also about the demand for art and the demand for this particular

artist and period? Try to develop a range of likely scenarios that would permit that $24-million sale. Look at market conditions over different five-year periods in the past. Do you need a particularly good five-year period, or would an average period be enough? You obviously can't do it with a bad one. What this exercise does is force you to abandon the easy bottom-up analysis, like simply asking your dealer or another collector what they think about the future.

A third exercise is to write a pre-mortem; this is a retrospective that you pretend is written in the future. You are writing five years from now, to explain the failure of the investment under consideration now. The pre-mortem forces you to commit to a considered analysis and listing of what could happen. If you don't get around to doing the pre-mortem, do a post-mortem after an investment disappoints. What did you not consider? Why should you have foreseen this outcome?

In either the top-down analysis or in a pre-mortem, don't focus on a single descriptor: "very good," "good," "not so good," "very bad." Most successful planners use at least two variables when thinking about the future. The variables must be independent of one another (e.g., "continued acceptance of current Brazilian artists" and "whether my job will continue to pay big annual bonuses"). If the variables are related (e.g., "my bonuses" and "the state of the economy"), in reality you are considering only one variable.

Think of the future demand for a work of art as at least somewhat related to four different variables: the strength of the national (or world) economy; the continued demand for art as a positional good; the desire for art as an investment good; and the demand for the work (or style) of a particular artist. Four variables produce twenty-four possible outcomes. Only one of these is the status quo. More than half the twenty-four possible outcomes will be negative for your investment in a particular artwork.

Many of the variables are determined by almost unpredictable events: an artist being taken on (or dropped) by an über dealer; a newsworthy backstory created for the art or artist; or fortuitous luck. Luck or randomness does play a huge role. The best example I know involves Leonardo da Vinci's *Mona Lisa* (1503–16) in the Louvre, the best-known painting in the world. It is undoubtedly a marvellous work, but why the best-known? Prior to 1911, Leonardo's two best-known works were *The Last Supper* (1495–98), now at the Convent of Santa Maria delle Grazie in Milan, and *The Virgin and Child with St. Anne* (1503–1519), also at the Louvre. **205**

Mona Lisa was stolen from the Louvre in 1911 by maintenance worker Vincenzo Peruggia, an Italian who kept the painting in his apartment for two years before trying to sell it to the Uffizi Gallery in Florence. (Pablo Picasso was high on the investigators' list of suspects, but was cleared.) There was continuous publicity, first around the theft, then around Peruggia's arrest. *Mona Lisa* was reproduced on the front page of many of the world's newspapers and magazines, with extravagant descriptions—which the Louvre provided—of its importance and value. The work vaulted from "a top-ten Leonardo" to its current status.

Back with my third exercise on writing a pre-mortem, it can be made fun. Try giving the scenarios catchy names—"disasterville" for the worst scenario and "nirvana" for the best, for example. Moderate outcomes can be "deep embarrassment" and "barely tolerable." For a more creative twist use music titles—"Gloomy Sunday" and "Time to Say Goodbye," or "I Lost My Heart to a Starship Trooper" and "Beautiful." And yes, I am a Sarah Brightman fan. Then figure out the risk you are taking, and multiply the probability of failure by how important that failure would be to your total investment portfolio.

The hardest part of my art exercise is the final step, estimating future demand for the work of a particular artist. In the art market, this means choosing the artists or at least the schools of art that will be in favour five years hence. You have to guess what artworks other people are guessing that others are guessing will be in favour. Dealers or collectors who insist they know that particular artists (whom they represent) will be more valuable five years hence are guessing what collective wisdom will conclude in the future.

The response of my partner, Kirsten, to reading about the exercises was, "No one would ever do all that!" But you would do a similar analysis if you were spending millions of dollars on an income property or an initial public offering of stock. Should you not make the same effort for an art investment?

Perhaps Kirsten is right. In that case, throw up your hands and abandon estimating uncertainty and risk. Instead, use a mental heuristic, a shortcut to making a judgment. Avoid answering a hard question and instead pose an easy one. Think, "Have I ever heard of anyone losing money on an art purchase from very low-probability potential art market risks?" If the answer is no, take a deep breath and buy the art. Understand

that a lot of managers (and my former MBA students) exhibit the same behaviour, best illustrated by huge over-optimism leading to corporate mergers and acquisitions that fall short of hoped-for synergies of cost and revenue.

People have been guessing about investment art for a long time. Consider the story of Thomas Holloway, inventor of Holloway's Pills and Ointment. Holloway was a self-made millionaire and a renowned philanthropist in the Victorian era. In 1882, and with the advice of the keeper of Queen Victoria's art collection, he speculated the then-outrageous sum of £6,615 on Edwin Long's *The Babylonian Marriage Market* (1875) (see photo insert after page 96), at the time a record price for any British artist. The picture shows young women in Assyria being auctioned off as brides—the tale depicted comes from Book 1 of Herodotus' *Histories*. Other great artists of the time that Holloway publicly considered and rejected for purchase were Jules Breton and Ludwig Knaus.

The following year, just before Holloway's death, an effort was made to resell the Long. The best offer was reported as £2,500. Several selling efforts following Holloway's death were unsuccessful. *Marriage Market* is today in the picture gallery of Royal Holloway College in London (which Thomas Holloway founded).

Edwin Long and the work are little known today, although several of Long's paintings are in the National Gallery in London. Jules Breton and Ludwig Knaus are more obscure.

Postscript

MATERIAL IN THE BOOK COMES FROM MY OWN EXPERIENCES AND ADVEN-tures in the contemporary art world, from personal interviews and from secondary sources. Some of the anecdotal material and some estimates are single-source. Often when I tried to confirm a story by a dealer or auction specialist, other sources agreed that it "sounded right." In the art world, this often means the version others heard originated with the same source as mine. Even material confirmed by multiple sources may be an art-world urban legend. Treat anecdotal material in the book as legend that I hope closely mirrors art-world reality. The text is not footnoted (except for endnotes to provide quote citations) because the book is intended as a journey through the curious world of high-end contemporary art rather than as a reference text.

I offer two disclaimers. One originates with economist Tim Harford and applies wonderfully to this book. "Seeing the world through the eyes of an economist is rather like seeing it through the ears of a bat. We notice a lot that others miss, and we miss a lot that others notice."[111]

The second disclaimer comes with the journalistic maxim that a writer, even an economist, should never be part of the story. The artists, collectors, dealers and auctions I write about were chosen to illuminate features of the art market. In a few cases I have been part of the story. Several times I have invited the subject of a story to read a draft and offer corrections or additions.

The insert section includes a number of art images. In a perfect world,

the collection would have been different. There were images that were not available, and some I could not use because the artist's representative asked for conditions that I could not meet.

Some material in the book has previously appeared in different form, in my writing for *The Times* (London), *Harper's Art* (China), *Fortune* (US), *Apollo* (UK), *Canvas Daily* (Dubai) and the *National Post* (Canada). Several of the headings were appropriated from other sources. "Art, Pay, Love" is a headline from a 2014 *Fortune* magazine review by Shalene Gupta of my art market book *The Supermodel and the Brillo Box*. "High School with Money" is from Jerry Saltz, a wonderful art writer whom I have quoted in this and my other books. "The Art of More" is from a 1997 BBC television art documentary, and more recently was used as the title of a 2015–16 art-world television drama on Crackle, a streaming video channel.

As is obvious from the text, I have had extensive input from active and former dealers, auction house specialists, collectors and others in the art world. Some demanded that they not be identified by name or position. One offered to cut off both of my typing fingers if I even accidently identified him as a source. I have refrained from retelling some of the best stories where a source would be too readily apparent.

Many of those I spoke with, for this book and the previous one, did not request anonymity. They are, in alphabetical order and again with my thanks: Her Excellency Sheikha al-Mayassa bint Hamad bin Khalifa al-Thani, museum director, Qatar; Rita Aoun-Abdo, Tourism and Culture Authority, Abu Dhabi; Oliver Barker, Sotheby's; Charlotte Burns, formerly *The Art Newspaper*, now Art Agency, Partners at Sotheby's; Donald Burris, art attorney, Los Angeles; James and Jane Cohan, James Cohan Gallery; Stephane Cosman Connery, formerly Sotheby's and a partner at Connery Pissarro Seydoux, now a private dealer; Michael Findlay, Acquavella Gallery; Melanie Gerlis, *The Art Newspaper* and the *Financial Times*, London; Christiane Fischer, AXA Art Insurance; Ellsworth Kelly, artist (died December 2015); Angela Lee, Northwestern University, Illinois; Richard Lehun, Stropheus Art Law, New York; Alex Logsdail, Lisson Gallery, New York; Nicholas Logsdail, Lisson Gallery, London; Aaron Milrad, collector and art lawyer, Toronto; Pilar Ordovas, Ordovas Gallery, London; Beatrice Panerai, Class Editori, Milan; Judith Prowda, Stropheus Art Law, New York; Patrizia Sandretto Re Rebaudengo, art patron, Turin; David Schick, Consumer Edge Research, luxury goods **209**

investment specialist in Washington; and Ossian Ward, art critic and author, London.

There are several writers whose knowledge and insights on the art market I follow and treasure. These include Art Basel director Marc Spiegler, New York gallerists Edward Winkleman and Adam Lindemann, Isaac Kaplan of (online) Artsy and Brussels-based art collector Alain Servais.

My great debt in the preparation of this book is to my partner, Kirsten Ward, for her support in the trials and frustrations of the writing enterprise. Kirsten is not a fan of economic or art-world jargon. If she can't understand the point I'm trying to make, I rewrite it. If she rolls her eyes at what I have tried to say, it gets discarded. If you make it through the book and feel a little wiser about the art world, much of the credit goes to her.

My London editor, Celia Hayley, unerringly identifies the inconsistencies in the flow of the "finished" manuscripts I send her, and politely tells me how to reconstruct the book. John Pearce, my literary agent at Western Creative Artists of Toronto, provides support and creative ideas and Carolyn Forde of WCA does a great job with international sales. Thank you to Cheryl Cohen for diligent editing, and to Anna Comfort O'Keeffe and Nicola Goshulak of Harbour Publishing/Douglas & McIntyre for their help and patience. And thanks to Megan Ferguson for a great job of fact-checking, and for preparing the reference notes.

I will close with a tribute to one of the architects of today's auction world. In April 2015, Alfred Taubman died at the age of ninety-one. Known to his friends as "Big Al," Taubman was a former majority shareholder in Sotheby's and one of the great characters and innovators in the art world of the 1980s and '90s. He changed the way people shopped, both at the many shopping malls he built and owned, and at auction houses.

Taubman was one of the first to build large enclosed malls and introduce customer-friendly features such as food courts. He commissioned museum-quality art "to enliven the space." In 1983 Taubman was invited to be a "white knight" during a takeover bid for Sotheby's by New York investors Marshall Cogan and Stephen Swid. Henry Ford II, another partner and he purchased the auction house—then headquartered in London—with a bid of $125 million.

He understood the potential if the firm could reach a broader public. Of his own experience he said, "Unless you were a dealer or a duke, stepping over the threshold of a major auction house took real courage

and self-confidence ... Even though I was a good customer, an avid collector, and financially well-off ... [auction house representatives] were rude, unresponsive, and often condescending."[112]

Taubman brought the culture of luxury retailing to high-end auctions. He insisted that everyone who entered Sotheby's be treated with respect. He introduced glamorous celebrity sales, notably of the Duchess of Windsor's jewels in 1987, and items from the estate of Jacqueline Kennedy Onassis in 1996. In his first seven years of ownership Sotheby's sales increased by 400 percent, largely because two-thirds of sales were then to individuals rather than the two-thirds to dealers situation prior to his takeover.

Taubman's influence extended beyond the US and Western Europe. As pop art captured art-world leadership in a postwar world awash in "Made in America," so the American/UK way of marketing art took hold around the world—including the Taubman way of auctioning it. Much of what major Chinese auction houses have copied from Western houses is directly traceable to Taubman's innovations.

In later years he was remembered for his 2001 conviction by a US federal jury for colluding with Anthony Tennant, his counterpart at Christie's London, to raise consignor fees. He always denied involvement. He was fined and, because he was seventy-one and had diabetes, served only nine months as inmate 50444-054 at the Federal Medical Center in Rochester, Minnesota.

Taubman offered generous praise and word-of-mouth promotion of my first art market book, which also made him—in my eyes—a good guy with great taste.

Endnotes

Chapter 1 High School with Money

1 Jeffrey Deitch, quoted in Calvin Tomkins, "A Fool For Art: Jeffrey Deitch and the Exuberance of the Art Market.," *The New Yorker*, November 12, 2007, http://www.newyorker.com/magazine/2007/11/12/a-fool-for-art.

2 Anny Shaw, "Adrian Ghenie painting sells for record £6.2m at Christie's," *The Art Newspaper*, October 7, 2016, http://theartnewspaper.com/news/back-to-business-as-usual-at-christie-s-in-london/.

3 Rolando Jimenez, quoted in Edward Helmore, "Buy! Sell! Liquidate! How ArtRank Is Shaking Up the Art Market," *The Guardian*, June 23, 2014, https://www.theguardian.com/artanddesign/2014/jun/23/artrank-buy-sell-liquidate-art-market-website-artists-commodities.

Chapter 2 The Orange Balloon Dog

4 Peter Schjeldahl, "Selling Points: A Jeff Koons Retrospective.," *The New Yorker*, July 7, 2014, http://www.newyorker.com/magazine/2014/07/07/selling-points.

5 Miriam Elia and Ezra Elia, *We Go to the Gallery*, Dung Beetle Learning Guide 1a (London: Dung Beetle Ltd., 2015).

6 Brett Gorvy, quoted in Christie's, "Jeff Koons *Balloon Dog (Orange)* Press Release," September 9, 2013, http://www.christies.com/presscenter/pdf/2013/release_2791_koons_pwc.pdf.

7 Henry Alford, "Oops. I Left My Millions at Home," *The New York Times*,
 November 15, 2013, http://www.nytimes.com/2013/11/17/fashion/A-view-of-the
 -Christies-and-Sothebys-art-auctions-from-the-outside.html?_r=0.

8 Gallerist, "'Rendered speechless': Brett Gorvy Has a Lot to Say about This Week's
 Auctions," *Observer*, November 11, 2013, http://observer.com/2013/11/rendered
 -speechless-brett-gorvy-has-a-lot-to-say-about-this-weeks-auctions/.

9 Graham Bowley, "The (Auction) House Doesn't Always Win: Christie's and
 Sotheby's Woo Big Sellers with a Cut," *The New York Times*, January 15, 2014,
 http://www.nytimes.com/2014/01/16/arts/design/christies-and-sothebys-woo-big
 -sellers-with-a-cut.html.

10 Brett Gorvy, quoted in Stacy Perman, "Pop Goes the Art Market," *Fortune*,
 March 28, 2015, http://fortune.com/2015/03/28/art-art-auctions/.

Chapter 3 Three Studies of Lucian Freud

11 Mark Rothko, quoted in Dorothy Seiberling, "The Varied Art of Four Pioneers,"
 LIFE, November 16, 1959, 82.

12 Jussi Pylkkänen, quoted in Dan Duray, "Christie's Contemporary Sale
 Nets $691.6 M., Auction Record, with Bacon, Koons in Front," *Observer*,
 November 13, 2013, http://observer.com/2013/11/christies-nets-691-6-m-at
 -contemporary-sale-auction-record-with-bacon-koons-in-front-2/#slide9.

13 Pilar Ordovas, quoted in Eric Spitznagel, "FAQ: Why Does Francis Bacon's Art
 Auction Record Matter?" *Bloomberg*, November 15, 2013, http://www.bloomberg
 .com/news/articles/2013-11-15/faq-why-does-francis-bacons-art-auction-record
 -matter.

Chapter 4 $26 Million for Nine Words

14 Roberta Smith, "Painting's Endgame, Rendered Graphically: A Christopher
 Wool Show at the Guggenheim," *The New York Times*, October 24, 2013, http://
 www.nytimes.com/2013/10/25/arts/design/a-christopher-wool-show-at-the
 -guggenheim.html?_r=0.

15 Christophe Van de Weghe, quoted in Vernon Silver and James Tarmy, "The
 350, 000 Percent Rise of Christopher Wool's Masterpiece Painting," *Bloomberg*,
 October 9, 2014, http://www.bloomberg.com/news/articles/2014-10-09/price-of
 -christopher-wools-apocalypse-now-soars-with-art-market.

214

16 Brett Gorvy, quoted in Christie's, "Release: Christopher Wool's Apocalypse Now, 1988 The Seminal Painting of Contemporary Art—An Emblem of a Generation," November 12, 2013, http://www.christies.com/about/press-center/releases/pressrelease.aspx?pressreleaseid=6772.

Chapter 5 Jeff Koons and *Popeye*

17 Scott Rothkopf, quoted in Carol Vogel, "Think Big. Build Big. Sell Big. Whitney Retrospective for Jeff Koons's Monumental Ambitions," *The New York Times*, June 11, 2014, http://www.nytimes.com/2014/06/15/arts/design/whitney-restrospective-for-jeff-koonss-monumental-ambitions.html.

Chapter 6 Ludwig's *Play-Doh*

18 Jeff Koons, quoted in Ingrid Sischy, "Jeff Koons Is Back!," *Vanity Fair*, July 2014, http://www.vanityfair.com/culture/2014/07/jeff-koons-whitney-retropective.

19 Adam Lindemann, quoted in Andrew M. Goldstein, "Dealer Adam Lindemann on Picking Winners in a Superheated Art Market," *Artspace*, June 11, 2014, http://www.artspace.com/magazine/interviews_features/how_i_collect/how-i-collect-adam-lindemann-52372.

20 Jeff Koons, quoted in Vogel, "Think Big. Build Big. Sell Big."

21 Koons, quoted in Sischy, "Jeff Koons Is Back!"

Chapter 7 Sotheby's and Third Point

22 "Exhibit 99.3: Letter to William F. Ruprecht," US Securities and Exchange Commission, October 2, 2013, https://www.sec.gov/Archives/edgar/data/823094/000119312513388165/d605390dex993.htm.

23 Daniel Loeb, quoted in Deepak Gopinath, "Hedge Fund Rabble-Rouser," *Bloomberg Markets*, October 2005, 60.

24 Amy Cappellazo, quoted in Nate Freeman, "House Arrest: How One Topsy-Turvy Season at Sotheby's Could Change the Auction World Forever," *ArtNews*, August 10, 2016, http://www.artnews.com/2016/08/10/house-arrest-how-one-topsy-turvy-season-at-sothebys-could-change-the-auction-world-forever/.

25 Miuccia Prada, quoted in Ella Alexander, "Prada Defends High Price Points," *British Vogue*, April 15, 2013, http://www.vogue.co.uk/article/miuccia-prada-defends-prada-prices-explains-ecommerce-plans.

Chapter 8 Foraging for Collectors and Consignors

26 Brett Gorvy, quoted in Colin Gleadell, "Art Sales: The $2 Billion Art Bonanza," *The Telegraph*, May 20, 2014, http://www.telegraph.co.uk/luxury/art/34082/art -sales-the-2-billion-art-bonanza.html.

27 Lewis Carroll, *Through the Looking-Glass*, Millennium Fulcrum Edition 1.7 ed. (Champaign, IL: Project Gutenberg, 1991), http://www.gutenberg.org/files/12/ 12-h/12-h.htm.

28 Judith H. Dobrzynski, "How Auction Houses Orchestrate Sales for Maximum Drama," *The New York Times*, October 28, 2015, http://www.nytimes.com/2015/11 /01/arts/design/how-auction-houses-orchestrate-sales-for-maximum-drama.html.

29 Xin Li, quoted in Derek Blasberg, "How Xin Li Went from the Runway to the Center of Nine-Figure Art Auctions," *Vanity Fair*, November 2015, http://www .vanityfair.com/style/2015/11/xin-li-model-art-auctions.

30 Eileen Kinsella, "Meet Xin Li, Christie's Secret Weapon for China Sales," *artnet News*, November 8, 2014, https://news.artnet.com/market/meet-xin-li-christies -secret-weapon-for-china-sales-160712.

31 Rebecca Mead, "The Daredevil of the Auction World," *The New Yorker*, July 4, 2016, http://www.newyorker.com/magazine/2016/07/04/loic-gouzer-the -daredevil-at-christies.

32 Wang Wei, quoted in Amy Qin, "With Modigliani Purchase, Chinese Billionaire Dreams of Bigger Canvas," *The New York Times*, November 17, 2015, http://www .nytimes.com/2015/11/18/arts/international/with-modigliani-purchase-chinese -billionaire-liu-yiqian-dreams-of-bigger-canvas.html.

Chapter 9 Lisson Goes to New York

33 Melanie Gerlis, "'Amateur management' blamed as book claims third of galleries run at a loss," *The Art Newspaper*, August 29, 2015, http://theartnewspaper.com/ market/art-market-news/amateur-management-blamed-as-book-claims-third-of -galleries-run-at-a-loss/.

34 Marc Spiegler, quoted in Blake Gopnik, "Great Art Needs an Audience," *The Art Newspaper*, February 12, 2014, http://old.theartnewspaper.com/articles/Great-art -needs-an-audience/31726.

35 Emmanuel Perrotin, quoted in Nicolai Hartvig, "Art Basel Opens in Time of Turbulence for Dealers," *The New York Times*, June 11, 2013, http://www.nytimes.com /2013/06/12/arts/Art-Basel-Opens-in-Time-of-Turbulence-for-Dealers.html?_r=1. **215**

36 Sean Scully, quoted in Deborah Solomon, "Becoming Modern: The Met's Mission at the Breuer Building," *The New York Times*, November 25, 2015, http://www.nytimes.com/2015/11/29/arts/design/becoming-modern-the-mets-mission-at-the-breuer-building.html?_r=0.

37 Nate Freeman, "Christie's 'Artist Muse' Sale Nets $491.4 M., Led by a $170.4 M. Modigliani, the Second-Highest Price Ever Realized at Auction," *ArtNews*, November 9, 2015, http://www.artnews.com/2015/11/09/christies-artist-muse-sale-nets-491-4-m-led-by-a-170-4-m-modigliani-the-second-highest-price-ever-realized-at-auction/.

Chapter 10 **The Art Adviser**

38 Adam Lindemann, quoted in Henri Neuendorf, "Art Demystified: What Is The Role of Art Advisors?" *artnet News*, August 11, 2016, https://news.artnet.com/art-world/art-demystified-role-of-advisors-596927.

39 Amy Cappellazzo, quoted in Adrienne Gaffney, "Amy Cappellazzo," *Wall Street Journal*, November 29, 2012, http://www.wsj.com/articles/SB10001424127887324894104578115181650750570.

40 Amy Cappellazzo, quoted in Dodie Kazanjian, "What Does Amy Cappellazzo's Move from Christie's Say about the Changing Face of the Art Market?," *Vogue*, March 7, 2014, http://www.vogue.com/865154/amy-cappellazzo-leaves-christies-contemporary-art-market/.

41 Cappellazzo, quoted in Kazanjian, "Amy Cappellazzo's Move from Christie's."

42 Ibid.

43 Ibid.

44 Ibid.

45 Annelien Bruins, quoted in Andrew M. Goldstein, "Art Advisor Annelien Bruins on the Realities of Art Investment," *Artspace*, February 12, 2014, http://www.artspace.com/magazine/interviews_features/expert_eye/art_advisor_annelien_bruins-52046.

46 Sandy Heller, quoted in Carol Vogel, "Landmark De Kooning Crowns Collection," *The New York Times*, November 18, 2006, http://www.nytimes.com/2006/11/18/arts/design/18pain.html.

47 Donald B. Marron, quoted in Robin Pogrebin and Graham Bowley, "Soaring Art Market Attracts a New Breed of Advisers for Collectors," *The New York Times*, August 22, 2015, http://www.nytimes.com/2015/08/23/arts/design/soaring-art-market-attracts-a-new-breed-of-advisers-for-collectors.html.

48 Bruins, quoted in Goldstein, "Art Advisor Annelien Bruins."

49 Pogrebin and Bowley, "Soaring Art Market."

50 Joshua Roth, quoted in Melena Ryzik, "Joshua Roth Takes United Talent Agency into the Art World," *The New York Times*, September 13, 2015, http://www.nytimes.com/2015/09/14/arts/design/joshua-roth-takes-united-talent-agency-into-the-art-world.html.

Chapter 11 Perelman v. Gagosian

51 Fleischman Law Firm, MAFG *Art Fund LLC, and MacAndrews & Forbes Group LLC v Larry Gagosian and Gagosian Gallery, Inc.*, Index No. 653189/2012 (New York County: Supreme Court of the State of New York, September 12, 2012), 8, http://hyperallergic.com/wp-content/uploads/2014/02/MAFG-Art-Fund-LLC-v-Gagosian.pdf.

52 Barbara R. Kapnick, MAFG *Art Fund, LLC V Gagosian*, 2014 NY Slip OP 30321 (U) (New York: Supreme Court of the State of New York, February 3, 2014), 28, http://www.courts.state.ny.us/reporter//pdfs/2014/2014_30321.pdf.

53 Ronald Perelman's lawyers, quoted in Robert Frank, "The Feud That's Shaking Gallery Walls," *The New York Times*, October 18, 2014, http://www.nytimes.com/2014/10/19/business/the-feud-thats-shaking-gallery-walls.html.

54 Kapnick, MAFG *Art Fund, LLC V Gagosian*, 26.

55 Ibid., 19.

56 David Friedman, quoted in Chris Dolmetsch, "N.Y. Art Gallery Owner Gagosian Wins End to Perelman Suit," *Bloomberg*, December 4, 2014, http://www.bloomberg.com/news/articles/2014-12-04/n-y-art-gallery-owner-gagosian-wins-end-to-perelman-suit.

Chapter 12 The Knoedler Fakes

57 Thomas Hoving, *False Impressions: The Hunt for Big-Time Art Fakes* (New York, NY: Simon & Schuster, 1996), 17.

58 Glafira Rosales, quoted in William K. Rashbaum and Patricia Cohen, "Art Dealer Admits to Role in Fraud," *The New York Times*, September 16, 2013, http://www.nytimes.com/2013/09/17/arts/design/art-dealer-admits-role-in-selling-fake-works.html.

59 John Howard, quoted in *Bloomberg*, "The Other Side of an $80 Million Art Fraud: A Master Forger Speaks." December 19, 2013, http://www.bloomberg.com/news/articles/2013-12-19/the-other-side-of-an-80-million-art-fraud-a-master-forger-speaks.

60 Peter Stern, quoted in Laura Gilbert, "Knoedler Cases Focus on Due Diligence," *The Art Newspaper*, November 1, 2014, http://theartnewspaper.com/news/news/knoedler-cases-focus-on-due-diligence/.

61 Ann Freedman, quoted in Laura Gilbert, "'Document Dump' Reveals New Details in Knoedler Case," *The Art Newspaper*, October 8, 2014, http://old.theartnewspaper.com/articles/Document-dump-reveals-new-details-in-Knoedler-case/35881.

62 Helen Frankenthaler, quoted in Laura Gilbert and Bill Glass, "Former Director of Scandal-Beset Knoedler Gallery Breaks Her Silence," *The Art Newspaper*, April 18, 2016, http://theartnewspaper.com/news/former-director-of-scandal-beset-knoedler-gallery-breaks-her-silence/.

63 Domenico and Eleanore De Sole, quoted in Laura Gilbert, "Lawyers Battle to Tip Balance of Evidence Before Knoedler Trial," *The Art Newspaper*, December 21, 2015, http://theartnewspaper.com/news/lawyers-battle-to-tip-balance-of-evidence-before-knoedler-trial/.

64 Jack Flam, quoted in M H Miller, "In Court, Experts Say Knoedler Ignored Warnings about Forgeries," *Art News*, February 5, 2016, http://www.artnews.com/2016/02/05/in-court-experts-say-knoedler-ignored-warnings-about-forgeries/.

65 Milton Esterow, "Fakers, Fakes, & Fake Fakers," *ArtNews*, November 20, 2013, http://www.artnews.com/2013/11/20/fakers-fakes-fake-fakers/.

66 Richard Feigen, quoted in Laura Gilbert, "Have Multi-Million-Dollar Forgery Scandals Changed the Art Market for Good?," *Artsy*, October 19, 2015, https://www.artsy.net/article/artsy-editorial-have-multi-million-dollar-forgery-scandals-changed-the.

67 Gary Feinerman, quoted in Dan Duray, "Chicago Judge Rules Peter Doig 'absolutely did not paint' Disputed Work," *The Art Newspaper*, August 23, 2016, http://theartnewspaper.com/news/judge-rules-peter-doig-absolutely-did-not-paint-disputed-work/.

Chapter 13 **Government-Plundered Art**

68 T. Jefferson, "Glenn Beck: Does Congress Matter?," Glenn Beck, September 18, 2009, http://www.glennbeck.com/content/articles/article/198/30765/?utm_source=glennbeck&utm_medium=contentcopy_link.

69 Anthony J. Costantini, quoted in Tom Mashberg, "A Son Seeks Art Looted by the East Germans," *The New York Times*, November 27, 2014, http://www.nytimes.com /2014/11/28/arts/international/stasi-art-seizure-leads-to-court-case-involving -new-yorkers.html.

Chapter 14 Freeports and Tax Ploys

70 Nicholas Brett, quoted in David Segal, "Swiss Freeports Are Home for a Growing Treasury of Art," *The New York Times*, July 21, 2012, http://www.nytimes.com/2012 /07/22/business/swiss-freeports-are-home-for-a-growing-treasury-of-art.html.

71 Nick Paumgarten, "Dealer's Hand: Why Are so Many People Paying so Much Money for Art? Ask David Zwirner," *The New Yorker*, December 2, 2013, http:// www.newyorker.com/magazine/2013/12/02/dealers-hand.

72 Rybolovlev family trust, quoted in Eileen Kinsella, "Rybolovlev Denies 'Panama Papers' Allegations," *artnet News*, April 6, 2016, https://news.artnet.com/ exhibitions/billionaire-collector-dmitry-rybolovlev-denies-panama-papers -allegations-466880.

Chapter 15 The Uneasy Marriage of Art + Fashion

73 Nicolai Ouroussoff, "Art and Commerce Canoodling in Central Park," *The New York Times*, October 20, 2008, http://www.nytimes.com/2008/10/21/arts/design /21zaha.html.

74 Mitchell Oakley Smith, quoted in Alice Gregory, "Art and Fashion: The Mutual Appreciation Society," *Wall Street Journal*, March 28, 2014, http://www.wsj.com/ articles/SB10001424052702303725404579459503054211692.

75 Ruth La Ferla, "The Artist's Fall Collection," *The New York Times*, November 8, 2007, http://www.nytimes.com/2007/11/08/fashion/08ART.html.

76 Takashi Murakami, quoted in Jeff Howe, "The Two Faces of Takashi Murakami," WIRED, November 1, 2003, https://www.wired.com/2003/11/artist/.

77 Damien Hirst, quoted in Andrew Rice, "Damien Hirst: Jumping the Shark," *Bloomberg*, November 21, 2012, http://www.bloomberg.com/news/articles/2012-11 -21/damien-hirst-jumping-the-shark.

78 Oscar de la Renta: The Retrospective," de Young Fine Arts Museum of San Francisco, April 14, 2016, https://deyoung.famsf.org/exhibitions/oscar-de-la -renta-retrospective.

79 Jason Farago, "Thom Browne's Shoes: High Fashion and High Art," *The New York Times*, March 17, 2016, http://www.nytimes.com/2016/03/18/arts/design/thom-brownes-shoes-high-fashion-and-high-art.html.

Chapter 16 Art Market Regulation

80 Martin Roth, quoted in John Gapper, "Art World's Shady Dealings Under Scrutiny at Davos," *Financial Times*, January 22, 2015, https://www.ft.com/content/620cbf76-5125-300e-93e7-3448c1197ead.

81 John Gapper and Peter Aspden, "Davos 2015: Nouriel Roubini Says Art Market Needs Regulation," *Financial Times*, January 22, 2015, https://www.ft.com/content/992dcf86-a250-11e4-aba2-00144feab7de.

Chapter 17 Art in an Uber World

82 Tim Goodman, quoted in Jenny White, "Canny Savings: How Fine Art Bourse Does It," *Private Art Investor*, July 7, 2015, http://www.privateartinvestor.com/art-business/canny-savings-how-fine-art-bourse-does-it/.

83 Carlos Rivera, quoted in Edward Helmore, "Buy! Sell! Liquidate! How ArtRank Is Shaking Up the Art Market," *The Guardian*, June 23, 2014, https://www.theguardian.com/artanddesign/2014/jun/23/artrank-buy-sell-liquidate-art-market-website-artists-commodities.

Chapter 18 Not Your Father's Museum

84 Thomas Campbell, quoted in "The Met Vs. MOMA: Bob Colacello Uncovers The Battle For Art, Prestige, And Young Trustee Blood," *Vanity Fair*, January 2015, http://www.vanityfair.com/culture/2015/01/met-moma-art-museum-war.

85 Thomas Campbell, quoted in Carol Vogel, "Met's First Plans for the Whitney's Old Home," *The New York Times*, November 13, 2014, http://www.nytimes.com/2014/11/14/arts/design/mets-first-plans-for-the-whitneys-old-home.html.

86 Thomas Campbell, quoted in Calvin Tomkins, "The Met and the Now: America's Preëminent Museum Finally Embraces Contemporary Art.," *The New Yorker*, January 25, 2016, http://www.newyorker.com/magazine/2016/01/25/the-met-and-the-now.

87 Andrew M. Goldstein, "How Arnold Lehman Transformed the Brooklyn Museum from a 'Startup' to a Cultural Juggernaut," *Artspace*, April 4, 2015, http://www.artspace.com/magazine/interviews_features/expert_eye/arnold-lehman-interview-part-1-52730.

88 Arnold Lehman, quoted in Andrew M. Goldstein, "Arnold Lehman on the Future of the Brooklyn Museum," *Artspace*, April 6, 2015, http://www.artspace.com/magazine/interviews_features/expert_eye/arnold-lehman-interview-part-2-52716.

89 Jeffrey Deitch, quoted in Jerry Saltz, "The New New Museum: How the Whitney Might Just Solve the Impossible Problem of Contemporary Art," *Vulture*, April 19, 2015, http://www.vulture.com/2015/04/jerry-saltz-on-new-whitney-museum.html.

90 Arnold Lehman, quoted in Jillian Steinhauer, "On Leaving the Brooklyn Museum After 17 Years: An Interview with Arnold Lehman," *Hyperallergic*, April 13, 2015, http://hyperallergic.com/198257/on-leaving-the-brooklyn-museum-after-17-years-an-interview-with-arnold-lehman/.

Chapter 19　　Museum Exhibitions

91 Helen Molesworth, quoted in Julia Halperin, "Almost One Third of Solo Shows in US Museums Go to Artists Represented by Just Five Galleries," *The Art Newspaper*, April 2, 2015, http://old.theartnewspaper.com/articles/Almost-one-third-of-solo-shows-in-US-museums-go-to-artists-represented-by-just-five-galleries/37402.

92 Michael Plummer, quoted in Gareth Harris and Anny Shaw, "Who's Bankrolling the Venice Biennale?," *The Art Newspaper*, May 7, 2015, http://theartnewspaper.com/reports/who-s-shoring-up-venice/.

93 A spokeswoman for the British Council, quoted in Harris and Shaw, "Who's Bankrolling the Venice Biennale?"

94 Robert Storr, quoted in Halperin, "Artists Represented by Just Five Galleries."

95 William Powhida, "Artistic Success in America Means Wearing the Right Old School Tie," *The Art Newspaper*, April 30, 2015, http://theartnewspaper.com/comment/comment/artistic-success-means-wearing-the-right-old-school-tie/.

96 Deborah Sontag and Robin Pogrebin, "Some Object as Museum Shows Its Trustee's Art," *The New York Times*, November 10, 2009, http://www.nytimes.com/2009/11/11/arts/design/11museum.html.

97 Sontag and Pogrebin, "Some Object as Museum Shows Its Trustee's Art."

98 Jerry Saltz, "Less Than the Sum of Its Parts," *New York Magazine*, March 26, 2010, http://nymag.com/arts/art/reviews/65115/.

Chapter 20 Private Museums

99 Nick Paumgarten, "Dealer's Hand," *The New Yorker*, December 2, 2013, http://www.newyorker.com/magazine/2013/12/02/dealers-hand.

100 J. Paul Getty Trust, *Trust Indenture* (Los Angeles, 2006), http://www.getty.edu/about/governance/pdfs/indenture.pdf.

Chapter 21 The Most Influential Buyer

101 Sheikha al-Mayassa bint Hamad bin Khalifa al-Thani, quoted in John Arlidge, "Forget about the Price Tag: Qatar's Sheikha Mayassa Is Outbidding the Art World," ES *Magazine* (*Evening Standard*), October 4, 2013, http://www.standard.co.uk/lifestyle/esmagazine/forget-about-the-price-tag-qatars-sheikha-mayassa-is-outbidding-the-art-world-8856384.html.

102 Takashi Murakami, "The World's 100 Most Influential People: Sheika Al-Mayassa Bint Hamad Bin Khalifa Al-Thani," TIME, April 23, 2014, http://time.com/70911/sheika-al-mayassa-2014-time-100/.

103 Lorena Muñoz-Alonso, "Fondazione Sandretto Re Rebaudengo Celebrates StellaRe Award and 20th Anniversary with Star-Studded Gala," *artnet News*, May 6, 2015, https://news.artnet.com/art-world/fondazione-sandretto-re-rebaudengo-celebrates-stellare-award-and-20th-anniversary-with-star-studded-gala-294743.

104 Susan Hack, "Qatar's Billion-Dollar Art Collection Causes Controversy," *Bloomberg*, October 2, 2014, https://www.bloomberg.com/news/articles/2014-10-02/qatar-s-billion-dollar-art-collection-causes-controversy.

105 Sheikha al-Mayassa, quoted in Arlidge, "Forget about the Price Tag."

106 Hack, "Qatar's Billion-Dollar Art Collection Causes Controversy."

Chapter 22 Gaming the Art Bubble

107 Robert Hughes, *Nothing if Not Critical* (New York: Penguin Books, 1990), 237.

108 Daniel Kahneman and Gary Klein, "Strategic Decisions: When Can You Trust Your Gut?," *McKinsey Quarterly* (McKinsey & Company), March 2010, http://www.mckinsey.com/business-functions/strategy-and-corporate-finance/our-insights/strategic-decisions-when-can-you-trust-your-gut.

109 Tobias Meyer, quoted in Ingrid Sischy, "Money on the Wall," *Vanity Fair*, December 2006, http://www.vanityfair.com/culture/2006/12/jeffrey-deitch-200612.

110 Amy Cappellazzo, quoted in Dodie Kazanjian, "What Does Amy Cappellazzo's Move from Christie's Say about the Changing Face of the Art Market?," *Vogue*, March 7, 2014, http://www.vogue.com/865154/amy-cappellazzo-leaves-christies-contemporary-art-market/.

Postscript

111 Tim Harford, "The Pillars of Tax Wisdom," *Financial Times*, November 20, 2015, https://www.ft.com/content/4fee3138-8d6b-11e5-a549-b89a1dfede9b.

112 Alfred Taubman, quoted in Anthony Calnek, "A. Alfred Taubman: The Visionary Collector Who Transformed the Art Market on Sotheby's Blog," Sotheby's, October 1, 2015, http://www.sothebys.com/en/news-video/blogs/all-blogs/the-collection-of-a-alfred-taubman/2015/10/a-alfred-taubman-visionary-collector-art-market.html.

More Reading

For those with interest in individual chapter subjects, the list below has additional material that I have found of interest. These are not references keyed to text material, although many are referred to in the text.

Chapter 1 **High School with Money**

Akerlof, George A. and Robert J. Shiller. *Phishing for Phools: The Economics of Manipulation and Deception*. Princeton: Princeton University Press, 2015. Akerlof and Shiller are both Nobel Prize economists. The book argues that as long as there is profit to be made, sellers will exploit our psychological weaknesses through manipulation and deception. Rather than being benign, markets are filled with tricks and traps and will "phish" us as "phools."

Jones II, Paul Tudor. "Why We Need to Rethink Capitalism." TED2015, March 2015. https://www.ted.com/talks/paul_tudor_jones_ii_why_we_need_to_rethink _capitalism?language=en.

Piketty, Thomas. *Capital in the Twenty-First Century*. Paris: Éditions du Seuil, 2013 and Cambridge MA: The Belknap Press of Harvard University Press, 2014.

Thaler, Richard H. *Misbehaving: The Making of Behavioral Economics*. New York: W.W. Norton, 2015.

Thaler, Richard H. "Unless You Are Spock, Irrelevant Things Matter in Economic Behavior." *The New York Times*, May 12, 2015.

Thaler, Richard H. and Cass R. Sunstein. *Nudge: Improving Decisions About Health, Wealth, and Happiness*. New York: Penguin Books, 2009.

Velthuis, Olav and Stefano Baia Curioni (eds). *Cosmopolitan Canvases: The Globalization of Markets for Contemporary Art.* Oxford; New York: Oxford University Press, 2015. This is a series of academic studies which challenge assumptions about the art market, notably about the degree of globalization.

Chapter 2 The Orange Balloon Dog

Vogel, Carol. "Think Big. Build Big. Sell Big: Whitney Retrospective for Jeff Koons' Monumental Ambitions." *The New York Times*, June 11, 2014.

Chapter 4 $26 Million for Nine Words

Ganek, Danielle. *Lulu Meets God and Doubts Him.* New York: Plume, 2008.
Silver, Vernon and James Tarmy. "The 350,000 Percent Rise of Christopher Wool's Masterpiece Painting." *Bloomberg*, October 9, 2014.

Chapter 5 Jeff Koons and *Popeye*

Plagens, Peter. "Confectionary Overload." *The Wall Street Journal*, July 21, 2014.
Rosenbaum, Lee (CultureGrrl). "Koons, Whitney, Wynn and My 'Greater Fool' Theory of Trophy Art." July 24, 2014.
Salmon, Felix. "Jeff Koons: a master innovator turning money into art." *The Guardian*, July 3, 2014.
Sischy, Ingrid. "Jeff Koons Is Back!" *Vanity Fair*, July 20, 2014.
Vogel, Carol. "Think Big. Build Big. Sell Big: Whitney Retrospective for Jeff Koons' Monumental Ambitions." *The New York Times*, June 11, 2014.

Chapter 6 Ludwig's *Play-Doh*

Goldstein, Andrew M. "Dealer Adam Lindemann on Picking Winners in a Superheated Art Market." *Artspace*, June 11, 2014. This is the article where Lindemann discusses flipping Koons' *Hanging Heart* sculpture.

Chapter 8 Foraging for Collectors and Consignors

Crow, Kelly. "The Art World's High-Roller Specialist." *The Wall Street Journal*, November 6, 2014.

226 Mead, Rebecca. "The Daredevil of the Auction World." *The New Yorker*, July 4, 2016.

Chapter 9 **Lisson Goes to New York**

Paumgarten, Nick. "Dealer's Hand: Why Are so Many People Paying so Much Money for Art? Ask David Zwirner." *The New Yorker*, December 2, 2013.

Resch, Magnus. *Management of Art Galleries.* Ostfildern: Hatje Cantz (2014). This is a doctoral dissertation, originally a bestseller on Amazon. It sets out options followed by successful galleries.

Tully, Judd. "London Calling." *Blouin Art+Auction*, June 2014.

Chapter 10 **The Art Adviser**

Crow, Kelly. "Christie's to Lose Contemporary-Art Chief." *The Wall Street Journal*, December 13, 2013.

"Fiduciary." *Investopedia.* October 7, 2016. http://www.investopedia.com/terms/f/fiduciary.asp.

Goldstein, Andrew M. "Art Advisor Annelien Bruins on the Realities of Art Investment." *ArtSpace*, February 12, 2014.

"International Fair Report 2016." London; New York: *The Art Newspaper International Edition*, June 2016.

Kazanjian, Dodie. "What Does Amy Cappellazzo's Move from Christie's Say About the Changing Face of the Art Market?" *Vogue*, March 7, 2014.

Pogrebin, Robin and Graham Bowley. "Soaring Art Market Attracts a New Breed of Advisers for Collectors." *The New York Times*, August 22, 2015.

Chapter 11 **Perelman v. Gagosian**

Dolmetsch, Chris. "N.Y. Art Gallery Owner Gagosian Wins End to Perelman Suit." *Bloomberg*, December 4, 2014.

Frank, Robert. "The Feud That's Shaking Gallery Walls." *The New York Times*, October 18, 2014.

Halpern, Julia. "Trust No One: Victory for Gagosian in Two-Year Case." *The Art Newspaper*, January 2015.

Konigsberg, Eric. "The Trials of Art Superdealer Larry Gagosian." *New York Magazine*, January 28, 2013.

The initial decision in the cases discussed in the chapter is Kapnick, Barbara R. MAFG
 Art Fund, LLC v Gagosian. 2014 NY Slip OP 30321 (U). New York: Supreme Court
 of the State of New York, February 3, 2014. This is the ruling of Justice Barbara
 Kapnick, and includes identification of the works of art included in the proposed
 art swap.

The appeal court decision is MAFG *Art Fund, LLC v Gagosian.* 2014 NY Slip OP 08499.
 New York: Supreme Court of the State of New York, December 4, 2014.

The ABA case mentioned is *Arthur Properties, S.A. v ABA Gallery, Inc.* No. 11 Civ. 4409.
 Southern District of New York: US District Court, November 28, 2011.

The Cowles case is *Cowles v Gagosian.* 2012 NY Slip OP 33156 (U). New York County:
 Supreme Court of the State of New York, August 22, 2012. Citing DDJ *Mgt. LLC
 v Rhone Group LLC.* 2010 NY Slip OP 05603 [15 NY3d 147]. New York: Court of
 Appeals, June 24, 2010.

Chapter 12 The Knoedler Fakes

Bowley, Graham. "Peter Doig Says He Didn't Paint This. Now He Has to Prove It." *The
 New York Times,* July 7, 2016.

Charney, Noah. *The Art of Forgery: The Minds, Motives and Methods of Master Forgers.*
 London: Phaidon Press Ltd, 2015.

Cohen, Patricia. "Suitable for Suing." *The New York Times,* February 22, 2012.

Kinsella, Eileen. "Dodgy eBay Sellers Peddle Tall Tales and Fake Art." *artnet News,*
 July 9, 2014.

Maloney, Jennifer. "The Deep Freeze in Art Authentication." *The Wall Street Journal,*
 April 24, 2014.

Perenyi, Ken. *Caveat Emptor: The Secret Life of an American Art Forger.* New York:
 Pegasus Books, 2013.

Chapter 13 Government-Plundered Art

Cascone, Sarah. "Reclaiming Art Seized by Castro's Government Will Be An Uphill
 Battle." *artnet News,* January 8, 2015.

O'Grady, Mary Anastasia. "Castro's Art Theft Puts Sotheby's on the Spot." *The Wall
 Street Journal,* October 29, 2004.

"In the Shadow of the Holocaust: An Art Trove Exposes a Legal Vacuum." *The Economist,*
 November 30, 2013.

228 Mashberg, Tom. "A Son Seeks Art Looted by the East Germans." *The New York Times,*
November 27, 2014.

Tully, Judd. "A New Cuban Front." *Blouin Art+Auction,* March 2015.

Chapter 14 Freeports and Tax Ploys

Alden, William. "Art for Money's Sake." *The New York Times Sunday Magazine,*
February 3, 2015.

Bowley, Graham and Doreen Carvajal. "One of the World's Greatest Art Collections
Hides Behind This Fence." *The New York Times,* May 28, 2016.

De Sanctis, Fausto Martin. *Money Laundering Through Art: A Criminal Justice Perspective.*
Cham; New York: Springer, 2013. This is a doctoral dissertation written from a
legal perspective. If you are interested in the use of Bitcoins and other minutia in
art dodges, this is the book.

Segal, David. "Swiss Freeports Are Home for a Growing Treasury of Art." *International
New York Times,* July 21, 2012.

"Über-Warehouses for the Ultra-Rich." *The Economist,* November 23, 2013.

Wayne, Leslie. "Cook Islands, a Paradise of Untouchable Assets." *The New York Times,*
December 14, 2013.

Chapter 15 The Uneasy Marriage of Art + Fashion

Currid, Elizabeth. *The Warhol Economy: How Fashion, Art and Music Drive New York
City.* Princeton: Princeton University Press, 2007.

Farago, Jason. "Thom Browne's Shoes: High Fashion and High Art." *The New York
Times,* March 17, 2016.

Gregory, Alice. "Art and Fashion: The Mutual Appreciation Society." *The Wall Street
Journal,* March 28, 2014.

Kubler, Alison and Mitchell Oakley Smith. *Art/Fashion in the 21st Century.* New York:
Thames & Hudson, 2013.

Warhol, Andy and Pat Hackett. popism: *The Warhol Sixties.* Orlando: Mariner Books, 2006.

www.whereartmeetsfashion.wordpress.com for other examples of art + fashion.

Chapter 16 Art Market Regulation

Adam, Georgina. "Guidelines to regulate market are an 'impossible dream.'" *The Art
Newspaper,* March 2015.

Gapper, John and Peter Aspden. "Nouriel Roubini Says Art Market Needs Regulation."
 Financial Times, January 22, 2015.

Gapper, John. "Art worlds shady dealings under scrutiny at Davos." *Financial Times*,
 January 22, 2015.

Gerlis, Melanie. *Art as an Investment?: A Survey of Comparative Assets.* Farnham: Lund
 Humphries, 2014.

Heddaya, Mostafa. "A Regulated Art Market?" *Blouin Art+Auction*, April 2015.

Reyburn, Scott. "Can an Economist's Theory Apply to Art?" *The New York Times*,
 April 20, 2014.

Chapter 17 Art in an Uber World

Alden, William. "Art for Money's Sake." *New York Times Magazine*, February 3, 2015.

gallerypoulsen. Instagram post. March 5, 2015. https://instagram.com/p/z2ci5MRSyy/.
 The Poulsen photo shot from the Pulse Art fair. The *Nachlass* work is at the
 center rear.

"Out with the old, in with the new." *The Economist*, January 3, 2013.

de Pury, Simon and William Stadiem. *The Auctioneer: Adventures in the Art Trade.* New
 York: St. Martin's Press, 2016.

Winkleman, Edward. *Selling Contemporary Art: How to Navigate the Evolving Market.*
 New York: Allworth Press, 2015.

Chapter 18 Not Your Father's Museum

Art Museums by the Numbers 2014. Association of Art Museum Directors, 2015. This is
 the source for funding information on art museums in the chapter. It is based on
 responses from 204 museums in the United States and 16 in Canada and Mexico.

Cohen, Patricia. "Writing Off the Warhol Next Door." *The New York Times*,
 January 10, 2015.

Crow, Kelly. "The New Whitney Marks a Change in Museum Design." *The Wall Street
 Journal*, April 9, 2015.

Goldstein, Andrew M. "How Arnold Lehman Transformed the Brooklyn Museum
 from a 'Startup' to a Cultural Juggernaut." *Artspace Magazine*, April 4, 2015.

Goldstein, Andrew M. "Arnold Lehman on the Future of the Brooklyn Museum,"
 Artspace Magazine, April 6, 2015.

Sheets, Hilarie M. "Blurring the Museum-Gallery Divide." *The New York Times*,
 June 18, 2015.

230 Vogel, Carol. "A Collector's Personal Perspective." *The New York Times*,
October 12, 2014.

Vogel, Carol. "Like Half the National Gallery in Your Backyard." *The New York Times*,
April 18, 2013.

Chapter 19 Museum Exhibitions

Halperin, Julia. "Almost one third of solo shows in US museums go to artists
represented by just five galleries." *The Art Newspaper*, April 2, 2015.

Martinez, Alanna. "Art World Power Is All About Who You Know—And What
Gallery You Show At." *New York Observer*, April 3, 2015.

Chapter 20 Private Museums

Barnes, Brooks. "The Art Museum in Steve Tisch's Backyard." *The New York Times*,
May 14, 2016.

Cooper, Andrew Scott. *The Fall of Heaven: The Pahlavis and the Final Days of Imperial
Iran*. New York: Henry Holt and Co, 2016.

Chapter 21 The Most Influential Buyer

Pogrebin, Robin. "Qatari Riches Are Buying Art World Influence." *The New York Times*,
July 22, 2013.

Vogel, Carol. "Sheikha al-Mayassa bint Hamad bin Khalifa al-Thani of Qatar Museums."
The New York Times, December 26, 2013.

Chapter 22 Gaming the Art Bubble

Kazakina, Katya. "Art Flippers Chase Fresh Stars as Murillo's Doodles Soar." *Bloomberg*,
February 7, 2014.

Postscript

Taubman, A. Alfred. *Threshold Resistance: The Extraordinary Career of a Luxury Retailing
Pioneer*. New York: Harper Collins, 2007. This is Taubman's memoir.

Index

All art is listed under artist. The locator **INS** indicates a colour photo in the insert after page 96.

233

INDEX

237

INDEX